STUDIES IN THE HISTORY OF SCULPTURE
NUMBER I

'THE HYDE

EPSTEIN'S RIMA

PARK ATROCITY'

CREATION AND CONTROVERSY

TERRY FRIEDMAN

PUBLISHED BY

**THE HENRY MOORE CENTRE
FOR THE STUDY OF SCULPTURE
LEEDS CITY ART GALLERIES
1988**

NOTES ON THE TEXT AND ILLUSTRATIONS

Works illustrated in the text are by Epstein, unless otherwise stated.

Numbers in square brackets [1–49] correspond to illustrations in the text.

Numbers prefixed by D [D 1–56v], including those on the verso [v], correspond to drawings in the *Rima Sketchbook*, with the addition of D 57 (whereabouts unknown), illustrated following the text.

Dimensions are given in centimetres, height before width.

© 1988
The Henry Moore Centre for the Study of Sculpture
Leeds City Art Galleries
Calverley Street, Leeds LS1 3AA
Yorkshire, England

ISBN 0 901981 37 0

Design by Peter McGrath

Printed in Great Britain
by W. S. Maney and Son Limited
Hudson Road, Leeds LS9 7DL

FOREWORD

This investigation of Sir Jacob Epstein's most controversial sculpture, the *Rima* relief on the *W. H. Hudson Memorial* in Hyde Park, London, has been inspired by material in The Henry Moore Centre for the Study of Sculpture, and is the first in a series of publications, issued under the general title, Studies in the History of Sculpture, intended to highlight important holdings in the permanent collection of the Leeds City Art Galleries.

In 1925, the year it was unveiled, *Rima* was the focus of prolonged press coverage. Two subsequent pioneer studies of the artist, *The Sculptor Speaks: Jacob Epstein to Arnold L. Haskell*, 1931, and L. B. Powell's *Jacob Epstein*, 1932, deal with the work in some detail, as does Epstein himself in his autobiography, *Let There Be Sculpture*, 1940. But since those heady days this remarkable carving has attracted little attention among historians, artists or the public. The exceptions are John Glaves-Smith's 'Rima revisited: Epstein and W. H. Hudson', a paper read at the Ninth Annual Conference of the Association of Art Historians, London, in 1983, and Ruth Walton's *In Defence of Epstein's Rima*, a BA Honours degree dissertation, London University Institute of Education, 1984 (both unpublished), Evelyn Silber's recent monograph, *The Sculpture of Epstein*, 1986, and *Jacob Epstein: Sculpture and Drawings*, 1987 (the catalogue of the exhibition held at Leeds City Art Gallery and Whitechapel Art Gallery, London), where a brief, preliminary version of the present study appears.

'*The Hyde Park Atrocity*' (*The Daily Mail's* condemnatory headline following the unveiling in Spring 1925) is the fruit of two fortuitous events: the Study Centre's 1987 exhibition, which brought together a large number of the artist's works and much new information, and its purchase four years earlier of a remarkable sketchbook for the *Rima* relief, made by Epstein in 1923. The drawings have recently been unbound and individually framed for conservation purposes and so that they can be displayed to the public.

In preparing this publication, made possible by a special grant from the Henry Moore Foundation, the Study Centre is especially grateful to Dr Silber for her insight and comments, to Beth Lipkin for her generous support and to Elizabeth Barker, Stanley Burton, Ian K. Dawson, Anthony d'Offay, Dr Meryl R. Foster, Melanie Hall, James Hamilton, T. G. H. James, Leeds Photo Litho, Peggy-Jean Lewis, Bernard Lyons, Angela Mace, Laura Mack, Peter McGrath, Malcolm McLeod, Elsje Prinz, Daru Rook, Dr Jeffrey Sherwin, Peyton Skipwith, Ruth Walton and Adam White. The British Architectural Library, The Royal Academy Library, The Royal Institute of British Architects Drawings Collection and The Tate Gallery Archives in London, The Henry Moore Foundation, Public Record Office at Kew and The Royal Society for the Protection of Birds at Sandy, have kindly permitted the publication of material in their keeping.

DR TERRY FRIEDMAN

PRINCIPAL KEEPER
LEEDS CITY ART GALLERY AND
THE HENRY MOORE CENTRE FOR THE STUDY OF SCULPTURE

JACOB EPSTEIN (1880–1959) was born in New York City and studied part-time between 1894 and 1901 at the Art Students' League. Though he established a considerable reputation as an illustrator of ghetto life, his determination to be a sculptor led him in 1902 to Paris. There he trained at the Ecole des Beaux Arts and the Académie Julian, and made his first sculptures. In 1905 he moved to London and within two years received the important commission to carve eighteen over-lifesize figures on the main façades of the British Medical Association Building in the Strand. Their unveiling in 1908 provoked the first public outcry against the candour of his approach to public sculpture. During the next few years he developed a distinctive, naturalistic style of modelling which was widely praised and led a fellow artist, Eric Gill, to proclaim him 'the greatest portrait sculptor of our time'. Meanwhile, Epstein's stone carving became more rigorously formalised and abstracted; he began to carve direct without using preparatory sculptural models, and his interest in non-Western art, already apparent in the Indian-inspired *Maternity*, 1910 (Leeds) and the Assyrian-derived *Tomb of Oscar Wilde*, 1910–12 (Père Lachaise Cemetery), was strengthened after he became friendly with Brancusi and Modigliani during visits to Paris in 1912 and 1913. A vocal minority applauded Epstein as a great *avant garde* sculptor. The Art Establishment, conservative critics and the majority of the public looked on the work with apprehension, revolted as much by his radical reinterpretation of cherished traditional subjects as by the blatant modernism of his style.

In December 1922 Epstein began his second public work in Britain: the large Portland stone relief commemorating the naturalist and writer, William Henry Hudson, as the focal point of a public memorial in the Bird Sanctuary in Hyde Park, London. The commission progressed slowly and with difficulty. Following HM Office of Works' rejection of the inaugural designs: a fountain embellished, first with a portrait and then with a figure of Hudson, the Memorial Committee recommended a new theme inspired by Rima, the heroine of Hudson's most famous novel, *Green Mansions*. Epstein enthusiastically set to work on the composition in February 1923 and it was finally approved twelve months later. Its evolution is exceptionally well charted in the Committee's Minutes and correspondence, as well as in a unique sketchbook, dated 1923, comprising eighty-seven pencil and coloured wash drawings, now in the collection of The Henry Moore Centre for the Study of Sculpture, Leeds City Art Galleries, and published here in its entirety for the first time. Their variety, invention and sense of urgency reveal the artist's excitement in discovering the expressive sculptural possibilities offered by Hudson's strange and beautiful adventure. Carving began in September 1924 and was completed within eight months. On 19 May 1925, the *Memorial* was unveiled by the Prime Minister, Stanley Baldwin, with unexpectedly calamitous results.

Epstein's unconventional interpretation of the subject shocked most people and *Rima*, as the Memorial came to be popularly known, was condemned as 'The Hyde Park Atrocity', 'A Travesty of Nature', 'Bolshevist art' and worse! The second half of 1925 was dominated by an unprecedentedly vituperative and relentless press campaign, fuelled by Parliamentary debates, public protests, anti-semitic attacks and acts of vandalism, all aimed at discrediting the sculptor and getting rid of the appalling horror. The *Memorial* was the most talked about work of art of its time, perhaps the most controversial in the annals of Twentieth century art in Britain. In the end, championed by such persuasive voices as Muirhead Bone, R. B. Cunninghame Graham, George Bernard Shaw and Sybil Thorndike, the Pro-Epsteiners forced the Establishment to relent, and *Rima* stood secure.

CONTENTS

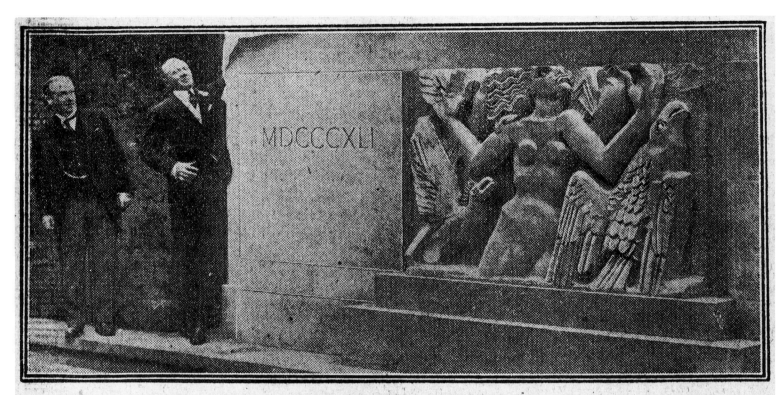

The Prime Minister, on the left, at the unveiling of the memorial in Hyde Park to the late W. H. Hudson, a great Nature lover. The memorial, designed by Epstein, depicts "Rima" amidst a flight of birds.

2. STANLEY BALDWIN UNVEILING RIMA
FROM THE LEEDS MERCURY, 20 MAY 1925

*when Mr. Baldwin unveiled the monument a real
shudder seemed to pass through the spectators, and
someone behind me said, 'Poor Hudson!'.*

GEORGE MACMILLIAN, IN THE MORNING POST,
26 NOVEMBER 1925

*according to many eye-witnesses, Mr Baldwin
pulled the cord, looked at the memorial, and was so
staggered at what he saw that his jaw fell.*

A. F. TSCHIFFELY, DON ROBERTO: BEING THE
ACCOUNT OF THE LIFE AND WORK OF
R. B. CUNNINGHAME GRAHAM 1852–1936
1937, p. 403

I

'RIMAPHOBIA'

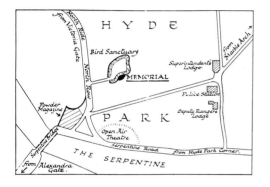

1. INVITATION CARD TO THE UNVEILING
OF THE HUDSON MEMORIAL, WITH VERSO
HMCSS: EPSTEIN ARCHIVE

*The pie was opened; and if the birds did not begin
to sing, at least the reporters did. A few seconds
were occupied in quietness by taking-in of the
general effect; then all eyes were concentrated upon
the panel; then a hum began, which grew into a
buzz, which grew into a roar, as excited men
rushed about catechising all and sundry about Mr.
Epstein's panel . . . And, afterwards, what a
rumpus!*

J. C. SQUIRES, IN THE LONDON MERCURY,
JUNE 1925, XII, no. 68, pp. 114–15

In December 1940 the architect, Charles Holden wrote to His Majesty's Office of Works asking what might be done to protect Epstein's Portland stone relief, known as *Rima*, on the *William Henry Hudson Memorial* in Hyde Park, which had been hit by shrapnel during a recent German air raid. Holden's firm had designed the surrounding architecture and planting seventeen years earlier and now, 'after many visits and after seeing it in all sorts of lighting and weather', he believed it was 'one of the finest pieces of sculpture of the 20th Century', ranking with 'some of the best mediaeval sculpture as at Chartres, for it is in the direct line of the mediaeval tradition'; and, despite misgivings expressed by critics as to its artistic merits, he remained convinced that the relief was 'really important as marking a turning point in the history of sculpture'.[1] Yet, for Holden this unfortunate war damage must have seemed far less consequential than the devastating verbal abuse which had rained down upon the sculpture following its unveiling on 19 May 1925 [1].

Though the press had recently noted a general indifference to public statuary ('The man in the street takes them for granted, meekly, as things which arrive from somewhere ready-made'),[2] outdoor monuments commemorating famous writers were still a rarity in London, especially to one so recently dead.[3] On this particular sunny day, in which the slight breeze wafting in from the Serpentine mingled with Arcadian music performed by a small orchestra hidden behind shrubberies fragrant with lilac and pink hawthorn blossom,[4] a large crowd had assembled at the Bird Sanctuary to see the Prime Minister himself unveil the newest memorial. After praising Hudson's extraordinary talent for awakening the public to the beauties of nature,[5] Mr Baldwin drew back the curtain to reveal the relief. He was probably expecting a graceful vision of the dryad-heroine of Hudson's best-known novel, *Green Mansions: A Romance of the Tropical Forest*. What he saw before him was the distorted figure of a nude girl, savagely cropped at the hips, madly gesticulating and surrounded by monstrous birds, all carved in an apparently crude and unnaturalistic manner [2]. According to eye-witnesses, a shudder ran down the Prime Minister's spine, while the spectators, at first befuddled and silent, now emitted a 'gasp of horror'![6]

The public and critics were divided on the artistic merits of the relief, but the incident might have passed without further controversy had not the conservative press, claiming to represent the voice of ordinary people, launched within a few days of the unveiling a campaign of vilification unequalled in venom and spite and often delivered in a provocative and brutal language. 'The Hyde Park Atrocity', 'A Travesty of Nature', 'Socialist Taste in Art', 'Bolshevik', bellowed *The Daily Mail*. An 'Outrage on Womankind', a 'Nightmare in Stone' (*The Morning Post*). 'Anarchism in Stone' (*The Evening News*).[7] A flood of angry letters soon appeared in the press, branding both the repulsive object and its sculptor, whose name became synonymous with 'art atrocity'.[8] Between the May unveiling and the last months of 1925, over two hundred articles and letters appeared in London newspapers and journals, with the provincial press following suit. Epstein was interviewed and ridiculed. Skits and cartoons were published in *Punch*. Caricatures were presented on the stage of the Aldwych Theatre. Vast numbers of people visited the notorious memorial and the crowds grew so great that it became impossible even to glimpse the relief!

Everyone was talking about *Rima*. The fashionable portrait painter, Sir John Lavery remarked on it to the architect, Sir Edwin Lutyens at a dinner party. Sir John Collier, RA, stigmatised it at an Authors' Club meeting. To a perplexed audience attending the opening of the Cambrian Academy Exhibition at Conway, Lord Kenyon confessed his inability even to comprehend it. The painter/sculptor, J. Edward Homerville Hague, RA, harangued a crowd gathered at the Bird Sanctuary for twelve hours; the marathon was recorded in newsreel and shown to cinema audiences.[9] Questions were asked in Parliament and the ensuing debates gleefully reported in the dailies (see Appendix B5). During a carriage ride through Hyde Park in 1928 Soames Forsyte commented on the relief to his daughter, Fleur.[10] Dornford Yates mocked it in *Adèle and Co.*, 1931:

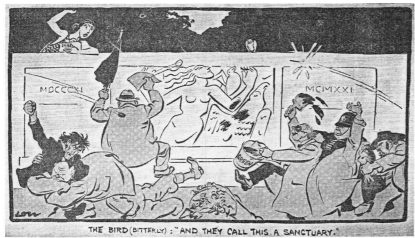

THE BIRD (BITTERLY): "AND THEY CALL THIS A SANCTUARY."

3. DAVID LOW, 'THE BIRD (BITTERLY): "AND THEY CALL THIS A SANCTUARY"' FROM THE STAR, 23 NOVEMBER 1925

II
HUDSON'S ELYSIUM

He was one of the weirdest mixtures I ever met . . . It is quite probable that, when there was so much opposition on the part of the public, he would have taken up the cudgels for Epstein even though in his heart he may not have liked Epstein's conception. As for those people who have written the press to say that Hudson would have disliked it or loathed it, it simply shows that they did not know Hudson as a man, although they may have known him as a writer.

HUGH DENT, MEMORIAL COMMITTEE TREASURER, TO F. H. EVANS, 28 MAY 1925 (RA)[4]

'Good Lord', he said, 'it's alive. I've been trying to wave it away. "Love-in-a-Mist" by Epstein. If Rima could see him she'd wrap herself round him and bark.'[11]

Rima split the art world into embattled factions. Many Royal Academicians were so disgusted by it — their President, Sir Frank Dicksee actually saw a 'DANGER THAT THE WORLD WILL BE MADE HIDEOUS'[12] — that they hoped the controversy would confirm their worst suspicions about the modern movement in sculpture and even mark its very extinction:

The Hyde Park panel
A Gravestone to a form of Modern Art

Born in Germany in the later half of the 19 Century and expired at the end of the first quarter of the 20th after a protracted & painful existence, of a contagion caught in the buried cities of Peru or in some unhealthy atmosphere of the East.
Much beloved by many art critics & experts in art, & its demise leaves these destitute of a subject which was quite a useful asset.[13]

On at least four occasions between 1925 and 1935 *Rima* was vandalised, the last under the aegis of the Independent Fascist League, which regarded it as an expression of an unholy alliance between Judaism and modernism.

Epstein, struggling to remain aloof of these events, nevertheless complained of a press cabal inciting agitation which 'rose to a froth of stupid abuse such as he has never experienced before',[14] and he accurately diagnosed the Nation as suffering from 'Rimaphobia' [3].[15]

At the heart of the least hysterical reactions to the *Memorial* relief was an inability to perceive any relationship between Hudson's Rima and the sculptured image. Just as Epstein's *Venus*, 1914, had appeared to travesty the Botticellian ideal,[1] *Rima* seemed to betray not only a beloved literary heroine but also the image of Hudson created in the minds of his numerous British admirers, who took him for an English man having the same sensitive feelings about animals and landscape as they. Not surprisingly, they were aghast that so 'ugly' a work could be allowed as a memorial to a man who 'loved the beauty of nature'.[2] In an article entitled 'Epstein and Hudson. Irreconcilables in Art. Charm v. Force', a well-known writer on modern art, Frank Rutter, put forward the notion that the 'genius of Epstein is at the opposite pole to that possessed by Hudson'. He saw Epstein's sculpture as the 'incarnation of virility and force' and the 'eagle that swoops upon its prey' as his archetypal bird; for Hudson birds were, by contrast, only 'feathered songsters'.[3] Yet, Hudson's personality and the facts of his life were curiously analogous to Epstein's: both men were outsiders living in Britain who held unconventionally radical and sometimes unpopular views.

William Henry Hudson [4] was born in 1841 on a small cattle ranch near the village of Quilmes on the pampas of La Plata, not far from Buenos Aires. His parents were settlers from Marblehead, Massachusetts. William's early career as a naturalist was spent alone travelling, collecting and observing in some of the wildest tracts of South America, experiences he later recounted in *Far Away and Long Ago*.[5] In 1874 he moved to London and began publishing accounts of his early adventures: *The Purple Land That England Lost*, 1885, *Argentine Ornithology*, 1888–89, *Idle Days in Patagonia*, 1893,

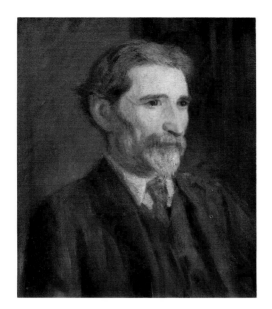

4. SIR WILLIAM ROTHENSTEIN
W. H. HUDSON, 1902?
OIL ON CANVAS, 51.4 × 41.3
THE NATIONAL PORTRAIT GALLERY, LONDON

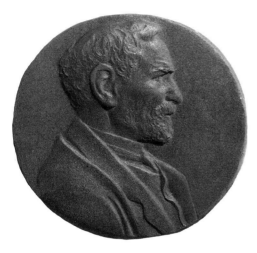

5. THEODORE SPICER-SIMSON
W. H. HUDSON, c1922–24
PLASTICINE, D 8.9
THE NATIONAL PORTRAIT GALLERY, LONDON

which are remarkable for their passionate committment to conserving natural species, which grew as he witnessed their rapid disappearance under the hunting-killing ethos of the pampas culture. Unconcerned with being stigmatised as a Philistine, he proclaimed in *The Naturalist in La Plata*, 1892, that the 'life of even a single species is of incalculably greater value to mankind, for what it teaches and would continue to teach, than all the chiselled marbles and painted canvases the world contains'.[6] He regarded preserving bird species as his object in life,[7] and in 1889 became a founder member of the Society for the Protection of Birds. His old friend, Sir Edward Grey, Viscount Grey of Fallodon, thought him

one of the comparatively few writers who combine knowledge of outdoor life with literary merit and quality high enough to give his books a permanent place in English literature ... He gives us, more amply than other writers, a sense of the largest aspects of nature — its spaciousness, its freedom, its infinite variety.[8]

John Galsworthy proclaimed him the chief standard-bearer of a new faith.[9] It was as an ornithologist that Hudson made his most profound contributions, exploring the subject in two unconventional directions: as a brilliantly descriptive and prolific commentator on birds at home and abroad, and as a pamphleteer seeking to dissuade the public from the invidious fashion for embellishing female haberdashery with feathers and stuffed birds.[10] For many years his was a lone voice in the wilderness. He and his wife were cronically hard up, and it was only the publication of *Green Mansions* in 1904 that brought modest affluence and wider fame (twenty-two editions appeared in English by 1925). Under the guise of a thrilling adventure story set in the remote tribal forests of Venezuela, *Green Mansions* is Hudson's homily on man's capacity for ignorant destruction of the natural world, symbolised by the savages' fatal pursuit of the dryad Rima, who lives in complete harmony with the birds in her forest sanctuary. Hence, the choice of the Hyde Park Bird Sanctuary as the location for the *Memorial* and Rima as the eventual subject of the carving.

Hudson died on 18 August 1922. A few months later a group of faithful friends met in London and launched a public appeal for funds to commission a memorial.[11] Among them were John Galsworthy and Lord Grey of Fallodon, both of whom had published appreciations of Hudson,[12] Joseph Conrad, who sat for Epstein in 1924,[13] the art critic, Edmund Gosse, James Bone, critic of *The Manchester Guardian*, and the painter, William Rothenstein, then Principal of the Royal College of Art and champion of the young Henry Moore.[14] There was also those who were soon to form the Hudson Memorial Executive Committee: James Bone's artist-brother, Muirhead Bone, the writer, Robert Bontine Cunninghame Graham, the publishers, Gerald Duckworth and J. M. and Hugh Dent, the essayist, Edward Garnett and Ethelind Gardiner, Secretary of the Royal Society for the Protection of Birds and Hudson's secret lover.[15] G. K. Chesterton, Walter de la Mare, Morley Roberts, The Ranee of Sarawak and others unable to attend the gathering expressed support for the project.[16]

At the inaugural meeting on 27 November, Graham, as Committee Chairman, put forward the conventional solution of a memorial portrait bust, perhaps with Epstein already in mind, for he was greatly admired in this field of sculpture. However, the Committee was not enthusiastic and instead endorsed a proposal for a bird fountain which would incorporate Hudson's image.[17] This would perhaps take the form of a portrait medallion of the sort modelled by Theodore Spicer-Simson [5].[18] Then doubts were voiced about the merits of this form of public commemoration, and later Sybil Thorndike, who was to sit privately for Epstein in 1925, summed-up the difficulties in her remarks to *The Times*:

We of the theatre once erected a statue to a great actor, and the committee chose a prominent R. A. for the work solely because he was 'safe'. They got what they asked for — a 'safe', dull, and entirely undistinguished portrait of a gentleman in bronze. But in life the actor was a flame of fire.[19]

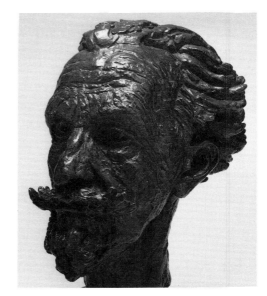

6. R. B. CUNNINGHAME GRAHAM, 1923
BRONZE, H 35
MANCHESTER CITY ART GALLERY

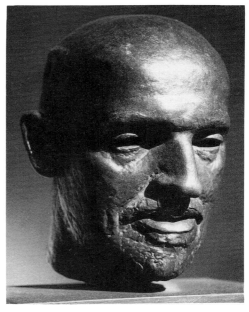

7. MUIRHEAD BONE, 1916
BRONZE, H 26.7

The choice of Epstein was unfortunate. It was as if one were to ask an engine-driver to adjust the hair-spring of a watch.

S. CASSON, XXth CENTURY SCULPTORS, 1930, p. 111

So Hudson's head was abandoned, though the Committee agreed to present Rothenstein's oil painting [4] to the National Portrait Gallery (see Appendix c). Alternative suggestions for a memorial in the form of a rough-hewn stone inscribed only with the author's name,[20] or of a bird-bath with an inscription (to be designed by Sir Edwin Lutyens),[21] or some undesignated polychrome ceramic object manufactured by the Doulton Pottery and Porcelain Company of Lambeth, South London, were never taken seriously.[22]

By December 1922 it was clear that the *Memorial* would bear little resemblance to previous comparable public monuments. Cunninghame Graham and Muirhead Bone now began to superbly manipulate their fellow Committee members, as well as Office of Works officials, into approving a more courageous, unorthodox solution. Graham (1852–1936), a distinguished Scottish Socialist and travel writer, was an old friend of Hudson's and a kindred spirit: he had ranched in the Argentine and ridden with the gauchos. (Epstein described the head he modelled of him in Spring 1923, during the months the *Memorial* was evolving, as possessing 'a whiff of the American Wild West': it 'seems to sniff the air, blowing from the Sierras' [6].[23] Bone (1876–1953), who sat for Epstein in 1916 [7], had defended his figures on the British Medical Association Building in the Strand against public and press criticism in 1908, and had also attempted to secure the sculptor's appointment as an official war artist, though without success.[24] He felt a conventional solution for the *Hudson Memorial* would lack boldness, remarking to Graham that he wanted 'something beautiful carved in stone — otherwise there will be absolutely nothing to look at at all, which is absurd!',[25] and believed implicitly that

Better than a pretty and polished thing [the relief should give] a feeling of power and remoteness which to my mind (and I knew the man) is very well in keeping with that strange figure, who was of English descent but born of American parents in a wild part of the Argentine.[26]

Bone and Graham envisaged the *Memorial* as a tribute to a man who had been 'a lover of Wild Nature'. Above all, it had effectively to suggest the wildness of Hudson's own character. Therefore, they replaced the portrait concept with a figure of Hudson reclining in a forest. When the bureaucrats in the Office of Works rejected this as inappropriate for a royal park, where portraits were inadmissible, Bone suddenly hit on the perfectly appropriate image of Rima: Hudson's 'bright spirit in human form, so akin to wild Nature'.[27] Bone was subsequently to play a crucial role in the evolution of the Rima idea and also emerge as its staunchest champion during the 1925 controversy. Epstein, as an admirer of both primitive culture and the heroic isolationism of writers like Walt Whitman, whom he had read as a youth, now seemed even more suitable to carry out the commission. Graham regarded him as 'the man' for the job: 'he is really a fine artist [and] will do something acceptable & fine (not "plain")'.[28]

On 6 December 1922 Bone was asked by the Committee to approach the sculptor 'with a view to ascertaining whether he would be willing to submit a design'.[29] Only Galsworthy objected, having apparently favoured the idea of a portrait bust, and at one of the meetings, Epstein later recalled, 'declared that, in his opinion, I was not the right man to do the Monument. He spoke ... with some bitterness'.[30] A traditionalist by nature, Galsworthy was later, through the person of his creation, Soames Forsyte, to condemn *Rima* as 'Stunt sculpture'.[31] In 1922 he was anxious that the Committee should not be in the position 'to take whatever Epstein cared to give us without being able to criticise it at all', and only when Bone assured him that 'all that was proposed was that E. should be asked to make us a model and that if we did not like it we would pay him for his model and go to another sculptor', did the novelist 'withdraw all his objections ... and quite support this idea', even going so far as to admit that Epstein possessed 'great talent'.[32]

Bone also recommended the project architect, Lionel Godfrey Pearson, FRIBA (1879–1953).[33] He was a senior partner in the prestigious firm of Adams, Holden and

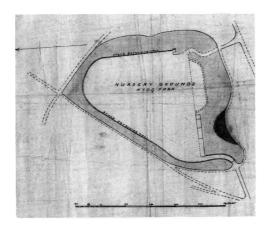

8. LIONEL G. PEARSON, SITE PLAN
FOR THE HUDSON MEMORIAL, 1923
PEN AND INK AND WASH
RIBA: AHP[42]3

Pearson, which had designed the BMA Building and the stone plinth of Epstein's *Oscar Wilde Tomb*, 1909–12, at Père Lachaise Cemetery, Paris [24].[34] Pearson specialised in public memorials, and during the period of involvement with *Rima* he had also designed the architectural structure of Sergeant Jagger's *Artillery War Memorial*, 1921–25, and Captain Adrian Jones's *Cavalry War Memorial*, 1924, both in Hyde Park and with figure sculpture far more conservative than Epstein's was to be.[35]

The decision to locate the *Hudson Memorial* in Hyde Park was not made immediately. The first public appeal for funds in November 1922 referred only vaguely to one of the Royal Parks in London.[36] Graham favoured a site in Kensington Gardens.[37] However, on 13 December the Office of Works, the responsible government authority, recommended the Bird Sanctuary just north of the Serpentine [1], and on 11 January 1923 the Committee applied for this designation.[38] Two weeks later Pearson was appointed architect.[39]

His initial survey [8] established the fundamental topography of the executed scheme: a narrow, arc-like plot (indicated in dark wash) on the southern perimeter of the Nursery Ground, open towards the south and facing the Serpentine, with (perhaps existing) planting forming a natural screen along the inner curve. A simple stone panel with water pouring from its bottom edge, presumably placed on the north side of the Sanctuary, was discussed at a site meeting attended by Pearson, Epstein, Bone, Graham and Sir Lionel Earle, Secretary to the Office of Works.[40] Bone reckoned the 'new plan showing what the Office ... will allow' would be ready by 14 February.[41] Positions for the birds' drinking and bathing pools were 'exhaustively discussed' on 22 March, when Pearson submitted his detailed plans.[42] Bone incorporated these ideas in a drawing he prepared during a visit to New York City in May 1923.[43] Pearson proposed making an accurate scale model of the whole scheme which would be submitted to the Office of Works and also put on display for public scrutiny; it was completed by 12 June.[44] Since the leading sculptors of the Royal Academy were hostile to Epstein's work, the Memorial Committee, as Bone later explained, 'had little grounds for supposing [the] model would be accepted for exhibition if offered there', and an alternative venue was found at The Architectural Club in Grosvenor House, where it was 'met with friendly criticism'.[45] Unfortunately, the model and all the early plans are lost, but it would seem likely that their essential features were incorporated in Pearson's detailed drawings of October–November 1923 [9–10].[46] Here the Sanctuary is shown as a simple arena with broad hemicycles to left and right of a central, rectangular lawn contained within a formal barrier of clipped hedges, with a few trees arranged in rough symmetry within and without the enclosure. A long, sleek stone screen of thin, subtly receding panels, resembling an altar-table, with the sculpture relief set in a shallow central recess, is positioned at the north end, while immediately in front a trio of stone-edged pools lay flush with the lawn. Despite this straightforward, unpretentious composition, the scheme encountered one fundamental problem. To allow spectators a broad view across the Sanctuary to the relief, a distance of about fifty-five feet, Pearson interrupted the line of perimeter hedge along the southern boundary and proposed erecting a low wall across the opening. However, since the Sanctuary was intended as an exclusive preserve for birds, the Office of Works, which was chiefly concerned with the sanctity of the enclosure and the birds' well-being, insisted on an unclimbable fence as 'part of the design'.[47] Pearson suggested an alternative solution in the form of a wrought iron railing preceded by a low viewing-platform flanked by formal planting [9]. Bone's bird's-eye perspective [11], published in March 1924 to launch the second public appeal for funds, shows bollards and chains, with a single rectangular lily pool immediately within the enclosure.[48] In Pearson's final plan of October 1924 [12],[49] an unsatisfactory compromise was reached by merely reinstating the existing iron fence bordering the Nursery Ground. This, the surviving arrangement, significantly diminishes the visual link between spectator and sculpture.

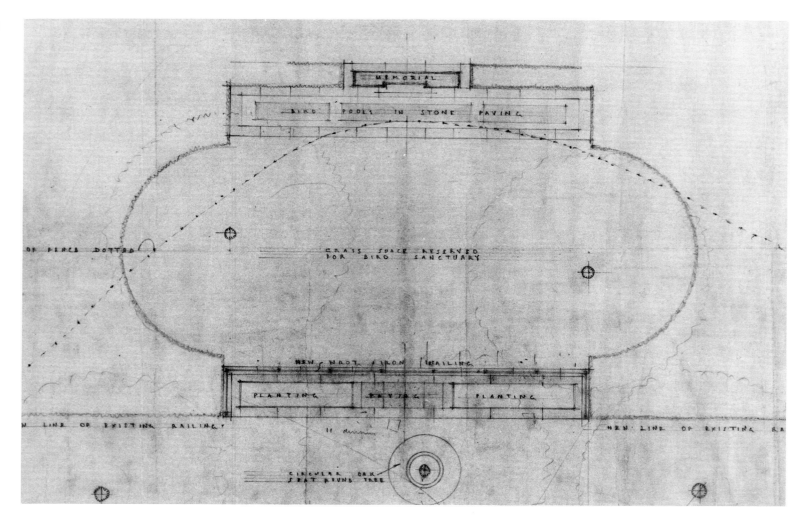

9. LIONEL G. PEARSON, SITE PLAN
FOR THE HUDSON MEMORIAL, DETAIL
23 OCTOBER 1923, PENCIL
RIBA: AHP[42]4

10. LIONEL G. PEARSON, SITE PLAN AND
ELEVATION FOR THE HUDSON MEMORIAL,
DETAIL, 5 NOVEMBER 1923, PENCIL
RIBA: AHP[42]8

OPPOSITE

11. MUIRHEAD BONE, PERSPECTIVE OF
THE PROPOSED HUDSON MEMORIAL, 1924
PENCIL, FROM COUNTRY LIFE
22 MARCH 1924, p. 425

12. LIONEL G. PEARSON, SITE PLAN
FOR THE HUDSON MEMORIAL
OCTOBER 1924, PENCIL, PEN AND INK AND
WASH
RIBA: AHP[42]5

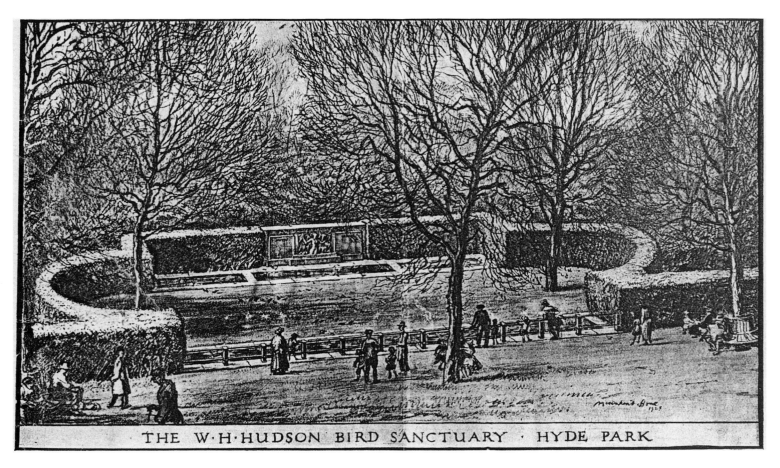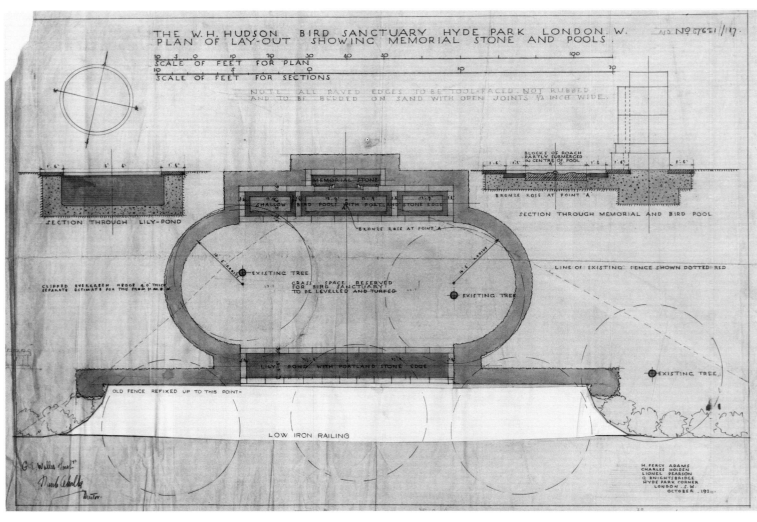

III
EPSTEIN'S FIRST DESIGN

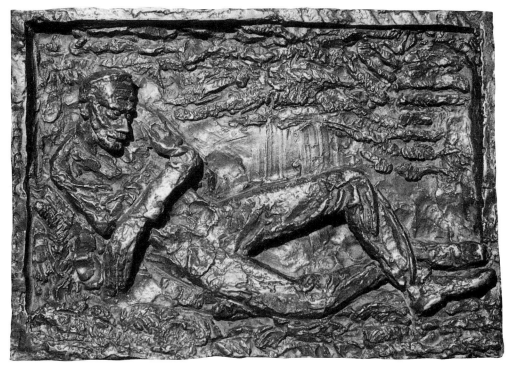

Meanwhile, Epstein was searching for a solution to the design of the relief itself. His first idea, probably begun in December 1922, was presented to the Committee on 10 January 1923 in the form of a small, vigorously modelled clay maquette, now lost but known from bronze casts [13], and for which the full-scale preparatory pencil study also survives [14].[1] Hudson is portrayed lifesize and reclining in a forest glade 'watching the birds drinking & bathing, in the runnels, & channels, & pools of water hewn in the stone' below him.[2] As there is no evidence that Epstein ever met Hudson, his features were presumably based either on photographs or Rothenstein's portrait

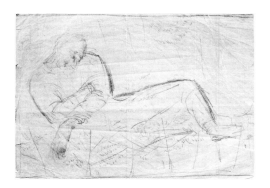

13. MAQUETTE FOR THE HUDSON MEMORIAL: HUDSON RECLINING IN THE FOREST
1922–23, BRONZE, 33 × 43.2
PRIVATE COLLECTION

14. STUDY FOR THE HUDSON MEMORIAL: HUDSON RECLINING IN THE FOREST
1922–23, PENCIL, 38 × 48.3
HMCSS: PRESENTED BY BETH LIPKIN
IN MEMORY OF SIR JACOB
AND LADY EPSTEIN, 1987

[4], and on the descriptions of those who knew him. According to Ford Madox Ford, he was

very lean, *very* tall, big-boned, long-limbed, grey ... slow in his motions. You have to be if you are a field naturalist. His head was smallish for its great frame, but as if chiseled by the wind, as rocks are; his cheeks weather-beaten. His eyes were small and keen, usually a little closed as if he were looking up along a strong wind ... He had a little, short, pointed grey hidalgo's beard and a heavy grey moustache. He was all gentleness and infinite patience ... He suggested, the immensely long fellow, a man holding in his hand a frightened bird, but making his examination with such gentleness.[3]

Rothenstein remarked how he would move with a 'strange, rather crab-like walk' and was

a little awkward as he sat himself down and disposed his long limbs, folding his large, beautifully formed hands across his knees. He had haunting eyes ... that scarcely moved in their orbits, but remained level, fixed on no particular point, held rather by memories of things past ... His cheek-bones were wide and prominent (once he said he had Indian blood in his veins) ... His fine, slightly narrowing brow was deeply furrowed, and his nose was that of a predatory bird.[4]

Like Wright of Derby's famous pastoral portrait of *Brooke Boothby* reclining near a stream and holding a copy of *Rousseau Juge de Jean Jacques* [15], Epstein's figure is derived ultimately from those antique Roman statues of river gods traditionally associated with the Tiber [16].[5] Epstein had experimented, perhaps as early as 1918, with the idea of a panisc group forming the centrepiece of a garden fountain [17].[6] His general preference for non-Western art, of which he had an outstanding collection,

15. JOSEPH WRIGHT, BROOKE BOOTHBY, 1781
OIL ON CANVAS, 148 × 206.4
THE TRUSTEES OF THE TATE GALLERY
LONDON

16. RIVER GOD TIBER OR MARFORIO,
ROMAN (RESTORED 1594)
MUSEO CAPITOLINO, ROME

17. STUDY FOR A 'GROUP FOR A GARDEN
TO BE IN BRONZE OR PORTLAND STONE
OVER LIFE SIZE IN THE CENTRE OF A
FOUNTAIN IN A GARDEN', 1918?
PENCIL, 35.6 × 50.8 CM
WHEREABOUTS UNKNOWN

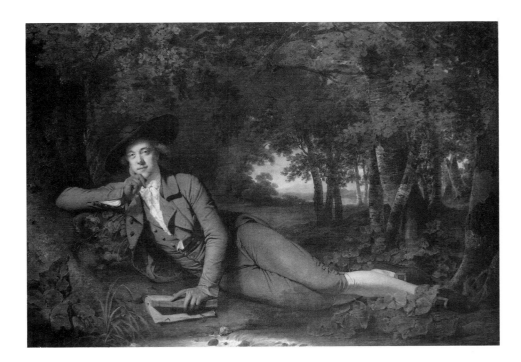

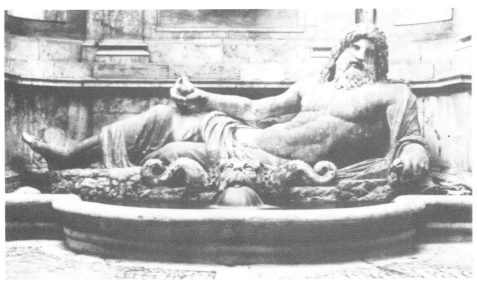

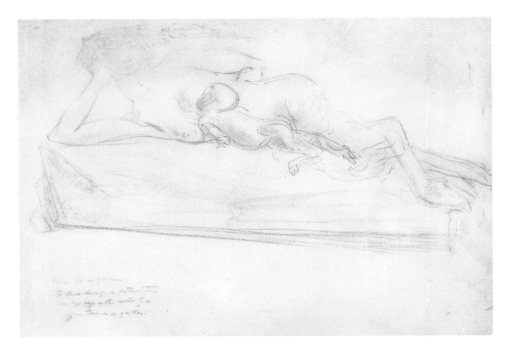

did not preclude interest in classical art; during the early Twenties he was persuing a lively correspondence in *The Times* protesting against the 'incredible crime' of the British Museum's recent restoration of the *Demeter of Cnidus* and other Greek marbles.[7]

The Hudson design was 'accepted as satisfactory' by the Memorial Committee in January 1923,[8] but before the maquette could be presented to the Office of Works, Bone was advised by letter that its officials disapproved of attempts to convert the royal parks into 'any sort of "Valhalla" of eminent persons' and that it would reject any scheme featuring a representation of Hudson.[9] The Government was supported by two formidable Epstein adversaries: the sculptor, Sir George Frampton and the architect, Sir Reginald Blomfield. Frampton (1850–1928), who had trained at the RA Schools and in Paris, was among the most successful exponents of the New Sculpture, a movement of late nineteenth century origin intent upon reviving the art of fine bronze casting inspired by Rodin and the Italian Renaissance, which still represented a mainstream force in the post-war period. His bronze statue of *Peter Pan*, 1912, in Kensington Gardens, was especially admired.[10] Blomfield (1856–1940), the grandson of a famous classical scholar, was, like Frampton, a defender of Classical and Renaissance cultures. He loathed the current fashion of 'presenting sculpture in blocks and squares ... inspired by the art of primitive peoples [in which] the hideous and the grotesque [is] the only possible presentation'. In 1923 he spoke of

The proper setting of the South Sea Island god [as being] its own altar surrounded by the relics of the last cannibal feast. To introduce him into our modern buildings is like letting loose a 'salvidge' man in a drawing room; for, however much we may gibe at our civilisation, it is impossible to divest ourselves of the traditions and associations on which it is built.[11]

The modernist raids on primitive art which resulted in the 'visible appearance of nature [being] ruled out' were rejected as 'a bedlam business in which you [radical artists] say anything you like in any way you please'. Blomfield, who had established a considerable reputation as a designer of public memorials in the classical taste and who regarded Alfred Stevens's *Wellington Memorial*, 1858–1912, in St Paul's Cathedral as the 'greatest masterpiece in the whole range of English art', believed that the 'old road is still the only road'.[12]

Bankrupt of inspiration [Epstein] goes back to the archaic and imitates Dutch doll-like forms which would disgrace a sculptor's journeyman. It is hoped that the 'scarecrow' will be allowed to remain as a monument to the death of the 'modernity' craze · which has so degraded our national art.

E. WAKE COOK, IN THE DAILY MAIL, UNDATED CLIPPING (TGA)

IV
THE
'WONDERFUL
WOMAN SPIRIT'

The rejection of the first design marked a turning point in the development of the commission. Ironically, in view of their overriding conservatism, the Office of Works officials had opened the way for Bone and Epstein to develop a far more radical, potent memorial sculpture. On 2 February 1923 Bone admitted to Graham that 'it is clear the design will have to be changed'. As 'anxious as ever to get something really strikingly imaginative and beautiful from Epstein', he proposed a new and dramatic solution: the relief would depict Rima, the 'wonderful woman spirit' in *Green Mansions*.[1]

The tale Hudson tells is of the remarkable adventures of a young Hispano-American named Abel Guevez de Argensola (perhaps Hudson himself) caught up in an unsuccessful conspiracy to overthrow a corrupt Venezuelan political regime. Escaping into the 'primitive wilderness' of the Upper Orinoco River, he decides to pursue a 'very peculiar interest in that vast and almost unexplored territory ... with its countless unmapped rivers and trackless forests; and in its savage inhabitants, with their ancient customs and character, unadulterated by contact with Europeans'. One day Abel wanders into the 'wild paradise' of a vast tropical forest 'strangely abundant' with birds — the green mansions of the title — where he discovers Rima, a 'mysterious

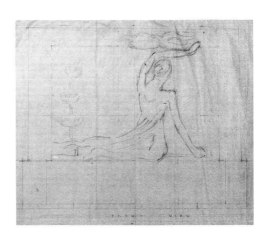

18. LIONEL G. PEARSON, ELEVATION
FOR THE HUDSON MEMORIAL, DETAIL
25 JUNE 1923, PENCIL
RIBA: AHP[42]7

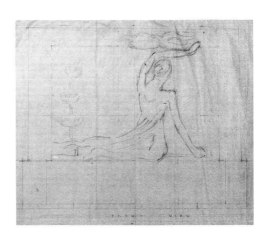

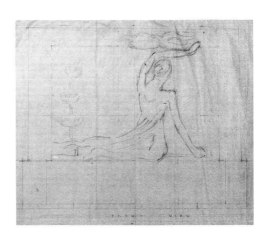

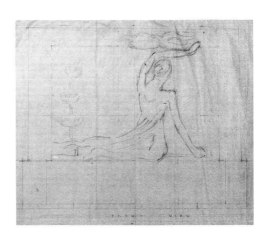

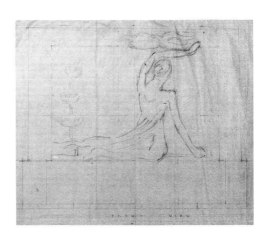

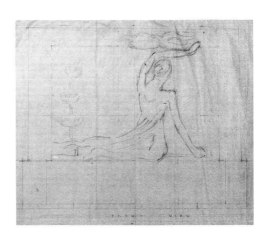

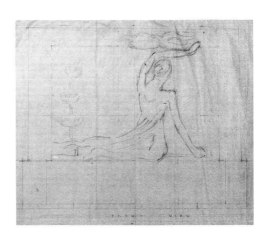

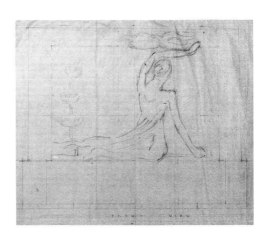

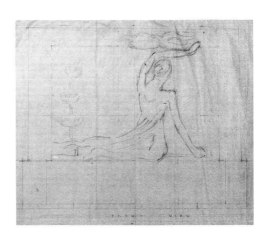

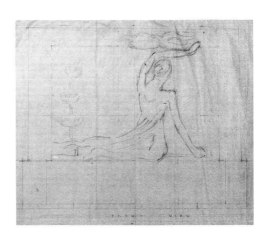

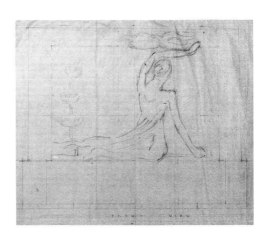

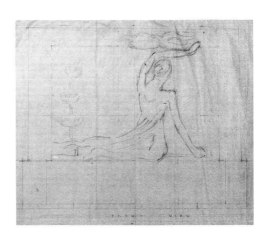

woodland girl . . . with the melodious wild-bird voice', and they fall in love.² The story
reaches its horrific climax with Rima's death at the hands of superstitious natives.
Bone regarded this as a 'very fine subject for the sculptor', one which 'ought to result
in a beautiful thing'. Presuming it would receive the Office of Works' approval, he
optimistically believed that at long last 'all is plain sailing'.³

Though Epstein was cautioned not to 'embark on the careful model' until the new
scheme received 'full approval',⁴ his new design was ready within two weeks, by
14 February 1923.⁵ It shows Rima in a setting of trees and birds, as she is first revealed
to the reader in the novel: 'It was a human being — a girl form, reclining on the moss
among the ferns and herbage, near the roots of a small tree . . . the hand raised towards
a small brown bird'.⁶ On the following day Epstein was formally commissioned to
undertake the carving.⁷ Bone, Graham, Pearson, J. M. Dent and Mrs Frank Lemon,
the Committee Secretary, met on 16 March at the sculptor's Guildford Street studio,
where they saw a miniature model of the relief showing a lifesize figure of Rima, the
tree from which she was 'springing' and indications of birds in flight over head. After
an hour 'spent in contemplation', followed by further deliberations at the nearby
Russell Hotel, the design was approved.⁸ During a second visit, on 18 April, Pearson
made a sketch of the maquette,⁹ now lost, and later incorporated it in a rough draft of
the proposed relief mounted on its stone screen [18].

The unforseen and startling transformation of imagery from a conventional portrait
of Hudson to the fictional 'half human, half spirit' heroine of one of his novels,¹⁰ whom
Epstein believed possessed a more symbolic than realistic nature,¹¹ and whom
Hudson conceived as 'a Rima of the mind'¹² (but who seems also to reflect the
primitive, long-limbed, bird-like figure Rothenstein had seen in Hudson himself),
had the salutary advantage, as Bone was quick to point out, that the Memorial
Committee 'might agree on a representation of <u>her</u> where [it] could never have agreed
exactly how to represent <u>him</u>'.¹³ This new proposal was submitted to the Office of
Works on 7 June 1923. Because it would require careful consideration before being
submitted to the King, a description of 'what the figure . . . intends to convey' was
requested, since 'considerable hostile criticism' was anticipated:

There is so much criticism in Parliament as regards the erection of any memorial in the Parks,
and inasmuch as the proposal represents infinitely more than a mere bird bath . . . as was
originally proposed . . . we shall have to tread very warily in this manner.¹⁴

Fearful that the design might again fail, Bone tried to convince the authorities that the
Memorial Committee was 'really anxious to give the Nation a dignified piece of art'
and could 'safely promise to add a new decorative beauty to Hyde Park'. He added:

Good sculpture is really too rare to be frowned upon . . . Epstein is really a very fine artist . . . He
is certainly looked upon with very great respect by the artists of England. Give him a chance to
show what a fine & noble thing he can do . . . I am very confident we could bring into existence
an artistic success which would be a popular success also — and I venture to think that has not
been too common in decorative sculpture works or memorials of any kind.¹⁵

At the same time, Bone cautioned his own Committee to take both a 'persistent and
conciliatory' approach towards the Office of Works, and asked 'if it would not be a
good idea to have a careful little model with everything — trees, benches, flagged path
shown modelled & properly coloured', which he offered to pay for out of his own
pocket because 'it would clearly show the scheme & there is nothing like little models
to win over opposition!'¹⁶ Before it could be prepared, however, word reached the
Committee that the Office, while recognising Epstein's genius, did not consider this
design 'worthy of his talent or the site' and had rejected it because it would 'evoke wide
and even bitter controversy'.¹⁷ At least one member of the Memorial Committee
attempted to disengage Epstein from the project altogether.¹⁸ But he was seasoned to
such difficulties and tenaciously held on,¹⁹ so that in July 1923 the Committee,
managed by the skilful Bone and Graham, invited him to submit yet another design.²⁰

V
RIMA REVISED

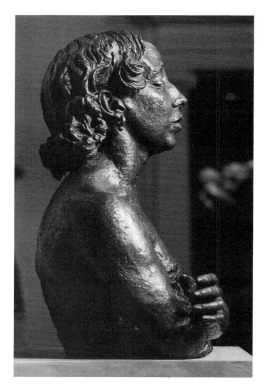

19. DOLORES: THIRD PORTRAIT,
BUST WITH CROSSED ARMS, 1923
BRONZE, H 57.2

Her hair was bobbed, she had too much paint and powder on her face, she had some kind of barbaric jewels in her ears ... and she wore a preposterous white dress [which] seemed to me wrong by every canon of decency and art ... This masterful girl ... seemed to claim the right to domineer, like a barbaric princess.

JOHN BUCHAN DESCRIBING CORRIE ARABIN,
THE HEROINE OF HIS THRILLER,
THE DANCING FLOOR, 1926
(1987 EDITION, pp. 62, 66)

It must have been about this time, July 1923, that Epstein retreated from London to the seclusion of his newly rented cottage at 49 Baldwyn's Hill, Loughton, on the edge of Epping Forest, to reconsider *Rima*, much as he had done ten years earlier by retreating to Pett Level on the Sussex coast to begin the great series of carvings of physical union, pregnancy and birth. He now re-read *Green Mansions* and was deeply moved.[1] Its special appeal for him was undoubtedly the vivid evocation of primeval forests and the ritualised behaviour of the Indian tribes seen through Western eyes. Hudson had earlier published stories about mysterious and vampiric women transformed into giant birds,[2] but *Green Mansions* offerd a daring adventure with an authentic atmosphere more akin to Darwin than to the romantic fantasies of Edgar Rice Burroughs's popular novel, *Tarzan of the Apes*, which first appeared in 1914.

Since 1912–13 Epstein had been acquiring ethnographic material ranging from masks to fetishes from Africa, and later from North America and the Pacific, as well as sculpture from ancient Egypt, Mesopotamia, Greece, India, the Far East and Central America.[3] Even before that time he was a regular visitor to the British Museum, while in Paris, where he lived from 1902 to 1905 and returned annually after the end of the Great War, he was familiar with the incomparably rich collections of the Musée d'Ethnographie du Trocadéro (now the Musée de l'Homme) and the Musée Guimet.[4] Unlike many of his fellow artists who were inspired by tribal sculpture in the early decades of the century (Brancusi, Derain, Gaudier-Brezska, Modigliani and Picasso), Epstein believed he possessed a special intuitive grasp of not only the aesthetic but the ritualistic significance of tribal carvings:

As fetishes their importance is religious or, at any rate, magical. They were used to impress, terrify and impart to the beholders a state of mind bordering on, or actually, hallucinatory. Unless one understands this purpose in the masks they can only be regarded as grotesque and fantastic.[5]

The concept of primitivism, 'Wild Nature', implicit in the character of Rima allowed Epstein to explore more fully than in any previous sculpture how these deeply-felt instincts about the ritual of primitive societies as revealed in their artefacts might be translated into a modern sculptural idiom. He later explained how he had 'started with the conception of Rima as a half-wild creature living in the woods with birds and animals' and worked towards this 'poetic idea expressed within the limitations of my material — the stone'.[6] So at Loughton, his first timid image of the bird-girl [18] metamorphosed into a more savage being [2].

The process of transformation is revealed in a remarkable set of eighty-seven pencil and wash drawings on fifty-six sheets, each uniformly 59.7 by 47 cm, forming a unique sketchbook which preoccupied Epstein during the Summer and Autumn of 1923 [D 1–56v]. Though circulated among a few Committee members in the last months of that year, before passing into the possession of Cunninghame Graham, it was unknown to a wider public until acquired for the collection of The Henry Moore Centre for the Study of Sculpture at Leeds City Art Gallery in 1983 (Appendix A).

The drawings reveal, sheet by sheet, a frenetic outpouring of ideas (in D 10 and D 46 one composition is furiously superimposed on another) which is unprecedented in Epstein's career and perhaps unique in twentieth-century sculpture. Though he obviously consulted *Green Mansions* frequently during these preparations and there are recognisable thematic groupings: Rima seated or reclining in the forest with her bird companions, Rima standing and Rima in flight, as well as independent studies of her head and hands, and of birds, there is no systematic arrangement of drawings in the sketchbook. Only in the episode when Rima and Abel first meet in the forest does the sculptor seem to make an attempt at a sustained sequence of images linked to events described in the story:

It was a human being — a girl form, reclining on the moss among the ferns and herbage, near the roots of a small tree. One arm was doubled behind her neck for her head to rest upon, while

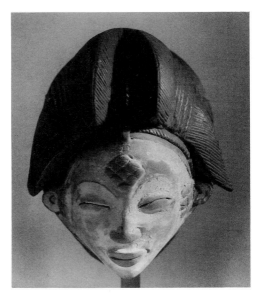

20. DANCE MASK, PUNU, GABON
WOOD, H 28.5
FORMERLY JACOB EPSTEIN COLLECTION

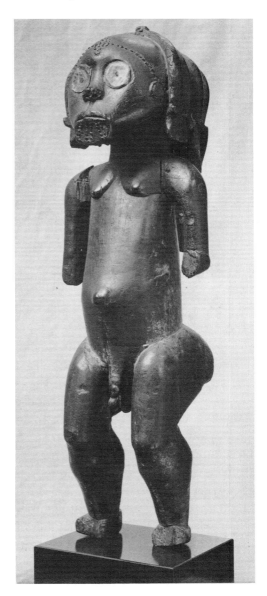

21. RELIQUARY GUARDIAN, FANG, GABON
WOOD AND METAL, H 69
FORMERLY JACOB EPSTEIN COLLECTION
CARLO MONZINO COLLECTION

the other arm was held extended before her, the hand raised towards a small brown bird perched on a pendulous twig just beyond its reach [D 1, 4, 7, 54].

She appeared to be playing with the bird, possibly amusing herself by trying to entice it on to her hand; and the hand appeared to tempt it greatly, for it persistently hopped up and down, turning rapidly about this way and that, flirting its wings and tail, and always appearing just on the point of dropping on to her finger [D 23, 24, 26, 28, 29, 33].

From my position it was impossible to see her distinctly, yet I dared not move. I could make out that she was small, not above four feet six or seven inches in height, in figure slim, with delicately shaped little hands and feet. Her feet were bare, and her only garment was a slight chemise-shaped dress reaching below her knees, of a whitish-grey colour, with a faint lustre as of a silky material. Her hair was very wonderful; it was loose and abundant, and seemed wavy or curly, falling in a cloud on her shoulders and arms [D 8, 9, 11].

I had not been watching her more than three seconds before the bird, with a sharp, creaking little chirp, flew up and away in sudden alarm; at the same moment she turned and saw me through the light leafy screen [D 17]. But although catching sight of me thus suddenly, she did not exhibit alarm like the bird; only her eyes, wide open, with a surprised look in them, remained immovably fixed on my face [D 18].

In an earlier passage describing how the 'Guayana savage judges a man for his staying power [by standing] as motionless as a bronze statue for one or two hours watching for a bird',[8] Hudson hinted at the sculptural possibilities of a 'savage' interpretation of Rima, whom he described elsewhere in the novel as having a 'luminous face [with] translucent skin showing the radiant rose beneath ... lustrous eyes, spiritual and passionate, dark as purple wine under their dark lashes [and] something like a smile flitting over her delicate lips'.[9] It was precisely because Epstein, too, associated her 'Wild Nature' with tribal ritual that he found no difficulty in rejecting conventional European concepts of womanhood in favour of the seductive qualities of one of his most alluring models, a cabaret entertainer named Dolores, who was a notorious *femme fatale* and social outsider [19].[10] Epstein had met her in 1912 at Frida Strindberg's theatre club in Heddon Street, Piccadilly, known as the Cave of the Golden Calf, which he had just decorated with brilliantly coloured, Egyptian-inspired carvings.[11] Public suspicion about Dolores's dubious character was fuelled when, in November 1925, at the height of the *Rima* controversy, she was arrested for throwing tomatoes and raw eggs at a caricature of the *Hudson Memorial* relief displayed on the stage of the Aldwych Theatre.[12] Above all, it was Dolores's bearing and looks — she regarded herself as a 'High Priestess of Beauty ... tragic and magnificent' — that disturbed conventional sensibilities.[13] The style, which he had been developing for several decades, in busts of Nan Condron, Madeleine Béchet, Fedora Roselli, Sunita and others,[14] was admired with misgivings by the critics. *The Studio*'s condemnation of two (unidentified) Epstein portraits, exhibited at the St George's Gallery in 1925, for their 'barbaric coarseness of execution' and 'presentation of debased types of humanity', was a characteristic reaction.[15]

While Dolores was undoubtedly the model for *Rima* [D 4, 14, 34], the sketchbook studies where facial features are treated with extreme stylised delicacy [D 3, 11, 13, 14, 15, 16, 17v] reveal Epstein's attraction to more formalised, sculpture sources in African tribal masks and reliquary heads, of which he was already assembling a superb collection [20]. The ferocious, open-mouthed faces of D 23v, 51v, resemble masks from the Bafo of Cameroon and the Mbunda of Zambia.[16] The treatment of head and hair in D 10 recalls the famous Fang reliquary guardian [21] which Epstein acquired in 1932 from the De Miré Collection in Paris but undoubtedly knew before that time and particularly admired as equal to 'anything that has come out of Africa'.[17] The elegant face in the lower right of D 42v is a reminder of the carved stone heads by Modigliani [22] Epstein saw in the artist's studio during a visit to Paris in 1912 and which reminded him of African masks.[18] Studies of *Rima* with angular limbs, stubby hands

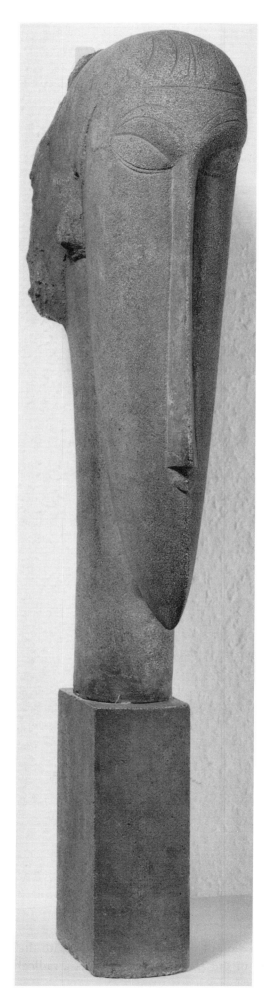

and conical breasts [D 27, 44, 45] are reminiscent of carved wood stools from Eastern Zaire and the celebrated Hawaiian *Diety* [23] in the British Museum, which Henry Moore was sketching at about this time.[19]

Epstein turned to Egyptian art (of which there was then already an incomparable collection in the British Museum) in other studies featuring Sphinx-like profiles [D 33, 48, 49] and perhaps corresponding to the passages in *Green Mansions*: 'a Rima glorified, leaning her pale, spiritual face to catch the winged words uttered by her child on earth', 'from her lips came a succession of those mysterious ... bird-like ... sounds' and 'I could scarcely remove my eyes from her eloquent countenance'.[20] Several of the sketchbook drawings [D 29v, 31, 32, 34v, 45, 56v] have kinship with the flying figure on the *Tomb of Oscar Wilde* [24].[21]

Passages in *Green Mansions* describing birds: 'a multitude of birds of many kinds, but mostly small, appeared in sight swarming through the trees ... flitting through the foliage ... hovering and ... darting this way or that' and 'a bird came with low, swift flight, its great tail spread open fan-wise',[22] called for a naturalistic rendering [D 9v, 10v, 11, 12v, 20, 20v, 21, 22, 39, 40, 41, 42, 47], which was based on careful scrutiny of a stuffed eagle acquired sometime in 1923 at a Tottenham Court Road auction by Epstein's wife, Margaret, who seems to have acted as his props-mistress, gathering exotic earrings, Spanish shawls and the like for use in the studio.[23] But when the treatment of birds is more geometric [D 37, 43, 46] Epstein turned to primitive sculptures.[24] Finally, the remarkable series of Vorticistic drawings depicting *Rima* astride a flying eagle [D 12, 31, 32, 35, 36, 38, 52], which have no textual counterpart, may have been based on a North American carved-wood bear with a human rider [25], which entered Epstein's collection around 1948 but which he may have seen much earlier.[25]

During the 1925 controversy critics commented on Epstein's reliance on non-Western sources, though the analogies they suggested were never specific and invariably part of the campaign of discredit: 'Assyrio-Amerindian', 'Babylonian', 'aboriginal statuary made in far back days by the natives of the Pacific islands'; even 'neolithic'.[26] One critic admitted he would not have disputed the relief's origin in ancient Persia, presumably a reference to Leonard Woolley's excavations at Ur of the Chaldees, begun in 1922.[27] Indeed, a letter to *The Saturday Review* went so far as to suggest that Epstein had dug at the site and 'brought back a fragment of ancient art ... to test our gullibilities'![28]

Yet, despite the unmistakable significance of the 'primitivism' of the novel in the development of Epstein's ideas, he seems finally to have decided to pursue a European classical solution in the carving. He was never averse to making use of a classical source if it served his own needs, and was a keen observer of Greek sculpture, which had inspired some of the BMA figures, probably also the now destroyed statues of *Girl with Dove*, 1906–07, and *Narcissus*, 1909–10.[29] One of the drawings, D 43v, a variant on the flying *Rima* theme, suggests that Epstein may have had the classical subject of Icarus in mind.[30] More to the point, his much-publicised altercations with the British Museum authorities in 1921 over their policy of restoring the *Demeter of Cnidus* to 'something more nearly approaching the Albert Moore ideal of Greek', reached a climax in February 1923, during the early stages of the *Hudson Memorial* commission.[31] But what evidence is there that he was looking at specific classical sculptures with regard to the executed *Rima*?

The Times critic suggested that Epstein had been motivated by the celebrated Greek marble relief thought to depict the birth of Aphrodite from the sea, which forms the central panel of the so-called *Ludovisi Throne* in the Terme Museum, Rome [26].[32] He

22. AMADEO MODIGLIANI, HEAD, 1911–12
STONE H 88
THE TRUSTEES OF THE TATE GALLERY
LONDON

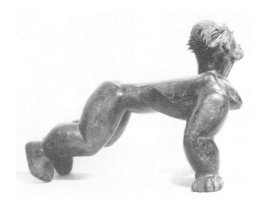

23. DEITY, HAWAIIAN, WOOD, SHELL,
TEETH, HAIR TUFTS, L 67
THE TRUSTEES OF THE BRITISH MUSEUM
DEPARTMENT OF ETHNOGRAPHY

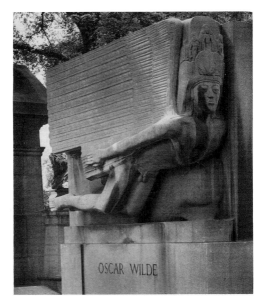

24. TOMB OF OSCAR WILDE, PÈRE LACHAISE
CEMETERY, PARIS, DETAIL, 1909–12
HOPTONWOOD STONE

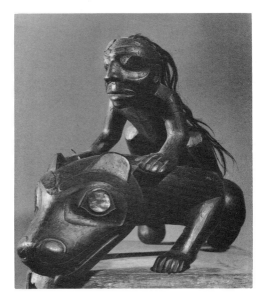

25. BEAR WITH A HUMAN RIDER, HAIDA,
NORTH WEST COAST OF NORTH AMERICA,
WOOD
FORMERLY JACOB EPSTEIN COLLECTION
WHEREABOUTS UNKNOWN

later admitted that this work had probably been in his thoughts.[33] Certainly there is an uncanny resemblance between Aphrodite's softly-rounded profile and the head in D4; also in the dominant central position held by the figures, both of which are cropped at the hips, and in the strictly frontal presentation of the torsos, both dramatised by the upraised arms [27]. In several of the sketchbook drawings [D4, 24, 26, 35, 52, 54] *Rima*'s distinctive seated pose seems to derive from the relief of a nude pipes-girl on the throne's side panel [28].[34] The sketchbook indicates Epstein returning again and again to a Ludovisi-like composition, refining the primitive elements through the classical experience. In several drawings, most notably the penultimate one [D55], he has transformed the antique model into a more dramatic ensemble corresponding to the climactic episode in the novel, when the savages set fire to a tree in which Rima has sought a final refuge:

Then Runi said . . . 'We must burn her in the tree; there is no way to kill her except by fire . . . Burn, burn, daughter of the Didi!' . . . the flames went up higher and higher with a great noise; and at last from the top of the tree, out of the green leaves, came a great cry, like the cry of a bird, 'Abel! Abel!' and then looking we saw something fall; through the leaves and smoke and flame it fell like a great white bird killed with an arrow and falling to the earth, and fell into the flames beneath.[35]

Epstein and Pearson together succeeded in creating in the *Memorial* an Elysium where the dynamically composed and vigorously carved figurative panel is a counterpoint to the quiet dignity of the architecture and planting surrounding it. Green mansions are the trees of a paradisaical forest [49]. The dappled light and shade filtering through the foliage on to the carved image of *Rima*, her bird companions seemingly in flurried flight from the Sanctuary, is the physical analogue of Hudson's description of the wild forest glade in which Rima dwells and is first revealed to the novel's hero:

Even where the trees were largest the sunlight penetrated, subdued by the foliage to exquisite greenish-golden tints, filling the whole lower spaces with tender half-lights, and faint blue-and-grey shadows

and of Rima herself:

The colour of the skin would be almost impossible to describe, so greatly did it vary with every change of mood . . . and with the angle on which the sunlight touched it, and the degree of light . . . [the] greenish grey . . . tint I . . . attributed to the effect of the sunlight falling on her through the green foliage . . . then a gleam of unsubdued sunlight fell on her hair and arm, and the arm at that moment appeared of a pearly whiteness.

Hudson even ascribed sculptural qualities to her:

Beneath the trees, at a distance, it had seemed a somewhat dim white or pale grey near in the strong sunlight it was not white, but alabastrian, semi-pellucid, showing an underlying rose-colour.[36]

All this would hardly have been lost on Epstein. The result is an uncommonly simple and sensitive ensemble, subdued by the general use of monochromatic Portland stone. Though these qualities are also to be found in some contemporary war memorials on the Continent,[37] they are largely absent from British interwar public sculpture, which was still immersed in elaborately pictorial and symbolic imagery, frequently executed in a variety of rich materials and raised aloft on pedestals or as part of graniloquent architectural complexes which isolated the sculpture from its natural surroundings. Epstein was contemptuous of this lack of concord, as he made clear during the *Rima* controversy when he censured *Nelson's Column* in Trafalgar Square as 'that silly column . . . carrying a puny little figure . . . which is out of all proportion and cannot be seen'.[38] In striking contrast, the close physical relationship between sculpture and Nature resulting from the omission of a pedestal, combined with the blatant directness of the sculpture message in the *Hudson Memorial* was a radical innovation, though misunderstood at the time.[39]

24

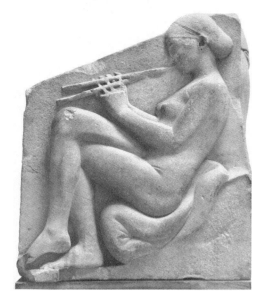

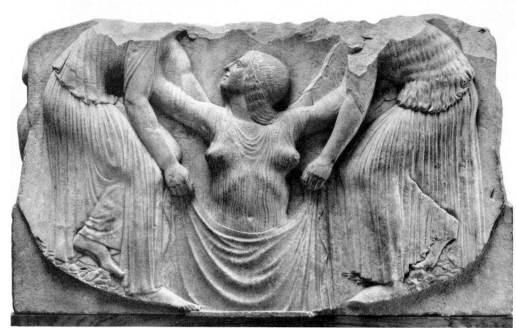

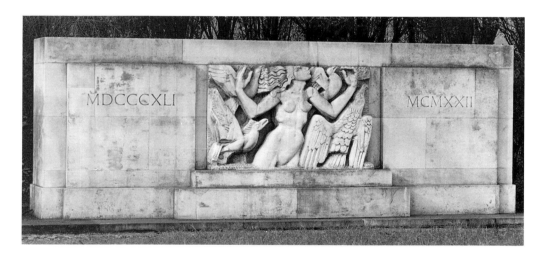

28. FEMALE PIPES-PLAYER
SIDE PANEL OF THE LUDOVISI THRONE
PAROS, GREECE, MARBLE, *c*470–460 BC
MUSEO TERME, ROME

26. THE BIRTH OF APHRODITE
CENTRAL PANEL OF THE LUDOVISI THRONE
PAROS, GREECE, MARBLE, *c*470–460 BC
MUSEO TERME, ROME

27. RIMA, IN 1948

The treatment follows the pseudo-Assyrian manner that we have come to associate with the work of Epstein. There is, admittedly, a cult for this sort of thing, but such work has absolutely nothing in common with the idealism of a man as Hudson.

THE LEEDS MERCURY, 20 MAY 1925

A more entertaining way of spending an idle-half hour is to stand in front of Epstein's Assyrio-Vorticist conception of Rima.

THE YORKSHIRE EVENING NEWS, 23 MAY 1925

I have before me a photograph of ... the Ludovisi Throne ... and between it and Mr. Epstein's panel there is a striking general resemblance [without] suggesting that [Epstein] copied [it].

THE TIMES, 25 MAY 1925

I have even been told of an art critic who compares the EPSTEIN burlesque of HUDSON'S Rima with the work of the sculptor of the Aphrodite of Cnidus! Could ignorance go further than that? ... What your Epsteiners need is a trip to Greece in the custody of a scholar, or even a conducted visit to the British Museum.

PUNCH, 10 JUNE 1925, p. 618

Surely the fundamental defect of the Epstein sculpture lies not so much in itself but in the fact that it is wholly out of place and unsuitable for its surroundings. It is an alto-relief, and the natural place for an alto-relief is a wall or door. But on the Hyde Park site there is no wall, and so, instead of the sculpture being carved on a wall, a kind of fragment of low wall has been built to receive the sculpture. No art can stand such a trial as this.

G. F. BRIDGE, 'THE EPSTEIN PANEL',
THE TIMES, 23 JUNE 1925

VI
RIMA CARVED

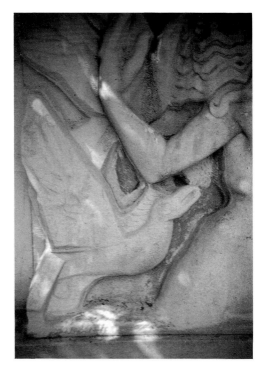

In order to judge the decorative quality of the panel, let anybody half-close his eyes and take in only the shadow pattern, and I think he will find that it combines a satisfactory balance with a remarkable suggestion of angular, energetic, upward movement

'VIEWS ON MR. EPSTEIN'S PANEL.
CONCEPTION, TREATMENT AND EXECUTION'
BY 'YOUR ART CRITIC', THE TIMES,
25 MAY 1925

Haskell: 'Surely people expected a piece of book illustration and were bitterly disappointed at not finding the obvious. Hence the accusation that you had not even read the book.' Epstein: 'it is obviously impossible to give an illustration of the book in sculpture that would be generally pleasing to all its readers and at the same time good as sculpture.'

THE SCULPTOR SPEAKS, 1931, pp. 28–29

29. RIMA, DETAIL, IN 1983

The splendid revised design finally received approval from the Office of Works and the King on 10 July 1924, eighteenth months after Epstein began work on the commission.[1] He now turned to the business of executing the sculpture.

One of the main problems was how to make the relief 'effective to the eye at a long distance'.[2] The Office of Works had insisted the Sanctuary was to be protected from public access by an enclosure of planting on the north, east and west sides and by a barrier (eventually an iron fence) on the south, from outside of which the relief would be seen across a distance of some 55 feet [11]. The effect of this decision can already be seen in a number of the sketchbook drawings where vigorous washes in blue, green, red, pink or mauve have been added to the outline of the figures or to the background (a method of presentation Epstein employed nowhere else in his drawings for sculpture) as a means of helping him visualise the impact the raised parts of the carved relief would make against the deeper, darker background when seen from afar. But before a satisfactory composition could be achieved, the size of the relief panel had to be decided and here the government prevaricated. Epstein related how three panels of different dimensions were considered and without consulting him the smallest was chosen.[3] He complained in February 1923 of not being able to 'get on with the new design ... because the O. of W. have not really fixed yet the <u>size</u> of stone they approve of and it is not much good planning a carving for it till that has been fixed owing to questions of 'life size' etc in the figure'.[4] Some attempt to give greater visual prominence to the relief was made by projecting the panel nine inches forward from the face of the stone screen and then disengaging it by inserting two inch-wide vertical channels to left and right. The Roman numerals recording Hudson's birth and death dates were repositioned from below the relief [10] to the screen flanks, where they appear much larger, while at the same time the dedication inscription was removed from the screen altogether and resited on the curb of the lily pool at the south end of the Sanctuary, making it easier to read and also clearing the relief of necessary but unwished-for detailing. Muirhead Bone thought 'One of the great merits of the [executed] panel is that it "carries" so well ... a trying test for any sculptor',[5] but Bernard Shaw ridiculed the authorities' meanness in providing a panel the size of a postage stamp![6] This reduction was to effect the final appearance of the carving as profoundly as the choice of subject and the sculptor's unorthodox interpretation of it.

A number of adjustments to the design had to be made. Some of the sketchbook drawings show preference for a less illustrative treatment. Like Moore, Epstein disapproved of pictorialism in sculpture, though it then still had a potent presence in public monuments in Britain.[7] Ironically, Frampton's *Peter Pan*, 1912, in nearby Kensington Gardens, with its fictitious hero surrounded by gamboling rabbits and fairies, was recommended by the Office of Works as an appropriate model.[8] However, Epstein was moving in the opposite direction. The forest glade which formed a lush background in his inaugural scheme [13–14] was subsequently reduced to a single, stylised plant [18], and though variations between these two treatments feature in the sketchbook, vegetation, earth, sky and even perspective were finally forsaken altogether in favour of an unspecific, roughly worked ground [29]. At the same time, the figures of Rima and birds were pushed up against the 'picture' plane so that they now occupy almost the entire area of the panel; indeed, *Rima*'s head is so forced to the top edge that to some observers it looked 'shaved off'.[9] For R. H. Wilenski the relief seemed 'a sort of fragment of a carved sarcophagus'.[10]

Furthermore, these changes no longer left space within the panel to accommodate Rima as a conventional full-length figure. Epstein now made another radical decision: to crop the figure at the hips and thereby push it even further forward towards the viewer. He had employed a partial figure to alarmingly modernistic effect in the *Torso from the Rock Drill* [30].[11] But where that work, it seems, had resulted from the sculptor's unexpected transformation of the original full figure of 1913 representing the driller in the act of creation, to the post-1914 amputated monster of destruction

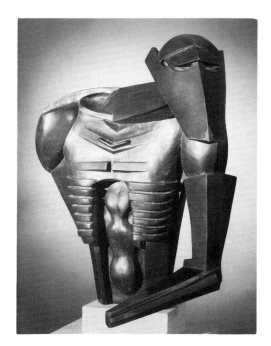

30. TORSO IN METAL FROM
THE ROCK DRILL, 1913–15
BRONZE, H 70.5
THE TRUSTEES OF THE TATE GALLERY
LONDON

The 'sculptor' of one of our most important war memorials, which was actually executed from his model by the uncannily skilled men who do such work, had to be shown how to hold a chisel and mallet when he wanted to make a slight alteration to the memorial.

THE EVENING STANDARD, 14 MAY 1929

[Epstein] achieved what to me is a masterpiece in which every cut with the chisel was an adventure — for unlike clay you can't cut it away and put it back again.

CHARLES HOLDEN, 1954
(BAL: HOC/1/20 (iii))

It is not generally realised that the practice of sculpture ie., of the stone or marble hewn out by the artist himself, is much rarer than supposed, and it is much in favour of a finer expression in sculpture that artists are returning to this first-hand direct carving on the material itself.

'SCULPTOR AND MODELLING', THE BUILDER,
19 JUNE 1925, p. 928

provoked by the loss of a close friend on the battlefield (the sculptor, Henri Gaudier-Brzeska),[12] the final appearance of *Rima* evolved from a major decision from outside and beyond Epstein's control. In June 1923 the Office of Works had objected to the 'ugly' elongation of the figure [18] and recommended making the arms 'shorter' and the relief itself 'less long': thus, the decision to reduce the size of the panel.[13] The amputation of the lower limbs, and with it the loss of both ground and landscape, produced the desired effect of an 'uprush of a wild, free spirit'.[14] The metamorphosis from full to partial figure can be seen in the sketchbook: for example, as Epstein's thoughts shifted from D 38, 53 or 56 to D 5 and, ultimately, D 55 and the carving itself.

In the final design [27] *Rima* and the birds have become the most prominent, indeed, the only feature in the relief. Epstein now resolved to carve them in an appropriately robust and direct manner. Significantly, he selected native grey-white oolite limestone from the Island of Portland rather than one of the more luminous and seductive, imported marbles.[15]

Much was made at the time of the sculptor's use of the direct carving method. Committee members wrote proudly of 'work direct on stone ... the whole thing ... hewn by hand out of one block ... entirely by his own hand',[16] and some regarded the finished relief as a notable example of getting back 'to real carving by the artist himself, and not the mere mechanical reproduction of clay originals'.[17] As early as 1860, Nathaniel Hawthorne had warned that the use of the pointing machine as a means by which the sculptor could be released from 'the drudgery of actual performance', at the same time permitted the studio assistant (himself 'some nameless machine in human shape') to replicate in the full-size plaster model with little or no need for further intervention.[18] This could result in a deadliness of surface. By contrast, for the modernist sculptor direct creative activity was all-important. Muirhead Bone offered an unusually lucid explanation of both the purpose and the results of direct carving in his 1925 government report on *Rima*. Epstein, he pointed out, had observed in some academic carvings in Portland stone that

the wasting of the stone on small and neatly finished shapes has eaten the modelling of the face and figure completely away and produced a most unpleasant effect, [from which he concluded] that stone carvings exposed to London air must become completely obliterated and sink into shapeless stone.

In order to

allow for this inevitable wastage (especially disastrous in the case of bas-relief, as that work has no outline beyond the square of its slab), and as his material is ... relatively soft stone, he considered it his duty to his clients and his own reputation to provide no small forms which such wastage could immediately seize upon, but rather to keep the effect as large and weighty as possible.

Bone concluded that as the relief

is a work entirely carved by his [Epstein'] own hand ... he has been able to leave the stone when he has defined the principal masses ... Consequently to many eyes the work in its present state may be said to look 'raw' and unnecessarily heavy, ... in a few years this 'rawness' will no longer exist and 'the margin of safety' allowed by the sculptor for weathering will have completely justified itself and the mellow weathering will have lent chiaroscuro to the whole Memorial stone.[19]

And this is, of course, exactly what happened. What L. B. Powell, an early and uncommonly perceptive biographer, called the 'square-cut directness' of the relief,[20] with its tense contrasts between rough-hewn surfaces and smooth, sharp-edged shapes, accentuated by dramatic linear incisions and crusty nodules, is evident in photographs taken during the carving process [31–33].[21]

Both *The Builder* and *The Times* recognised the merits of Epstein's unconventional approach. To *The Sphere's* observation: 'Your treatment of her [*Rima*] is too 'hard' for the sentimentalists', Epstein replied:

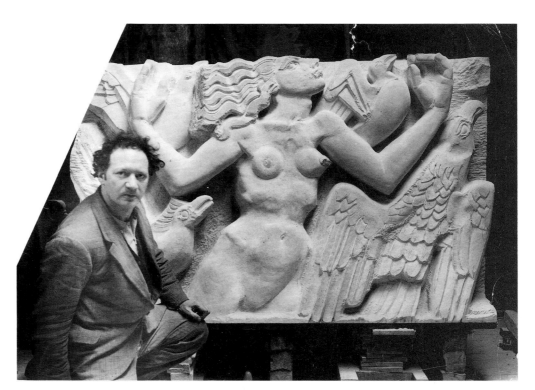

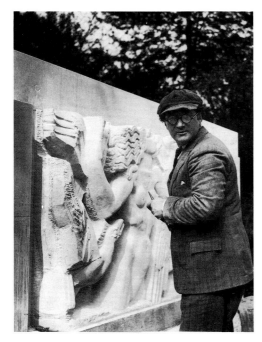

32. EPSTEIN CARVING RIMA,
PROBABLY EARLY 1925

31. EPSTEIN CARVING RIMA,
PROBABLY EARLY 1925. DAMAGED ORIGINAL
PHOTOGRAPH, FIRST PUBLISHED IN THE
DAILY MAIL, 21 MAY 1925

33. EPSTEIN INSTALLING RIMA
IN HYDE PARK, APRIL–MAY 1925

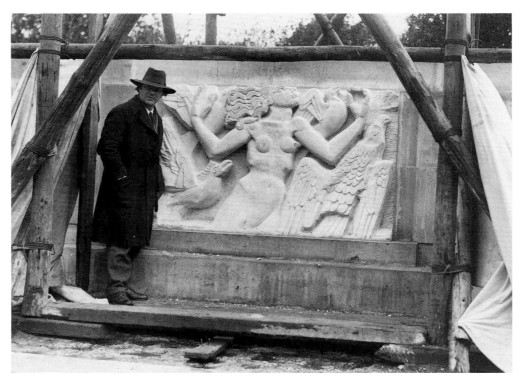

She is not a sentimental heroine. But in any case I have not made a portrait of a novel's heroine, I have made a sculptured design. Hardness is intrinsic in sculpture. Only bad sculpture is soft.[22]

He believed 'small niceties of workmanship ... out of place', preferring a 'bold and generally effective, even a rough' result.[23] Nevertheless, Eric Gill, a fellow sculptor involved in the commission [34], condemned this rough finish for looking as if Epstein had 'gnawed it with his teeth'.[24] Reginald Blomfield had spoken in 1920 of what he believed was the *avant garde* crusade to convince the public that

All great works of art ... show an effort, a roughness ... which is the essence of their beauty ... and by the acceptance of this simple formula artists henceforward will be freed from the necessity of spending long laborious days in the study of their art.

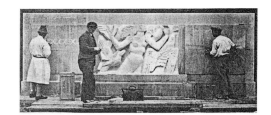

34. ERIC GILL, EPSTEIN AND AN
UNIDENTIFIED WORKMAN COMPLETING RIMA
IN HYDE PARK, MAY 1925

[Epstein is] an out-of-date sculptor still belonging to that pre-war period when 'the significance of the child's art' was the fashion . . . Bad craftsmanship and crudity were at the time a natural . . . reaction against academic smoothness and sentimentality . . . I am not criticizing Mr. Epstein's abilities, which I admire, but his persistence in an affected childishness of technique, which I deplore. If Mr. Epstein were to set to work and re-carve that panel, forgetting his theories, he would produce a masterpiece.

PATRICK ABERCROMBIE,
IN THE TIMES, 30 MAY 1925

And he warned that since 'All they have to do is to feel ferociously, and as there will be no standard but the emotionalism of the critic . . . the quality of feeling is immaterial'.[25] The misgivings felt by him and other writers, critics and academic artists, were based partly on the romantic but misinformed and harmful rhetoric often employed to explain direct carving, which suggested to the uninitiated, the sceptical and the merely outraged, some arbitrary and mystical ritual. For example, in reference to *Rima*:

In imagining and executing this sculpture out of a piece of the very stuff of earth itself, the artist, in his joy of design and chisel-cutting, has . . . re-expressed the flame of spirit which informs so much of Hudson's writings, and which, springing from close contact with the earth, burns to the skies.[26]

Epstein encouraged this by relating how he had worked on the relief in Epping through the Winter of 1924–25 'solitary, surrounded by silent and often fog-laden forest'.[27]

In fact, the carving was done in an ordinary, businesslike manner. The block of Portland stone had arrived at Baldwyn's Hill by May 1924,[28] but it proved too large to work in the existing studio. In the summer a special shed had to be built, and later that year felt-lined to protect Epstein against the winter winds.[29] In September he started carving with 'great enthusiasm'[30] and continued almost without interruption during the next seven months.[31] By the end of April 1925 the relief was 'practically finished',[32] with the final details carved after the panel was installed in Hyde Park.[33]

A contemporary photograph [33] records the wooden structure assembled on site to lift the heavy block of stone in position, while another [34] shows Epstein, an unidentified workman and Eric Gill (almost certainly the figure on the left wearing a smock) cutting Roman numerals on the stone screen. Gill was also responsible for the inscription on the lily pool border:[34]

THIS SANCTUARY FOR BIRDS IS DEDICATED TO THE MEMORY OF W H HUDSON
WRITER & FIELD NATURALIST

The completed memorial cost £1,875 18s 3d, of which £500 went to Epstein.[35] The entire sum was raised by contributions ranging from 9d to £100 sent by some 676 subscribers of all ages and from all walks of life.[36] This had seemed at the time to herald a popular triumph for new public sculpture, just as it was hoped the memorial relief itself would be regarded as a masterpiece. But in the eyes of most members of the public the venture turned out to be a disaster.

VII
THE PRO-
EPSTEINERS

[Epstein] is an artist with a very strong modern style. All artists with something new to say have had to pass through this process of finding their work strongly assailed by the older generation of artists and the uninformed public.

MUIRHEAD BONE, IN THE OBSERVER,
22 NOVEMBER 1925

The barrage of public and press abuse which followed the unveiling of the *Memorial* on 19 May 1925 startled but did not unnerve Epstein.[1] Within a week he had informed readers of *The Sunday Express*: 'So far no competent critic has complained about the work. I have received letters of congratulation from artists, both painters and sculptors'.[2] They included the sculptor, Eric Kennington, who proclaimed *Rima* a work of 'vitality and power'.[3] Even before the relief was unveiled, when the final design was first presented to the public in March 1924, James Bone, London critic of *The Manchester Guardian*, praised both the sculpture and its setting as being of 'a rare and beautiful kind expressive of the strangeness and fineness of Hudson's spirit and of his love of birds'.[4] As the controversy grew louder, the sculptor's friends (whom *The Daily Sketch* was eventually to dub the 'Pro-Epsteiners')[5] spoke out persuasively in his defence. Muirhead Bone wrote with some truth that *Rima*

has a sense of great sculpture about it which is perhaps too novel a quality in our memorials to meet with immediate assent. It excites as good art should, and is for the moment paying the penalty.[6]

Shaw hailed it as 'unquestionably the real thing, with all the power of stone and all the illusion of strenuous passion ... that live design can give'.[7] The Yankee art critic, Christian Brinton, let it be known to readers of *The Yorkshire Post* that if the British 'don't know how to appreciate Epstein and his art we shall be very glad to have him back in America'.[8] Roger Fry felt compelled to defend the relief as a demonstration of 'real inventive ingenuity and sense of proportion', qualities he regarded as 'almost always absent from our public sculpture',[9] though he privately wrote a friend:

London in a state of emotion about a sculpture of Epstein's. A Jew with immense dexterity who has concocted a relief ... against which all the Philistines had raised a hue and cry ... this object ... was exactly as I'd imagined — a thing lacking true artistic inspiration, but a counterfeit work of art with great decorative style. So in spite of my lack of sympathy for things of that order I had to come to the help of the sculptor and say that, whatever defects one might find, it was much better than all the other monuments of the academic schools that clutter up our parks, and crush, as best I could, the virulence and intolerance of those gentlemen the Philistines.[10]

Epstein's work held 'no terror' for Sybil Thorndike: she remained an 'unrepentant admirer' and could not understand the 'noisy protests against his conception of Rima'.[11] She thought the *Memorial* created an 'effect of extraordinary peace and beauty ... heightened by the vivid and arresting quality' of the relief itself; but, she warned readers of *The Times* on 25 May, 'this effect is likely to be entirely destroyed if the group is viewed for the first time in a spirit of violent partisanship'. Two days later she spoke to *The Evening Standard* of the 'supremely beautiful' relief and asked:

Have you ever held a bird in your hand and felt it striving to escape? I felt that there was that kind of thing in that piece of stone ... some bird-like thing which he had imprisoned in stone. Only a very great artist could have reproduced that.[12]

Arnold Whittick had 'not the slightest doubt that Mr. Epstein's work will be a vital force in art', for he 'at least gives us life, whilst too much English sculpture is still-born from the studio',[13] and Frank Rutter believed that 'Fifty British sculptors could have designed something prettier and more appropriate to Hudson: none could have given so striking and haunting a design as Epstein'.[14]

A few writers probed more deeply into the causes of critical misinterpretation disgorged by the controversy. James Laver, an assistant keeper at the Victoria and Albert Museum, tackled the judgment that Epstein had distorted the human figure out of pure spite, by pointing out that this was the 'only way of conveying the sense of movement in sculpture. There is an upward motion. The whole block is in flight', and he added that if the public had expected a 'semi-developed female figure feeding chickens, or a marble angel ... they should have gone to a monumental mason.'[15] *The Times* art critic attempted to get to the root of critical opposition:

To cavil at the departures from realism ... is to make humbug of the commonly professed admiration of the sculptures of Chartres and Reims. [Epstein works] in the much older tradition [and] Any 'archaic' suggestion in type of figure or treatment of form is due to that, and that only *plus* the irresistable influence of subject ... So much depends upon the conception of 'nature'. I cannot help thinking that those who are repelled by Mr Epstein's panel conceive of nature as an opportunity for picnics and of the birds as a sort of obsequious pensioners.[16]

Some support came unexpectedly, almost miraculously, from that bastion of anti-modernism, the Royal Academy, when the fashionable portrait painter, Sir John Lavery, RA, in a letter published in *The Daily Telegraph* on 25 May, congratulated Epstein on his 'dignified and beautiful tribute to Hudson', and then audaciously announced that he had taken the liberty of nominating the sculptor to that exclusive institution in order to 'silence the ridiculous ones, who look upon the R.A. as a hall-mark'![17] This naturally caused a good deal of consternation, since most Academicians abhorred *Rima*, and Epstein, needless to report, was not elected!

We object that the hands ... are too large, the head cut short, and the birds not like real birds. But if we consider the conception as a whole we forget the distortions with which the artist has sustained his rhythm, and react to its emotional significance.

ANA M. BERRY, THE ARTS LEAGUE OF SERVICE, IN THE TIMES, 28 MAY 1925

I am told I only see sculpture as a painter. Be that as it may, I prefer Epstein's 'Rima' in the Park to the Albert Memorial! Once at a dinner-party when London sculpture was being discussed — I think it was chez Lady Colefax — Edwin Lutyens leant across the table and in his playful manner said, 'John, I hear you are defending "Rima."' 'My dear Edwin, I have done worse than that. I have been defending the "Cenotaph."' He did not let me go free, but I remember the incident because he is difficult to score off.

J. LAVERY, THE LIFE OF A PAINTER, 1940, pp. 126–27

I am sick of the dishonesty of the artists about the Epstein monstrosity. The other night I met at dinner a famous R.A. painter who has been prominent in defending Epstein's masterpiece. At dinner he was ridiculing it and abusing its faults. I could not help saying: 'I thought I saw that you were praising it in public?' He looked rather non-plussed and then said: 'Oh! one has to stand up for a fellow artist in public!' So that art is now a trades-union, and honest opinion bowed out of court.

EDMUND GOSSE TO HAMO THORNYCROFT, JUNE 1925 (MANNING, p. 194)

While the inaugural attacks against *Rima* did not at first seem to warrant real concern, they were not dismissed lightly. Furthermore, Epstein's friends had been forewarned. At a dinner party given in June 1923 Lavery and a group of 'artistic people', including Cunninghame Graham, were obliged to agree that while Epstein was the 'only sculptor worthy of the name in England', considerable criticism of the relief was nevertheless anticipated from 'other "artists" in the *Gas Works* of Westminster'.[18]

VIII
THE ARMY OF OPPOSITION

Will the Under-Secretary make the 'Daily Mail' the absolute arbiter in these matters?

LORD HENRY CAVENDISH-BENTINCK,
IN A PARLIAMENTARY DEBATE ON RIMA,
25 MAY 1925 (PRO)

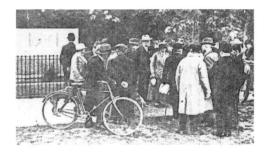

35. 'THROUGHOUT THE DAY CROWDS OF VISITORS DISCUSS THE EPSTEIN PANEL' FROM THE SPHERE, 30 MAY 1925, p. 258

Ordinary people don't like the memorial. There is a constant procession of men and women of all classes ... For the most part they express their opinion of it ... with a derisory smile or shrug of the shoulders. They are not by any means indignant, but rather amused, as at an exhibition of eccentricity, or at one of those incomprehensible absurdities occasionally produced by modern artists.

'THE HYDE PARK ATROCITY. ORDINARY MAN'S OBJECTION. COMMONS QUESTIONS'. "A SCARECROW", THE DAILY MAIL, 26 MAY 1925

Towards the end of May 1925, when Parliament got wind of reports that *Rima* was considered an offence to a large section of the public,[1] *The Yorkshire Post*, which regarded Epstein as 'unquestionably a great asset to English art', suggested that some MPs had been 'hypnotised into following the lead of those newspapers which are running a stunt' on the relief.[2] There can be no doubt that the attacks, rather than the result of spontaneous, large-scale public animosity, were being carefully orchestrated by the press, particularly the right-wing *Morning Post* and Lord Rothermere's *Daily Mail*.[3] The *Mail* launched the offensive with a series of articles which began to appear within a few days of the unveiling. It reported on angry and denunciatory crowds assembled at the Bird Sanctuary 'at times ... so thick that visitors had to push forward [to see] The Hyde Park Atrocity.' 'Immediately their eyes saw the work most of them looked aghast. Then they gave voice to the general condemnation of it ... "Coarse", "gross" and "vulgar" ... Hundreds from the church parade visited ... and expressed disgust' [35].[4] *The Times* published a letter from Captain A. L. Kennedy, who believed that no 'ordinary Englishman can see the spirit of bird-haunted woods' in this grotesquely inharmonious intrusion into a sanctuary which is a 'typically English conception set in a typically English public park'.[5] F. C. Tilney asked: 'Must those who paid the piper submit to the unpleasant tune of one individual sculptor's introspective ugliness?'[6] A correspondent to *The English Review* regarded this 'hideous masterpiece as, perhaps, the most famous example of a great sculptor who has sold his soul to the devil'.[7]

The Daily Mail published a list of hints for viewing *Rima*, which included wearing morning dress, smoked glasses (since the work belonged to the 'ultra modern school') and a 'rapt expression of wonder rising to awe'; Philistines should not shrug shoulders, wink, whisper, smile, laugh, frown, sniff, cough, groan and, above all, breathe: 'nothing betrays the utter ignorance of the public so much as its vulgar habit of breathing in the face of a work of art'![8] And though the Countess of Oxford refused to countenance joining what she called this 'pilgrimage of passion',[9] others were not so reluctant to exacerbate the growing hysteria. No less a personage than Sir Frank Dicksee, President of the Royal Academy, announced that *Rima* offended thousands and that he foresaw 'a danger that if such things are encouraged or allowed to remain in our midst they will be copied, and the world will be made hideous'.[10] Conan Doyle, who had subscribed £5 to the Memorial appeal, told *The Daily News* that he regarded the relief as 'an ugly thing. Nothing could be done to ameliorate it'.[11]

Nor was the controversy confined to the tabloids. At an Authors' Club dinner held on 5 October 1925, the RA painter, John Collier, vigorously attacked *Rima* as a specimen of the 'advanced art which was extravagantly praised by the critics and imitated with great success by the youngest art student, but loathed by the plain man [as] ugly [and] inhuman'.[12] In a private letter to the Hudson Memorial Committee *Rima* was called a 'monstrosity ... a crime alike against art & nature'.[13] Meanwhile, at the scene of the crime a small boy was heard to tell his mother: 'it oughtn't to be

36. PABLO PICASSO
THE THREE DANCERS, JUNE 1925
OIL ON CANVAS, 150 × 42
THE TRUSTEES OF THE TATE GALLERY
LONDON

*the public monument became a private monument.
Keep away, said the superior person, keep away,
you Philistines, you of the common sort. The
Epsteinian art is not for you. Of course you would
dislike it. Your sort has always clamoured against
the new and fresh fancies of genius.*

'ART AND THE SUPERIOR PERSON',
UNIDENTIFIED AND UNDATED CLIPPING (PRO)

*Is it 'A Travesty of Nature' or a work of 'Perfect
Craftsmanship'?*

THE ILLUSTRATED LONDON NEWS,
30 MAY 1925, p. 1069.

37. FRANK REYNOLDS
'ANOTHER TRIBUTE: PROPOSED MEMORIAL
TO A CRICKETER WHO HAS
NO INTEREST IN DUCKS'
FROM PUNCH, 24 JUNE 1925, p. 686

allowed',[14] and a Frenchwoman shouted: 'If you want art you must come to Paris for it', apparently unaware that in the same month Picasso was painting *The Three Dancers* [36].[15] James Laver recalled a 'fanatic [who] stood by the statue day after day denouncing it to anybody who would listen. When he tried to approach Epstein at Oddenino's to continue the argument, Mrs. Epstein lost patience and drove him off with a siphon of soda water. He retired, drenched, and was never seen again'.[16] There was also the painter/sculptor Homerville Hague, RA, who harangued a huge crowd in front of the offending sculpture for twelve hours, condemning it as 'the most outrageous thing that has ever been put up in a London park ... The head is a criminal's, and the torso like a woman's corset'.[17] This filibuster was not only reported in the press but captured for cinema audiences by Topical Budget newsreel.[18] Of this *Punch* merely remarked: 'We often wonder what artists do in their spare time'.[19]

Punch had already launched its own humorous brand of attack in the 3 June issue with comments such as: 'It is thought that the London sparrow recently discovered on a New York liner was migrating because he had received a bad shock in the Hyde Park bird sanctuary', and 'The controversy on the HUDSON Memorial suggests the need of a sanctuary for sculptors in some secluded spot',[20] as well as articles dealing with such diverse topics as Parliamentary debates:

[Cunninghame Graham's] quarry to-day was art, not politics. He had come to hear what Members had to say about the much-discussed memorial to his friend HUDSON. Their views were various, and the discussion began to grow hot until the SPEAKER closured a hostile critics, who had talked of 'elephantiasis', with the remark that he would like to see the question in writing.[21]

woman's golf:

I found thirty-two persons of either sex in front of the notorious railings ... The little crowd was strangely quiet ... 'it isn't art. It isn't sculpture ... A child could do it better if it wanted to.' ... Let me turn to the carving itself ... Consider the upward and wafting gesture of the outstretched hands, the set-back head and the rippling design of the hair. Without doubt the sculptor has intended to symbolize a drive or brassie shot sped true and fair towards the hole ... this is a female figure. It is strong and robust ... the sculptor has chosen, and I think more beautifully and wisely, to seek inspiration for his genius in the magnificent advance which has been made during the last few years in the standard of ladies' golf.[22]

a current production of *The Cherry Orchard* at the Lyric, Hammersmith ('Call this art?')[23] and various verses.[24] *Punch* embellished these amusing diversions with cartoons [37–38],[25] as did *The Builder* [39]; and it must have been about this time that Albert Buhrer drew 'A Carver' Mr. Jacob Epstein' [40], later published in *A Rude Book by Tell*, 1926, accompanied by the verse

> He carves in stone, and more's the pity
> For stone is obstinate and gritty,
> Oh how I wish he were a cutter
> In liquorice or lard or butter
> So that posterity might miss
> His primitive absurdities.[26]

Tempers frayed. In October 1925, Epstein took violent exception to defamatory remarks against *Rima* voiced at the Café Royal in Regent Street.[27] It may have been this hullabaloo which gave rise to *The Times*' appellation describing the rift between academia and modernism: the Philistines versus the Café Royalists.[28] Shortly after there occured the even more widely publicised and distressing incident at the Aldwych Theatre (see page 21).

Epstein's friend, Arnold Haskell, reckoned much of the criticism was 'fundamentally dishonest [with] not one solid argument ... only jokes about cruelty to birds'. The sculptor concurred:

38. ANONYMOUS, PUNCH AS RIMA
FROM PUNCH, I JULY 1925, p. 725

39. STANLEY P. SCASE
'A PROPOSED DESIGN FOR A MEMORIAL
TO A FAMOUS ARCHITECT'
FROM THE BUILDER, 19 JUNE 1925, p. 930

*That isn't Rima. That's the soul of a Shoreditch
poulterer's wife being conducted to hell by two
frozen hen turkeys.*

THE YORKSHIRE EVENING NEWS, 23 MAY 1925

*So much was said, both for and against his Rima
... that in the din of controversy no sane voice
could be heard. Indeed, no sane man could
comfortably speak either for or against the man,
and his work, so immoderately attacked, so
uncritically praised.*

WILLIAM ROTHENSTEIN, MEN AND MEMORIES,
1923, II, p. 129

*The objection of the public ... is inspired not by
bad art, or inferior art, but by something which is
not strictly speaking art at all, and which they
detest.*

THE MORNING POST, 18 NOVEMBER 1925

40. ALBERT BUHRER
'A CARVER MR. JACOB EPSTEIN'
FROM A RUDE BOOK BY TELL, 1926, p. 15

Probably the whole agitation was due to the usual total misconception of what the artist's function is, and also absolute ignorance of what can and what cannot be done in sculpture. Much of the discussion was ridiculous from the start, as my critics wished me to do something quite impossible with the medium, and with regard to the conditions under which the work was to be seen when finished. They heard the words 'Bird Goddess,' which suggested to them, something filmy, in very light relief.[29]

Subsequently, just this was offered by RKO in its lurid publicity poster for the 'SENSATIONALLY GLORIOUS' (though mercifully abortive) production of *Green Mansions* starring Dolores Del Rio and Joel McCrea: 'W. H. Hudson's startling novel of romance and adventure', an 'idyll of mystic beauty ... with nature in majestic pageantry and love beyond the reach of sin'![30]

IX
BEAUTY AND BARBARISM

Some people might imagine that ... Rima, who lived the wild free life among animals of the field and forest ... could be represented as a pretty, angelic composition, but that was not [Epstein's] idea.

F. W. JOWETT, FIRST COMMISSIONER OF
WORKS IN THE 1924 LABOUR GOVERNMENT,
IN THE TIMES, 28 MAY 1925

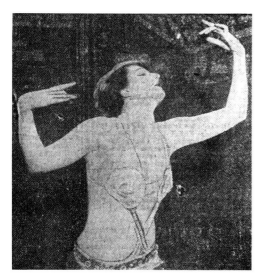

41. 'MISS BETTY BLYTHE'S SPECIAL POSE
FOR THE "DAILY NEWS" AS SHE THINKS
RIMA SHOULD BE PORTRAYED'
FROM THE DAILY NEWS, 7 OCTOBER 1925

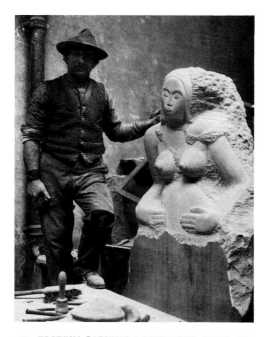

42. EPSTEIN CARVING MATERNITY, 1910–12
HOPTONWOOD STONE, H 206
LEEDS CITY ART GALLERIES

Why was *Rima* singled-out for such abusive treatment, which Epstein later admitted was unequalled in his career for 'venom and spite'?[1] Conservative critics and many members of the public were shocked by the idea that he had sought to illustrate 'the primitiveness of Hudson'.[2] They repudiated the sculptor's notion of depicting Hudson's heroine with such 'wild strength and stark violence'[3] as a means of bringing the spectator 'face to face with nature as Hudson understood it'.[4] Such an approach was regarded as symptomatic of that unhealthy *avant garde* fascination with the primitive, the abstract and the directly carved which produced crudities and ugliness in sculpture. There were also more sinister objections: political and anti-semitic. But above all, *Rima* was condemned because it opposed Establishment views, particularly those nurtured in art schools and at the Royal Academy, on the correct manner of representing beauty.

Debates about what constituted beauty in art abounded during the interwar years. In 1931 the *avant garde* critic, Herbert Read, identified at least a dozen current definitions and also recognised that 'Most of our misconceptions of art arise from a lack of consistency in the use of the words art and beauty'. 'We always assume', he observed, 'that all that is beautiful is art, or that all art is beautiful, that what is not beautiful is not art, and that ugliness is the negation of art'.[5] In a conversation published in *The Evening Standard* in 1929 concerning his recently unveiled group of *Night* on the London Underground Electric Railways Headquarters in St James's, Epstein explained:

Nature does not appear to the artist as she does to the ordinary, non-creative man. In all beauty there is an element of strangeness, of unfamiliarity, which ordinary non-creative people find alarming ... Millions of them confuse their own sentimental, personal, human ideas with the abstract idea of beauty. Therefore unfamiliar beauty frightens them.[6]

Interestingly, this passage echoes Hudson's reflections on Rima's beauty. Abel thought she surpassed in 'loveliness all human faces [he had] ever seen or imagined', though he admitted she 'probably will not seem ... as beautiful' to the reader since

is it not a fact that the strange or unheard of can never appear beautiful in a mere description, because that which is most novel in it attracts too much attention and is given undue prominence in the picture, and we miss that which would have taken away the effect of strangeness — the perfect balance of the parts and harmony of the whole? For instance, the blue eyes of the northerner would, when first described to the black-eyed inhabitants of warm regions, seem unbeautiful and a monstrosity, because they would vividly see with the mental vision that unheard-of blueness, but not in the same vivid way the accompanying flesh and hair tints with which it harmonises.[7]

British society in the Twenties still cherished Victorian ideals of womanhood and remained tied to the stereotypes defined by the rules of classical art: hence, it was thought that while beauty and force were not 'irreconcilables in the work of Greek sculpture, they may be so in Mr. Epstein's amorphous miscarrages in marble'.[8] This *beau idéal* is encapsulated in a poem by Hudson's biographer, Morley Roberts, written early in 1923, at a time he was involved in the *Memorial* commission:

> some man of marble showed the earth
> Breeding her children: here a curve or hand,
> The round of a woman's breast or fertile thighs,
> Until the marble grows a translucent veil
> And ages still expectant wait the birth
> Of beauty ...[9]

It is hardly surprising then that *Rima* should be condemned as something far outside this norm. The actor, Sir Johnston Forbes-Robertson, whose classical handsomeness was much adored, deplored 'this modern worship of ugliness' in which beauty is ignored.[10] There was even a fear that *Rima* would be regarded by future

43. WILLIAM ROBERTS
THE DANCE CLUB (THE JAZZ PARTY), 1923
OIL ON CANVAS, 76.2 × 106.6
LEEDS CITY ART GALLERIES

*Would the British Lions become Assyrian
monsters, or creatures of Brontosauric mein?
Would Nelson be only a half-Nelson, angular and
alien and Rima-like?*

'THE EPSTEIN TOUCH', UNIDENTIFIED PRESS
CLIPPING, 23 NOVEMBER 1925 (HMCSS)

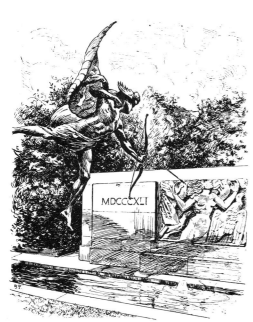

FOR THIS RELIEF NOT MUCH THANKS.
Epstein's Female. "KAMERAD!"
Gilbert's Eros. "I THINK NOT."

44. BERNARD PARTRIDGE
'FOR THIS RELIEF NOT MUCH THANKS'
FROM PUNCH, 3 JUNE 1925, p. 595

generations as 'representative of the anatomy of the human race today'.[11] Bone, in his spirited defence of the work, rightly compared the ridiculous claims being made about *Rima* with Dickens's brutal attack on the figure of the kneeling Mary in Millais's *The Carpenter's Shop*, 1849–50 (acquired by the Tate Gallery in 1921):

So hideous in her ugliness, that (supposing it were possible for any human creature to exist for a moment with that dislocated throat) she would stand out from the rest of the company as a Monster, in the vilest cabaret in France, or the lowest gin-shop in England.[12]

The aesthetic debate took a more vitriolic turn with the publication on 6 October 1925 of a speech made by the Hon. John Collier, RA, at an Authors' Club dinner. He denounced *Rima* as a 'bestial figure, horribly misshapen, with enormous claw-like hands and withered, pendulous breasts, an enormous and distorted pelvis, and the head and face of a microcephalous idiot'. Preferring the 'naturally beautiful female form' and the graceful flowing garment of the 'best period' of Greek sculpture, which did not 'conceal the figure and gave free play to the limbs', to Epstein's 'unwholesome and unpleasant … sort of impressionistic art', Collier warned of a decline in standards of beauty if 'we look with longing eyes on the woman who reminds us of the masterpieces of modern art'.[13] Epstein immediately counterblasted in the press by calling Collier 'the cross word artist [who] knows nothing about real art, and paints conundrums … He is not an artist but an eugenist'.[14] *The Daily News* tested these views by inviting comment from an American film favourite, Betty Blythe (star of 'The Queen of Sheba' and 'She'), currently appearing in vaudeville at the London Coliseum. Not surprisingly, Miss Blythe too found *Rima* 'Diseased, wasted, hideous, distorted … with her arms coarsened out of all beauty … with no hint of beauty'; and she asked what had 'women done to Epstein to deserve this?' [41].[15] Shaw recommended a suitable remedy for this sort of criticism:

a process called photo-sculpture … by which very pretty reliefs can be made by the camera. If Miss Fay Compton or Miss Gladys Cooper would pose as Rima, with a stuffed pigeon on each wrist … the result would be exactly what is wanted by the honest folk whose sense of beauty is outraged and mocked by Mr. Epstein's powerful proceedings.[16]

Shaw and others in close contact with recent developments might dismiss or ridicule the most foolish comments, yet so heavy was the thralldom of the classical norm of beauty, that few uninitiated members of the public or press were able to break their fetters and see the work afresh.[17] Instead, they fastened on every aspect of the image — the partial figure, the large hands — which separated it from the naturalistic tradition. Even critics attempting a sympathetic viewpoint laboured desperately for rationalisation: the

sudden constriction of the figure below the ribs … suggests a more sophisticated type than is proper to a dryad; though it is more than likely that the sculptor had a good reason for this, either formal, in the interests of the design as a whole, or else in fact — the barrel of the chest fully inflated, and the weight of the lower limbs pulling the pelvis away from it; a condition that could not be observed in a woman standing and raising her arms.[18]

Epstein's disturbing figure treatment encouraged, in turn, a condemnation of more specific anatomically grotesque passages: 'soup-plate hands … so terrifying that no nanny would own them'.[19] *Rima* was a 'deformed female … with elephantiasis of the hands', a 'goddess wearing boxing gloves'.[20] Only a few writers recognised the virtue of such an exaggerated approach. James Laver regarded tiny hands as the 'ideal of the drawing-room, [having] no place in the primitiveness of nature',[21] while Frank Rutter saw 'great hands [as] eloquent of the power and strength of a labourer and creator',[22] that is, the hands of the sculptor himself, which were used to interpret hands in many of his carved figures [42]. In the same way, Epstein's birds were regarded as 'monstrous [and] unknown to the ornithologist', 'carved even less artlessly than do our aborigines in Sarawak their hornbills'.[23] Nor could some observers properly relate

X
POLITICS AND ANTI-SEMITISM

bird to body, though the sketchbook drawings show that Epstein went to great trouble to integrate the poses of the upward striding girl and the darting eagles.[24] The majority of the public could not be dissuaded from believing, like Collier, that *Rima* was anything other than an 'entire perversion of the human form',[25] and in the end she was condemned as a 'vulture-like creation', a 'crude and malformed goddess', a 'pagan monstrosity ... repulsive [and] clumsy', a 'dreadful, naked coarse looking creature', a 'Scarecrow' with 'abominable and unnatural ... anatomical detail'.[26]

One correspondent to *The Morning Post*, however, offered a more interesting perspective by comparing these 'anatomical jerks' to 'jazz-dancing'.[27] The frantic zig-zag of arms and hair and birds' wings which could link Epstein's daring rhythms to Picasso's *The Three Dancers*, 1925 [36] or William Roberts's *The Dance Club*, 1923 [43], also carried disreputable cultural and sexual associations.[28]

Tethered to Victorian conventions of beauty, strict anatomical accuracy and naturalistic representation of the human figure, *Rima*'s critics failed to appreciate the fundamental differences between their perception of what appeared to them distorted and ugly and the modernists' radical reinterpretation of archaic and primitive sculpture forms as the basis of its new aesthetic. The conflict between these two concurrent ideals is poignantly expressed in Bernard Partridge's cartoon [44] showing the flying figure from the *Shaftesbury Memorial* shooting an arrow at *Rima*, with Epstein's female crying 'Kamerad!' and Gilbert's Eros retorting. 'I Think Not'.[29]

With few exceptions the initial protests against *Rima* relied on ridicule. They did not succeed so well as the antagonistic press had intended, and when it became evident that public outrage was not as universal as had been suggested, the Parliamentary debates, which had begun in May 1925, quickly cooled and a substantial legal platform appeared to have been lost by *Rima*'s detractors. Meanwhile, the public remained uncertain of the main issues of the controversy. So as spring turned to summer, Epstein's enemies launched a more concerted and venomous campaign based on political and racial rather than exclusively aesthetic considerations.

In the political anarchy of the Twenties, when the aims of Socialism, Fascism and Bolshevism often were not clearly separated, nor distinguished from the *ism* of modernism, *Rima* emerged as an especially convenient target. To discredit the relief, together with its sculptor, was seen by some as one significant way of defending Latin civilisation against the onslaught of Teutonic barbarism.[1]

The Daily Mail paved the way a few days after the unveiling by attacking the work on the grounds that it was an archetypal representative of 'Socialist Taste in Art':

The majority of those who know the circumstances of the acceptance of [Epstein's design by the Office of Works] say the panel is an example of what we may expect if the Socialists ever get into power again and have control of our artistic destinies. 'Bolshevism in art' is an expression that has been freely applied by pilgrims to the memorial ... 'Germanic' was hurled at it a hundred times.[2]

The *Mail* then reminded its readers that the scheme had been approved in 1924, during the period of the first Labour government, under Ramsay MacDonald; a government, moreover, which lasted only eleven months before being discredited and toppled by the Zinoviev letter scandal. *Rima* was branded a 'work tinctured with the Bolshevist spirit'; it was 'Sheer Bolshevism'.[3] By July 1925 the question of removing 'this specimen of Bolshevist art' was the subject of a widely-reported debate in Parliament.[4] It was even suggested that the Memorial Committee (whose Chairman, Cunninghame Graham, was a well-known Labourite) 'could doubtless secure from the Russian Government a suitable site in Moscow, close to the mummy of the late lamented Lenin, for the erection of ... Mr. Epstein's nightmare in stone [in] a new

Temple to Rimmon, seventh in order of the hierarchy of hell, and there enshrine his hideous masterpiece'.[5]

An attempt to explain what this meant in artistic terms was offered in an unusually long and interesting letter published in *The Evening News* later in the year, in which it was suggested that the spirit which inspired the relief and which 'successfully emulates the entire natural and pardonable crudities of the primitive Peruvians' was 'akin to the destructive reaction which, in other spheres, has produced Bolshevism itself'. The writer, Harold Owen, saw Epstein's 'originality' as 'ab-original' and 'modernity ... very like ancient barbarism'. That is, modernism, primitivism and political anarchy of various and ill-defined hues belonged to the same destructive process. *Rima* was the very 'symbol of that aggressive lack of spirituality which is ... *a revolt against civilisation*'. As an 'expression in stone of the spirit of anarchy', its parallel was modern music, with its 'deliberate discords, its contempt of melody, its absence of tonality, its pure savage sound'. Owen argued that *Rima* attracted people with a 'sympathetic bias towards every movement coming within the scope of the "Left" wing of political action ... where their preferences lay in the policy to be pursued towards the Soviet state' (not to mention Internationalism, British Imperialism, the Irish Question and a 'general decay of authority') which had become 'so constant ... in modern life that it links the Red Flag, Jazz [that is, Negro] music [and] Rima ... as affinities strung together on a thread of common purpose ... *leading us backward* to barbaric conceptions of life ... the ultimate purpose [of which] is the overthrow of civilisation'.[6] But then, and characteristic of such cultural contortions at the time, the 'Fascist boot' was placed squarely on the Pro-Epsteiners![7] A correspondent to *The Times* even described Epstein as a German with Bolshevist tendencies,[8] which, of course, was untrue and which he publicly denied, proclaiming emphatically: 'I Am a Sculptor'.[9]

The lie, nevertheless, had been voiced and it was a short but perhaps an inevitable step to insinuate that Epstein's artistic anarchism and the un-Englishness of his art ('The general public know that Rima is hideous, unnatural, un-English, and essentially unhealthy')[10] were due to the fact that he was an emigrant Jew.

Anti-semitic attacks directed towards Epstein's work began appearing soon after the end of the Great War, perhaps provoked by what some observers regarded as his unpatriotic attempts to defer conscription and participation in the national crusade against the Hun.[11] The first public manifestations of this were criticisms of *Risen Christ*, 1917–19 [45]. The academic sculptor, Frederick Pomeroy, had seen the statue at Parlanti's bronze foundry and promptly condemned it as a 'scrofulous, unhealthy looking thing' characteristic of Epstein's 'natural inclination ... towards filth' and a 'gratuitous insult to Christianity'.[12] When this magisterial figure was shown at the Leicester Galleries in London in 1920, Father Bernard Vaughan, who had fuelled public resentment against the British Medical Association figures in 1908,[13] described it in *The Graphic* as a 'gross and grotesque thing [with an] unshapely head ... receding brow ... thick lips ... untipped nose ... uncanny eyes [and] poorly built body', having the archetypal appearance of a 'Bolshevik ... an Asiatic-American or Hun Jew'; he thought it 'positively wicked and insulting to perpetrate such a travesty and to invite a Christian people [to] admire it'.[14]

Similarly venomous language was employed in *The Hidden Hand or Jewish Peril*, an anonymously published journal which had begun life in 1920 under the title *Jewry über Alles*. The March 1924 issue attacked the delight in deformity and degradation endemic in the sculpture of Epstein, whom it likened to 'no one except Lenin'.[15] In April, an article entitled 'Bolshevist Art and Jewish Art Control' claimed to expose Jewish-owned commercial galleries in London, among them the Leicester Galleries and the Goupil Gallery, where the 'Jew sculptor, Epstein' exhibited, as breeding-ground for the 'decadent art movements of recent years'. The public were warned about being educated by Epstein to appreciate the 'charms of ugliness inherent in the

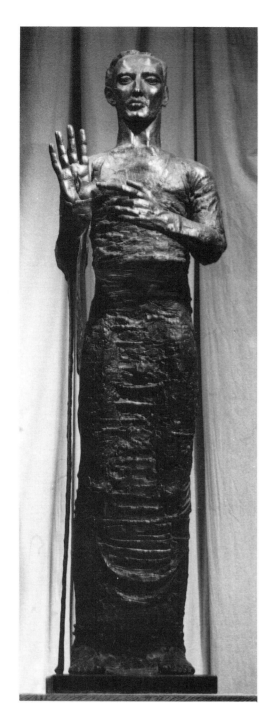

human form': his concept of Christ was 'all that Braunstein Trotsky could wish for in the way of blasphemy'.[16] Captain Adrian Jones's innocuous, late Romantic *Cavalry War Memorial*, 1924, in Hyde Park was hailed as the 'perfect antidote to the poisonous influence of works like the so-called "Christ" of the Jew, Epstein'.[17] *Risen Christ* was the target of a further article, published on 12 June 1925 (which suggested that the sculptor would have been imprisoned for blasphemy 'had our public men not all been under the same evil Jewish control which is exploiting Epstein himself'), though by that time a new scapegoat had been found in *Rima*.

How much longer are we going to tolerate this bestiality, this attack upon the Christian culture which we have inherited? ... The public must not allow itself to be silenced by the publicity given to 'expert' opinion, which has the impudence to say that it is incapable of appreciating true 'art' and 'Beauty'. This opinion is entirely Jewish and anti-Christian and is all part of the deliberate Jewish plot to destroy Christian culture.[18]

Nor were the portrayals of Epstein as a cultural ogre confined to such esoteric journals. Perhaps the most outrageously bigoted anti-semitic attack was perpetrated by the odious Joshua Brookes, who published the following letter in *The Saturday Review* on 28 November 1925 (and which was reprinted in *The Morning Post* the same day):

Sir,—

It is significant that nearly all the support for violence rather than beauty in art (*i.e.*, for Assyrian and Egyptian ideals rather than Greek) should come from Socialists, foreigners, and Jews. Jacob Epstein's name proclaims his nationality, and the two young women who protested at the theatre in favour of 'Rima' are both foreigners, while Bernard Shaw, who favours all extravagances in art, religion, and politics, is a Celt. But we English want our memorials in London to be in harmony with English taste, and English tradition. Those that favour Futurism, Cubism, or other decadent exaltations of the ugly and bizarre will usually be found to be Bolshevistic in their politics and to have some foreign, Jewish, or Celtic strain in their blood. Let them erect their atrocities in Dublin, Moscow, or Jerusalem, but not in London, nor in honour of an English writer, who loved gentleness and beauty.

45. RISEN CHRIST, 1917–19
BRONZE, H 218.5
THE SCOTTISH NATIONAL GALLERY OF
MODERN ART, EDINBURGH

XI
'THE HYDE PARK ATROCITY. TAKE IT AWAY!'

The early press attacks and on-the-spot harangues were intended to draw attention to the demand by some Hudson partisans for nothing less than *Rima*'s removal. *The Daily Mail* headline of 25 May 1925 blazed: 'THE HYDE PARK ATROCITY. TAKE IT AWAY!', and as early as the 22nd of that month Margaret Brooke, The Ranee of Sarawak, had privately protested to the Committee Secretary about the 'ignoble monument' and proposed that the Royal Society for the Protection of Birds 'get the Foul thing removed'.[1] Parliament alone had the power to enforce such an action. When MPs began debating the issue on 24 May, the young Tory MP for Warwick and Leamington, Anthony Eden, a Baldwin admirer and something of an art buff, attempted to quash the motion by prudently recommending in the case of all such

It really is time some limit was put on the Epstein memorial stunt. The unrestrained pursuit of this silly season topic is producing some terrifying suggestions ... Surely the nadir of ridiculousness would be reached by this setting up of Parliament as the sumpreme art authority of the nation.

THE LEEDS MERCURY, 28 MAY 1925

The greatest success has attended the campaign of the Morning Post *in its efforts to have ... Rima removed ... The public outcry against this so-called 'work of art' has died down; but the* Morning Post's *efforts have again revived it.*

'THE RIMA STATUE', THE MORNING POST, 21 NOVEMBER 1925

[Rima is] thoroughly in keeping with the univer fashion in modern European sculpture. One has only to visit the International Exhibition of Decorative Arts in Paris to see that. The sculptors of every country in Europe are proceeding on exactly the same lines.

Art cannot be bottled up in Sir Frank Dicksee's vintage.

'THE HUDSON MEMORIAL', MUIRHEAD BONE, THE OBSERVER, 22 NOVEMBER 1925

Sitting on the edge of a chair, his hair standing on end, and chomping a sandwich and saying to his sister, Fanny: 'Absolutely disgraceful — I must write to Gosse about it'. [Gosse's reply came on a postcard:] 'Dear Hamo, We must let these heathen rage.'

JOHN HAMILTON, THE ARCHITECT, RECALLING HAMO THORNYCROFT RETURNING AFTER FIRST SEEING RIMA, IN E. MANNING, MARBLE AND BRONZE: THE ART AND LIFE OF HAMO THORNYCROFT, 1982, p. 181

public sculpture an interim period of at least six months from the unveiling during which the public would be allowed to grow to 'appreciate the merits of a work of art', or otherwise.[2] In fact, Parliament found no evidence of a 'general desire for [Rima's] removal'.[3] Nevertheless, this did not prevent the press publishing various proposals, including covering the relief with ivy, or a rustic ornament, or a slab of reinforced-concrete: 'Think of the joyous debate some thousands of years hence, when the memorial would be rediscovered'![4] Others suggested storing the 'stumbling block [to] await the judgment of the future', either in the Tate Gallery or the Victoria and Albert Museum where, meanwhile, students could study it as an example of 'what to avoid in impressionable sculptural art'.[5] The vacant site in Hyde Park might then be re-embellished with a simple dovecote, or an altar, or a bird bath.[6] *Punch*, recognising the absurdity of the situation, recommended substituting *Rima* with its own mascot! [38].

The debate simmered through the summer and autumn of 1925 but the press refused to allow it to rest. Following John Collier's denunciation of the '"Bestial" Art of Epstein' on 6 October, *The Morning Post* launched a second and more sinister initiative under the banner 'New Demand for Rima's Removal Important Protest'. This took the form of a letter calling for the immediate expulsion of the 'inappropriate and even repellent' relief, signed by fifteen eminent members of the Establishment.[7] One of them, Sir Frank Dicksee, the seventy-two year old President of the Royal Academy, believed there was a 'Danger That the World Will Be Made Hideous' by *Rima*'s continuing public exposure.[8] The following day Epstein replied with 'A Counter-Blast for Rima', by hinting at a forthcoming letter which contained a panegyric of the much-disputed panel, a eulogy on the sculptor's achievement and 'Support From Nearly All the Greatest Artists'.[9] He also challenged Dicksee by charging him with a 'Breach of Artistic Manners' and insisted that the RA either discipline their President or request his resignation.[10] *The Manchester Guardian* questioned the validity of such a new and revolutionary concept as the removal of a public memorial which had received full official sanction, and exhorted the authorities to allow the 'Modernists at this time of the day ... at least one panel and one stone gun [Jagger's *Royal Artillery Memorial*, unveiled at Hyde Park Corner in October 1925] out of all our hosts of memorials. In Paris, Berlin, Stockholm, and Vienna they are almost the accepted art of our time. You cannot stop the clock of art ... No, we are not going back to Dicksee'![11]

When the Pro-Epsteiner letter, written by Muirhead Bone, finally appeared in *The Times* on 23 November, it was indeed a formidable defence against an 'unprecedented ... action' which, if carried out, would 'inevitably open an era of hasty decision and reprisal [which] all committees ... and all sculptors would find intolerable'. Among the 119 signatories were several fellow sculptors: Frank Dobson, Eric Kennington, Sir Bertram MacKennal and Leon Underwood; many architects and painters: C. R. Ashbee, Walter Bayes, Sir David Cameron, George Clausen, Francis Dodd (Bone's brother-in-law), H. S. Goodhart-Rendel, Selwyn Image, Augustus John, Gerald Kelly, Ralph Knott, Sir John Lavery, Ambrose McEvoy, C. R. W. Nevinson, William Nicholson, Sir William Orpen, Glyn Philpot, Henry Pool, Professor C. H. Reilly, Halsey Ricardo, A. E. Richardson, Frederick Cayley Robinson, William Rothenstein, C. F. A. Voysey and Edward Wadsworth, as well as Arnold Bennett, Laurence Binyon, Charles B. Cochran, Sir Sidney Colvin, Sir Martin Conway, Samuel Courtauld, Cunninghame Graham, George Eumorfopoulos, Edward Garnett, Ambrose Heal, C. Lewis Hind, P. G. Konody, Ramsay MacDonald, Eric Maclagan, Edward Marsh, Sir Alfred Mond, Frank Pick, Morley Roberts, Sir Michael Sadler, Bernard Shaw, Sybil Thorndike, Hugh Walpole, Hubert Wellington (author of a monograph on the sculptor, published in 1925) and Sir Robert Witt.[12] Guy Dawber, Edmund Gosse, Giles Gilbert Scott and Henry Tonks wrote independently, beseeching that Epstein should be 'spared vulgar abuse' and the relief allowed to 'stand the criticism of time'.[13] *The Times* also received letters protesting against the proposed removal from

255 students attending the Royal College of Art and the Slade School.[14] Rima's champions therefore, were broadly-based, by no means exclusively radical modernists (though interestingly Eric Gill was not among them) and with a majority among well-established traditionalists, including a number of RAs and three National Gallery Trustees. Of these, the critic, Edmund Gosse, had been the chief literary advocate of the so-called New Sculpture produced towards the end of the Victorian era by the English followers of Rodin and still much in demand in the Twenties. At first opposed to Rima, Gosse had apparently changed boats in mid-stream, for Dicksee told Hamo Thornycroft on 29 November 1925: 'I see that Gosse, who wrote to me to beg that something should be done to stop "this shameful man" [Epstein], has gone over to the other side'.[15]

The Demolition Committee, having been defeated 119 to 15, now tried another ploy. The Daily Mail publicised the fact that the Memorial Committee had been satisfied with Epstein's final design (which had also received approval from the Office of Works), despite the fact that two distinguished members of the Works' Committee of Taste: the sculptor, George Frampton, and the architect, Reginal Blomfield, had objected to the sculptor's earlier scheme.[16] This prompted Basil Peto, MP, to condemn the entire proceedings as irregular on the grounds that the subscribers to the appeals for funds had never been consulted about any of the designs and, moreover, that Epstein had virtually been given carte blanche.[17] However, Bone's letters of 23–24 November to The Times convinced the Government that Rima should not be jettisoned.[18] 'One up ... to the Rima-ites'![19]

The battlecry for removal ought to have stopped here, but The Morning Post persisted in publishing protest letters, the majority of which now regressed to 'vague generalisations ... cheap puns and loud abuse'.[20] Then suddenly and unaccountably the Government reacted by backpedalling and referred Rima to the newly-established Royal Fine Art Commission, successor to the Office of Works' Site Committee. Ironically, both Blomfield and Frampton were members.[21] Bone, one of the RFAC's 'most unvenomed opponents', phoned the Chairman on 26 November to give notice that should it raise objections to Rima, the Hudson Memorial Committee would immediately apply to the Office of Works pressing for the removal of Frampton's Edith Cavell Memorial in St Martin's Place, and it was only when Bone was assured that the Commission also favoured Rima's retention that he calmed down.[22] He then composed a dense, eleven-page memorandum to Viscount Peel, the new First Commissioner of Works, setting out a detailed history of the commission since November 1922 and concluding that 'the claim of the younger unacademic artist to represent contemporary artistic thought ... is not altogether an unreasonable one'.[23]

At this point the Royal Academy capitulated. Dicksee wrote to Thornycroft:

I quite agree with you about the Hudson Memorial. I shall do no more. But as much harm has been done by Lavery's letter to Epstein congratulating him on "The beauty & dignity" of his work & stating that he had put down his name for election at the R.A. ... I suppose in consequence of this, most people believe that the R.A. is in favour of his Panel ... But I think this protest will somewhat hinder the activities of that clique whose ways we know so well.[24]

On 30 November 1925, the Speaker of the House of Commons announced: 'I think this lady has taken up enough time'.[25] There was, however, to be one final humiliation.

XII
'THE INEVITABLE HAS HAPPENED'

Less than a week after the unveiling the public was already being encouraged to 'come round on a dark night and smash [Rima] to bits with a sledge-hammer', though it took six months and the intensity of the controversy for the inevitable to happen.[1]

At 11.15 pm, on 12 November, a party of law students returning from their annual Grand Dinner at Gray's Inn smeared the relief with green paint and the innocuous invective 'Oh! Epstein!' [46].[2] Low celebrates this in his cartoon showing PC Fitch

Is the public at last about to rise up in revolt against certain of the statues that blot our streets, like solidified nightmares? . . . It is a silly way of protesting. Better to avert the eyes from the ugly monument and pass on. Best to allow no more ugly monuments.

W.M., 'POOR RIMA', THE DAILY MIRROR,
14 NOVEMBER 1925

apprehending one of the vandals while Dolores (of Aldwych Theatre fame) throws eggs at an anarchic rabble fighting in front of the innocent sculpture [3]. Drawn by news of the outrage, the *Memorial* was besieged by a continuous stream of visitors.[3] A temporary canvas screen was erected and within a week the relief was cleaned, at a cost of £8 1s 10½d, using Stripso and Kleno paint-remover.[4] This 'disgraceful deface-ment' reminded a correspondent to *The Morning Post* of Michelangelo's *David*, which had to be protected against 'the vandalism of the Hyde Park hooligans of the time'.[5] When Epstein was notified of the incident he merely smiled, shrugged his shoulders and told *The Evening News*: 'I have nothing to say'.[6] But worse was to come.

On 8 October 1929, *Rima* was tarred and feathered.[7] *The Star* was reminded of a similar offence the previous year perpetrated against Frampton's *Peter Pan*: it was thought at the time that this was a retaliatory action by Epstein admirers for the indignities of 1925.[8] In January 1930 *Rima* was daubed with red, green and black paint.[9] The most savage onslaught occurred on 7 October 1935 when a group, later identified as the Independent Fascist League, spattered the relief with an abrasive alkaline, Permanganate of Potash, and attached a card emblazoned with a Swastika and the inscription 'God Save Our King and Britain from the Cancer of Judah'.[10]

Though physical violence against public sculpture was a common occurrence on the Continent during the Hitler years, it was virtually unknown in Britain, so much so that following the first *Rima* attack in November 1925, a correspondent to *The Nation* observed that the 'methods of intolerance, persecution and violence which, since the war, have been so marked a feature of politics, particularly in Moscow and Rome, have also invaded art'.[11] Now, in an atmosphere of international political degeneration and feverishly intensifying anti-semitism, the IFL's act must have given credence to the alien character which more than a few Britons believed they recognised in *Rima*.

46. ANONYMOUS, SKETCH OF THE
HUDSON MEMORIAL SHOWING EFFECTS OF
VANDALISM, 12 NOVEMBER 1925, PENCIL
PRO: WORK 20/175

XIII
'BANALITIES AND EYESORES'

We have seen that as late as 1925, and indeed even much later, the approved fashion in public sculpture in Britain was still firmly rooted in late Victorian ideals of classicism and naturalism introduced by the generation of academic sculptors who had come to prominence in the 1880s and 1890s and who still prevailed. Its leaders, Thomas Brock, George Frampton, Frederick Pomeroy, Hamo Thornycroft and Derwent Wood, had all been born between 1847 and 1871 and died only in the 1920s. Alfred Gilbert (whose great Symbolist *Memorial to Queen Alexandra* at St James's dates to 1932) died at the age of 78 in 1934, Alfred Drury (who had worked with Dalou in Paris in the early 1880s) died in 1944, age 88, Albert Toft in 1949, age 87, Goscombe John in 1952, age 92. John had remarked in 1937 that 'so much has happened since

[Thornycroft's generation] and we seem to live in another world; certainly in another world of sculpture (vide Epstein's latest outrage)'.[1] Most of these artists were RAs, several had received knighthoods and held senior posts in the sculpture departments of the Royal Academy Schools, the Royal College of Art and the Slade School. They had captured nearly all the important public commissions (Epstein's success in securing the British Medical Association, the *Hudson Memorial* and, in 1928, the London Underground Electric Railways Headquarters commissions, were rare exceptions). They fought vehemently against most aspects of modernism, or, as one sympathiser put it, the 'foolish affection of archaic angularity [and] wilful perversion of nature'.[2]

By 1925 there was still little significant public sculpture in the modernist style, and that did not enjoy wide approval. Eric Kennington's *24th Division War Memorial*, 1924, at Battersea Park was associated with the 'futurist art' admired by a 'limited group of people',[3] while Eric Gills's *Leeds War Memorial* (the stone relief of *Christ Driving the Money Changers from the Temple*, a biblical episode blatantly portrayed in Twenties dress) caused an uproar when it was unveiled in 1923.[4] Epstein's public reputation had suffered since the days of the BMA figures, and any perceptive observer who followed the subsequent course of his career and also took notice of the early publicity surrounding the *Hudson Memorial* — in March 1924 the projected relief had been described in the press as depicting a woman belonging 'half to nature and half to the human world'[5] — should have been forewarned what to expect. Yet, the sculpture unveiled in 1925 was, nevertheless, unexpectedly disturbing, and Epstein's enemies cleverly exhumed the BMA fiasco to strengthen their case against *Rima*:

THE BIRD SANCTUARY

When round the bird's sequestered
 shrine
 Hot controversies fume and sizzle,
And writers in the Press consign
 To Hades EPSTEIN and his chisel;

They miss the point; all this to-do
 Is merely waste of good invective,
And EPSTEIN's work, though strange
 and new,
Is for its purpose most effective.

When they revive the former feuds
 About the Agar Street abortions,
Which some acclaimed as perfect nudes
 And some as decadent distortions;-

Its motive, in so many words,
 Is less to add to Art Undying
Than to preserve the spot for birds
 And scare us human Pauls from
 prying.[6]

When Lord Edward Gleichen came to write his authoritative *London's Open-Air Statuary*, published in 1928, *Rima* was described as a 'masterpiece by the much-advertised apostle of Ugliness' and condemned for expressing 'the ruthlessness of Nature', whose soul was portrayed as the 'libido of the psycho-analyst'.[7]

But if many critics in the Twenties were contemptuous of modernism, some also remained uncertain about the virtues of more traditionalist sculpture made in the modern age. Looking about they came to the conclusion that they and the public had been lulled into a state of indifference by the sculpture erected in the parks and streets of London in past years, particularly memorials to the famous, many of which had sunk to 'nothing but banalities and eyesores'.[8] So this decade, which focused its attention on *Rima* above all, marked a crucial moment in the history of British sculpture, in which the academic and the innovative, the old and the new, lived as uncomfortable bed-fellows.

Towards the close of the *Rima* controversy, *The Daily Mail* suggested that the pedants should cease their opposition since the artists of the Epstein School had kept silent about the 'hideous' academic statues which encumbered London.[9] In fact, this was not strictly true. Epstein spoke with some audacity on the subject in *The Times* in September 1925. He thought there was 'hardly any good statues in London', though

In the squares and thoroughfares of the Metropolis there are works of sculpture which ... If they fail to arouse admiration, they do not excite disgust. If they are dull, they are invariably decorus.

'TAKE IT AWAY', THE MORNING POST, 18 NOVEMBER 1925

who has thought of protecting us against the atrocities that dominate Waterloo Place, the Mall, or the Embankment gardens? That would be a work of civic humanity.

KAPPA, IN THE NATION, 28 NOVEMBER 1925

[The] EPSTEIN memorial already shares with the ALBERT Memorial its pride of place as an evergreen source of Metropolitan humour ... The large birds of prey ... are carrying the amorphous Rima to some celestial Madam TUSSAUD'S

'THE CHALLENGE', THE MORNING POST, 16 JUNE 1925

After the purposeless monuments and war memorials to which we are accustomed we should be delighted that such a work has been approved by a public body. It is a precedent to be encouraged, since it may lead to the employment of sculptors whose work is recognised abroad but is never seen in our streets and public places, to the very great loss of our country.

ANA M. BERRY, HON. ORGANISING SECRETARY, ARTS LEAGUE OF SERVICE, IN THE TIMES, 28 MAY 1925

he admired Thornycroft's *General Gordon*, 1888, as a 'good, sober piece of work', while censuring the other sculptures in Trafalgar Square ('an unholy mess ... about the worst square in the world'). He particularly disliked *Nelson's Column*, recommending the removal of E. H. Baily's Early Victorian figure on top (a view which got him into trouble with the anti-semitic rag, *The Hidden Hand*).[10] Nor did he like the 'fearful concoction' of Brock's *Victoria Memorial*, 1901–24, in front of Buckingham Palace.[11] Muirhead Bone's list of sculptural misdemeanours, published in a letter to the Editor of *The Times* under the title 'Taste in Public Monuments', included not only some of the above but Bertram McKennal's *Edward VII*, 1924, at Waterloo Place and the war memorials honouring *Edith Cavell*, 1920, St Martin's Place (by Frampton), the *London Troops*, 1920, Royal Exchange (Drury), the *Royal Fusiliers*, 1922, Holborn (Toft) and the *Cavalry*, 1924, Hyde Park (Adrian Jones). Far from complete, this list was 'a melancholy one, for failure, imaginative and artistic ... lies over all of them', though Bone believed the fault lay as much with committees as with sculptors. And he asked

What is the reason of the curious discrepancy between the powerful world position of England and the bold schemes of her sons and the timid and innocuous character of her taste in public monuments? Is it that our passion for private individual judgment prevents us from giving power of attorney to any artist to represent our ideas in art?[12]

The Pro-Epsteiners were determined to resist those powerful factions which had made London so hideous with their ridiculous statues, and though there could have been no solace in the suggested association between *Rima* and the *Albert Memorial*, they believed Epstein's relief had succeeded where these other, more celebrated and admired works had not. The controversy was seen by *The Builder* as a

sure sign that the public is beginning to interest itself in artistic values. Twenty years ago anything might have been erected in Hyde Park, however fine or however monstrous, without anyone outside the world of art taking the slightest interest in it or expressing any opinion one way or the other. Now we can read in our morning papers a daily cascade of pro-Epstein and anti-Epstein sentiments, and this in itself is a wonderful portent because it looks like the beginning of public criticism.[13]

The American art critic, Christian Brinton, went even further: he reckoned it 'a sign of grace that the Derby and the Hudson Memorial ... should be "running a dead heat" in the race of public interest. A number of years ago ... no artistic controversy could hope to share the limelight with a sporting event'.[14]

XIV 'THE PROVOCATIVENESS OF GREAT ART'

The Builder's optimism at the outset of the controversy proved ill-founded. Public criticism, in fact, did little either to promote a general appreciation of Epstein's aims, or to confirm *Rima*'s special importance in the development of modernist sculpture, as Charles Holden was later to recognise. Though one observer at the time reported excitedly that the new relief 'shakes us out of our inattention',[1] it was unfortunately also a conspicuous and persuasive reminder to prospective clients that Epstein's art was highly contentious. In 1928 he had been proposed as the sculptor for a moorland memorial to Thomas Hardy, which would have incorporated a portrait medallion of the writer and a statue of one of his popular heroines, Tess of the D'Urbervilles. The scene appeared set for a re-run of *Rima*, but nothing happened because, as Augustus John related, 'the name of Epstein seemed to excite general uneasiness, if not alarm'.[2] It is significant that in the twenty-four years following the *Hudson Memorial* he received only one other public commission, the equally controversial *Day* and *Night* groups of 1928–29 on the London Underground Electrical Railways Headquarters, St James's.[3] Not unexpectedly, on that occasion *Rima* was used to bludgeon Epstein's

47. DAVID LOW, 'EPSTEIN SENSATION',
IN 'LOW'S TOPICAL BUDGET'
FROM THE EVENING STANDARD, 25 MAY 1935

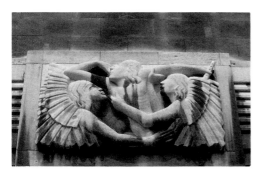

48. ERIC GILL
RELIEF PANEL, BROADCASTING HOUSE,
LANGHAM PLACE, LONDON, 1929–31
PORTLAND STONE

reputation still further: they were 'another example of what a French writer calls the "immense blaque de l'art libéré," which gave us the monstrous Rima in one of its recurrent epileptic fits'.[4] *The Daily Telegraph*, using the now-familiar vocabulary of abuse, observed:

The moment Epstein ceases to be psychological he ceases to be interesting. The unforgettable 'Rima' . . . has some psychological interest. It represents quite recognisably a human emotion . . . Night has no psychological significance whatever. It is a great coarse object in a debased Indo-Chinese style, representing a creature, half Buddha, half mummy, bearing upon her knee a corpse-like child of enormous size.[5]

And when, in 1935, it was rumoured that the British Medical Association figures were in danger of being removed, David Low placed *Rima* in the centre of a group of Epstein's most controversial carvings protesting the desecration [47].[6]

Moreover, not only was *Rima* proscribed but, despite intense public and critical attention, including a good deal of photographic exposure,[7] it was hardly recognised as a potential source of inspiration, and it seems to have made only a modest impact on the work of other British sculptors. Notable among these is the *West Wind* relief, 1928–29, by Frank Rabinovitch on the London Underground Electric Railways Headquarters, a commission received through Epstein, and the pair of reliefs by Eric Gill, 1929–31, on Broadcasting House, Langham Place [48].[8]

Rima's importance lay in other spheres. Because it incited such a prompt and vitriolic response which went beyond mere ridicule or even personal distaste for the artist and his work, it became a ready vehicle with which critics could channel political, religious and aesthetic, as well as pseudo-aesthetic, bigotry in their relentless campaign to discredit all provocative art of the *avant garde*.[9] More than any other work of the interwar years, *Rima* dictated public perceptions about the *avant garde* and the means by which the heavy hand of censorship, both verbal and physical, might be brought to bear upon it. An intransigent belief that future generations should not be allowed to imagine that this 'piece of artistic anarchy in any way reflected the true spirit of the age'[10] (which it nevertheless does in many ways, of course), urged anti-modernists to propose a system of censorship, what *The Daily Graphic* described as a charter of artistic rights on behalf of the public. Its workings were highly dubious. Since it was believed impossible to 'empanel a jury of average men to pass judgment on designs' or hold elections to 'decide which design should be accepted', it recommended providing a temporary licence to every public monument until 'popular judgment has decided in its favour'. Should this committee of moderators, comprising artists, critics and men possessing 'good amateur taste', ultimately decide against the particular monument, the licence would expire and the work would be removed.[11] *The Spectator* correctly recognised that this method 'never encourages a great thing in art because it is too terribly afraid of sanctioning a mistake'.[12]

By recollection of the events of 1925 or merely by association with the name of Epstein, the work of other radical sculptors could be condemned with impunity. For example, in 1928 *The Evening Standard* speculated that those who 'abhor Mr. Epstein's "Roma" [*sic*]' would also find little to admire in the sculpture of Henry Moore,[13] while the 'monstrous hands' of another Moore carving, exhibited at the Leicester Galleries in 1931 (for which Epstein wrote the memorable but provocative foreword to the catalogue), was regarded as a type 'Epstein favours' in *Rima* and *Genesis*, 1929–30.[14] *The Daily Mirror* thought Moore's *Reclining Figure* in Brown Hornton stone, 1929, 'surpasses in repulsiveness even that of Epstein', and *The Star*, in 1937, his *Mother and Child* (recently purchased by the Surrealist artist, Roland Penrose) as an example of an 'Epstein the Morning After the Night Before'.[15]

Serious critics struggled to evaluate *Rima*. Kineton Parkes, in *The Art of Carved Sculpture* 1931, found the relief anachronistic, believing that it would have been more acceptable cast in bronze, since Epstein was an 'undoubted master of modelling, but

the requirements of an instinctive carver are other than those exercised by the creator of the Hudson Memorial'.[16] In 1928, Stanley Casson, too, came to the conclusion that Epstein's ambitions were those of a modeller and that the 'simple, unpictorial, and impressive' achievement of the early BMA figures, which have 'all the qualities of sculpture', had vanished in *Rima*, which seems the work of an 'inexperienced youth. So great is the loss of style and technique to a sculptor who abandons stone'. Casson attempted to place the relief in the wider context of Epstein's art. Recalling that he belonged to 'an age when tolerance has thought it better to overwhelm an artist in garbage than drive him to the workhouse', he pressed his readers to 'forget for a moment that we are squids or musk-rats defending our heritage and our lives against insidious attack [and] pause to think what exactly the artist was trying to do'.[17] Yet, two years later, Casson wrote of the unfortunate choice of Epstein for the commission: 'It was as if one were to ask an engine-driver to adjust the hair-spring of a watch. Even if the Hudson memorial ... is, in itself, a very fine piece of decoration, yet it seems out of relation to Hudson.'[18] R. H. Wilenski alone among leading writers of the time concerned with sculpture championed *Rima* as a masterpiece of direct carving. He thought Epstein 'keenly conscious of the differences between the attitudes appropriate to the one process [carving] and the other [modelling]', and he believed his contribution to modern sculpture lay 'entirely in his carvings'. For Wilenski the magnificent bronze portraits represented 'the climax of the Romantic sculpture of the nineteenth century'.[19]

But for many *Rima* remained an irritating curiosity outside the English tradition. Most critics, as well as the public, did not believe that it possessed exceptional sculptural merit. Nor could they be persuaded to share the convictions of *The Manchester Guardian*, that 'the immemorial fate of gifted revolutionaries [was] to become, in a later generation, some of the most valued saints of the conservative calendar',[20] or of F. W. Jowett, that the relief would one day be recognised as a great work of art,[21] or of L. B. Powell, that it had already, by 1932,

joined company with the many works of art that were received with a chorus of popular condemnation, but have remained as enduring things that may be regarded as among the highest manifestations of imaginative genius.[22]

What of Epstein? There can be little doubt that the bitterness of the controversy haunted him. In his autobiography, *Let There Be Sculpture*, 1940, a substantial part of the discussion about the *Hudson Memorial* was based on contemporary press memorabilia, mostly of a derogatory nature, which is quoted almost to excess.[23] Yet, he remained unrepentant,[24] and Powell relates how from time to time he would visit *Rima* and wonder what all the fuss was about.[25]

We shall be surprised if this work is not in future reckoned among the finest examples in British art of direct carving in stone [and] become known, as it is sure to be, all over the world.

'MR. EPSTEIN AND HYDE PARK',
THE SPECTATOR, 30 MAY 1925

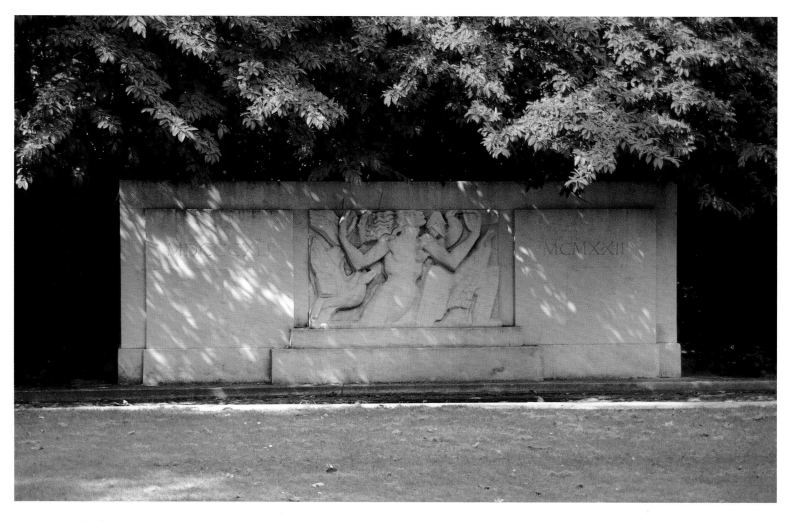

49. RIMA, IN 1983

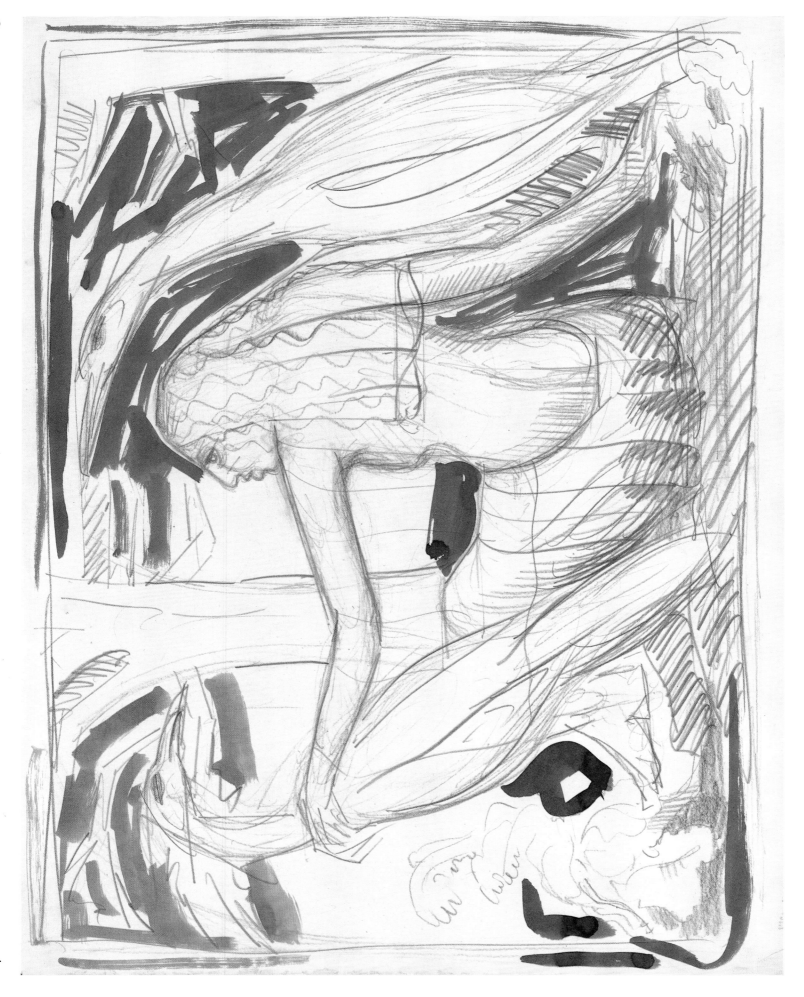

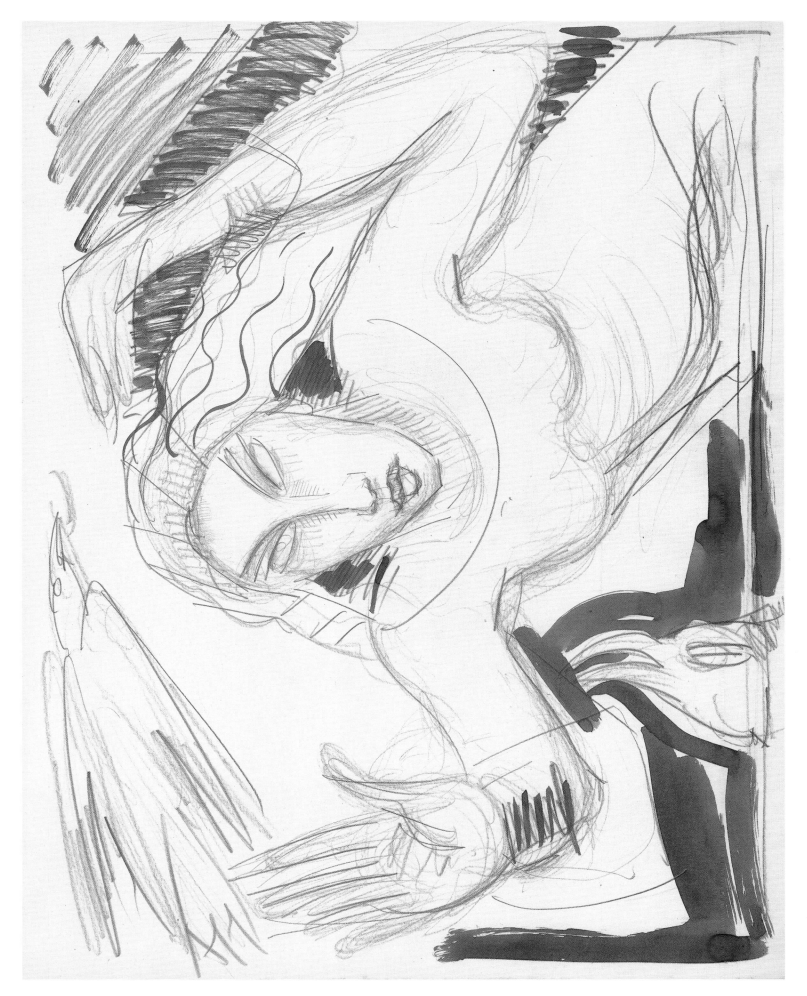

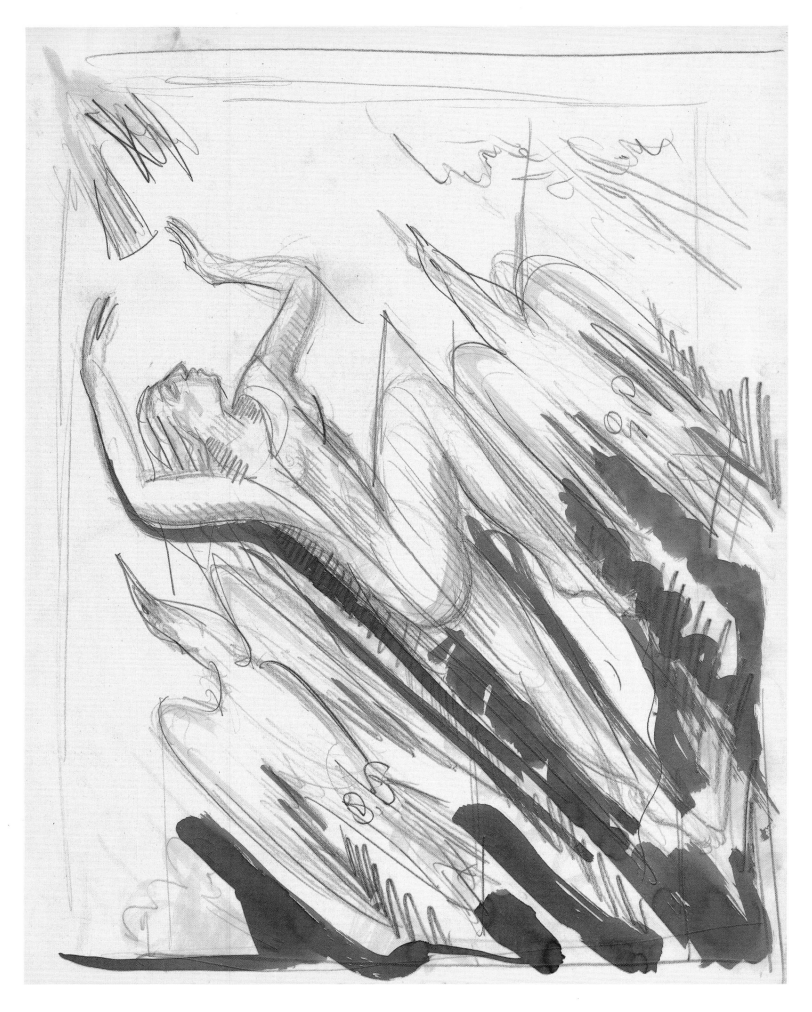

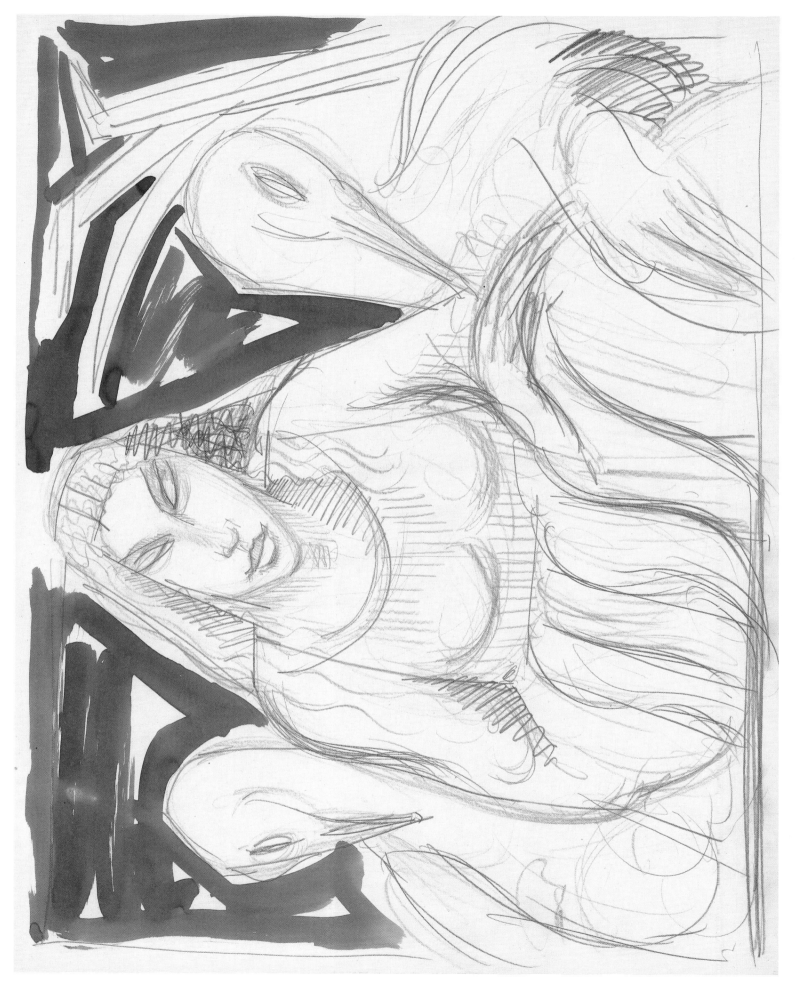

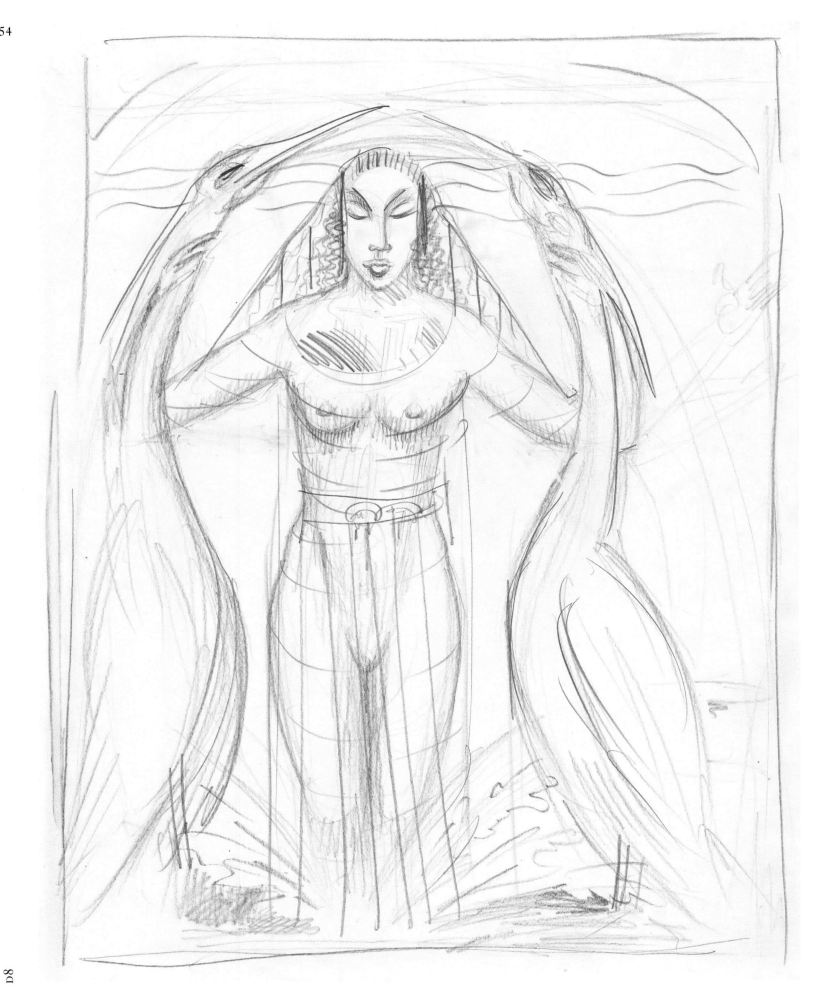

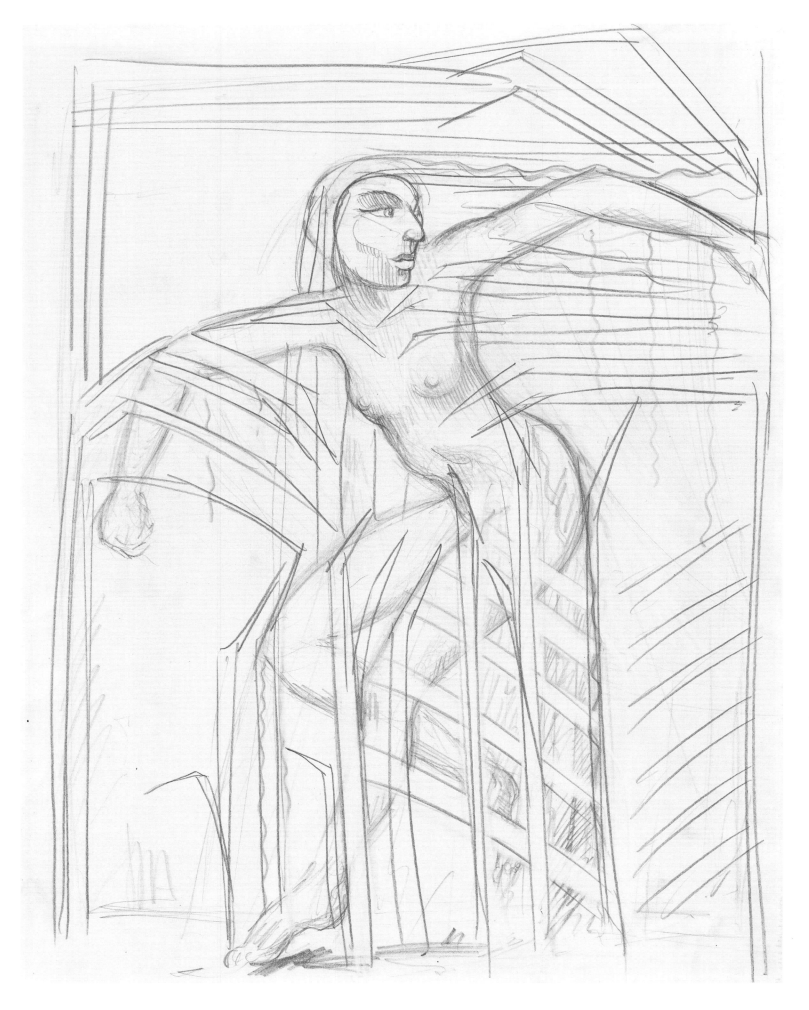

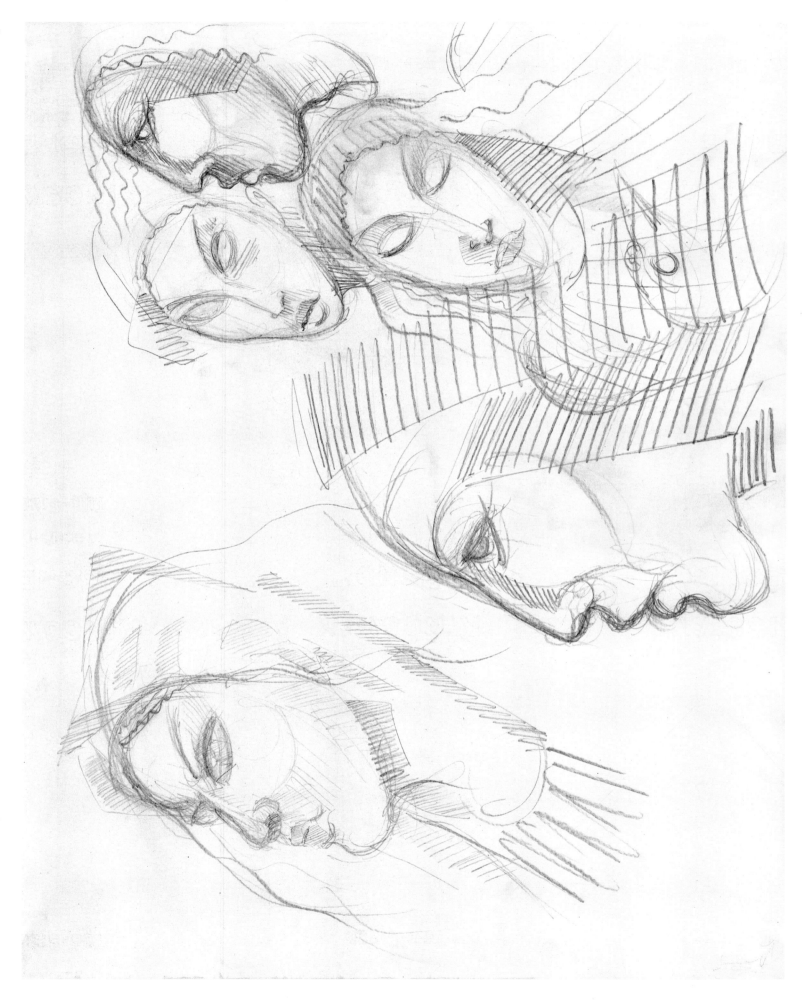

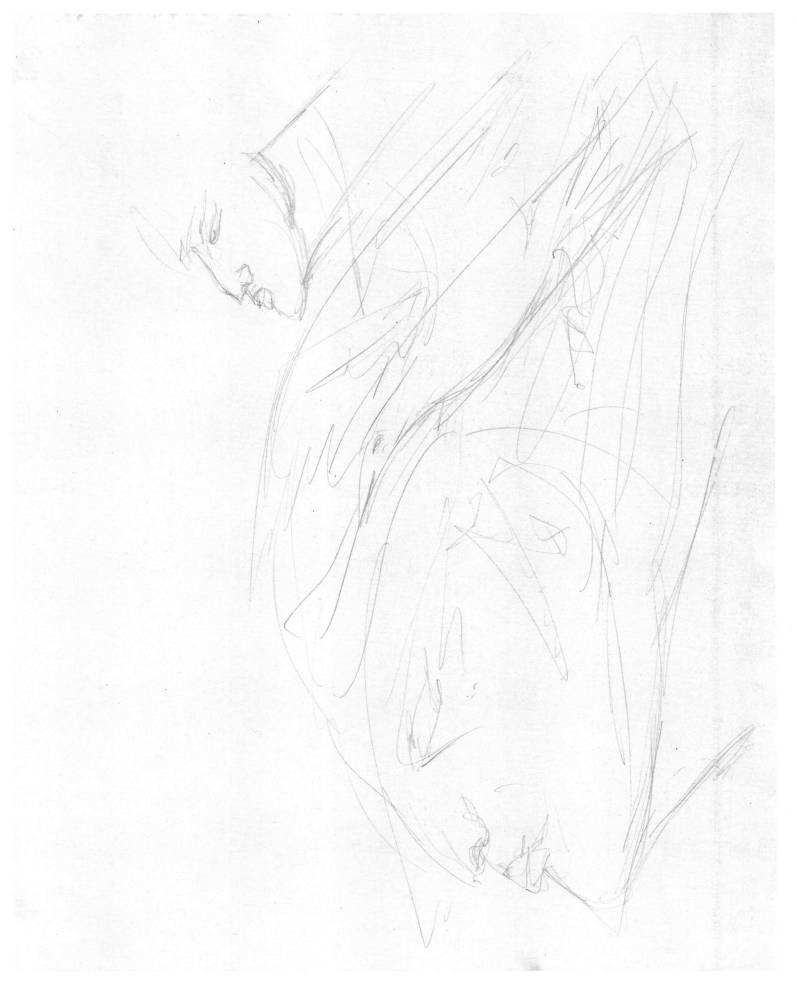

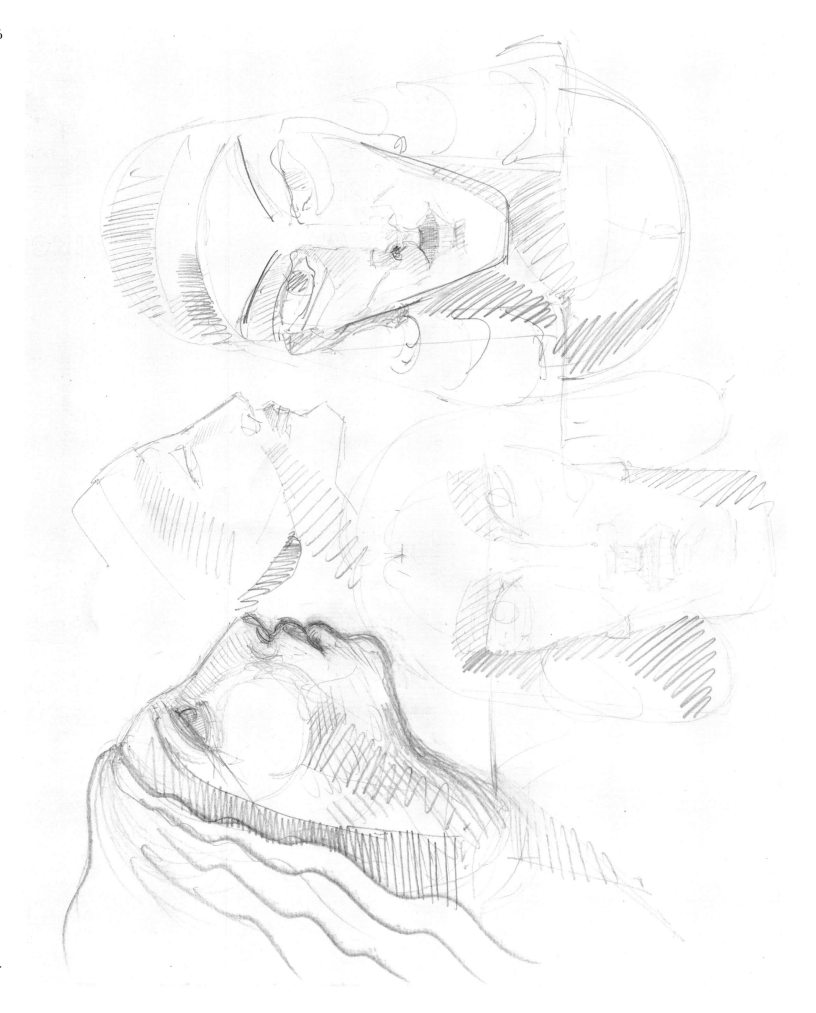

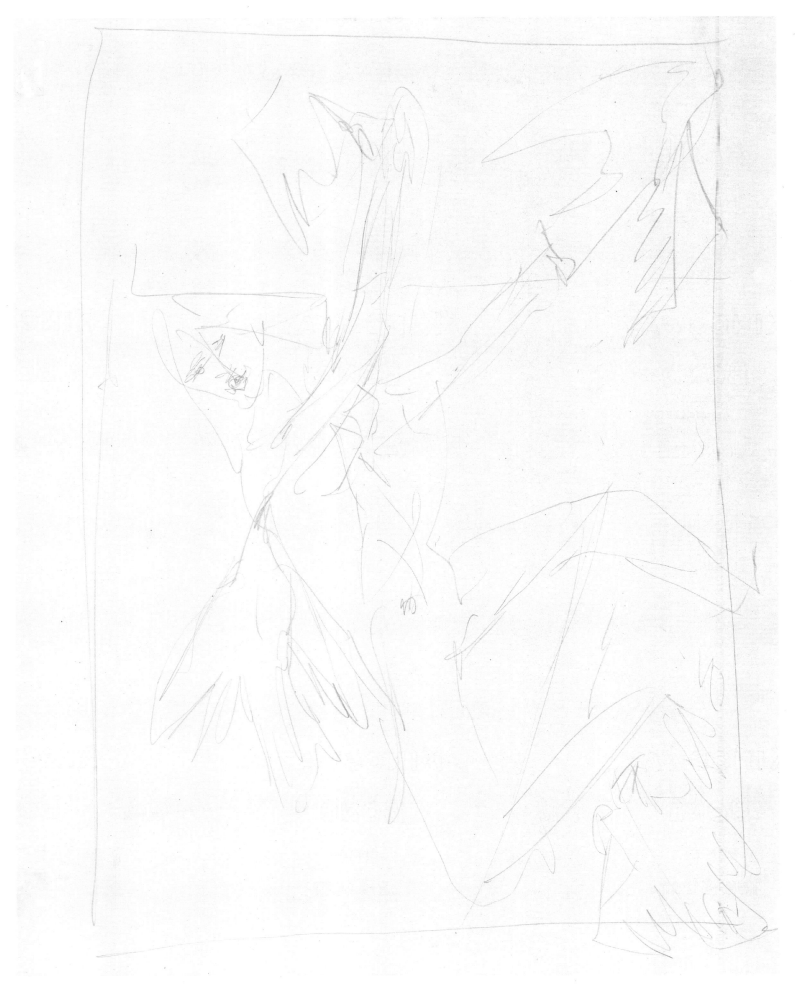

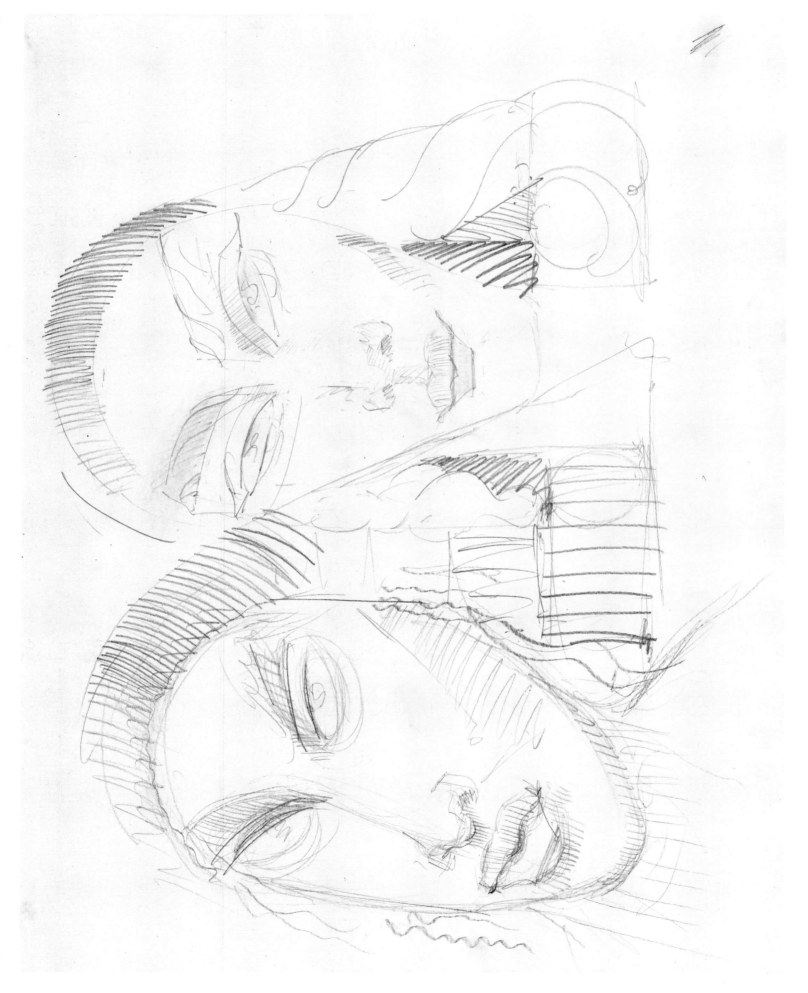

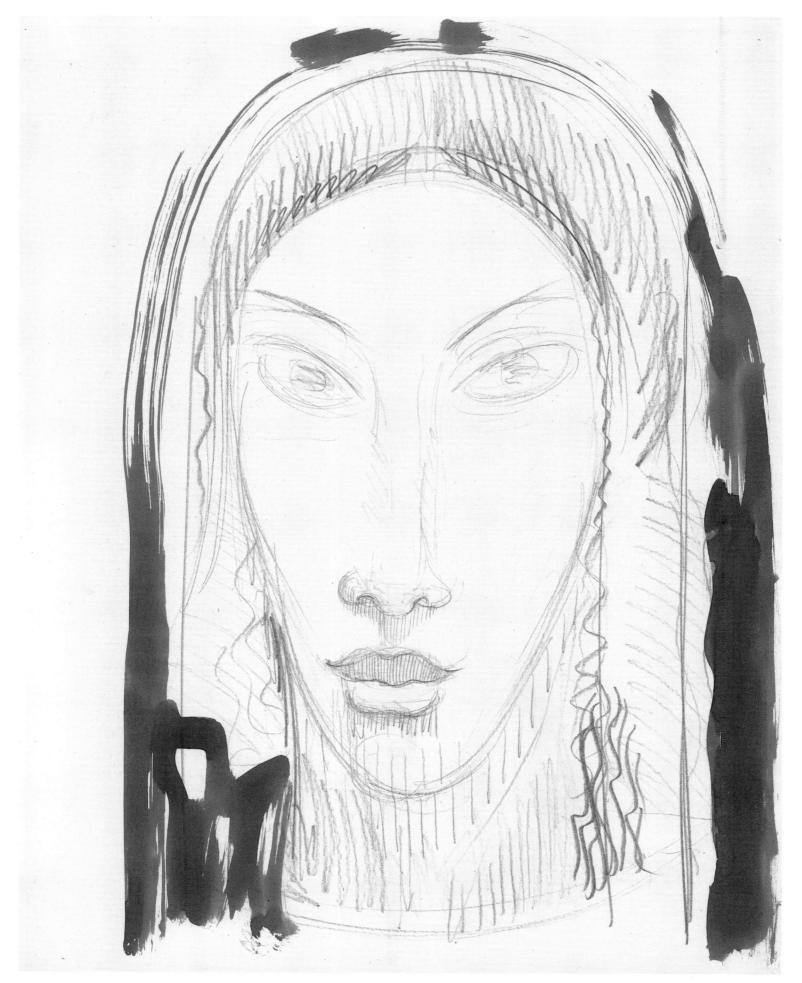

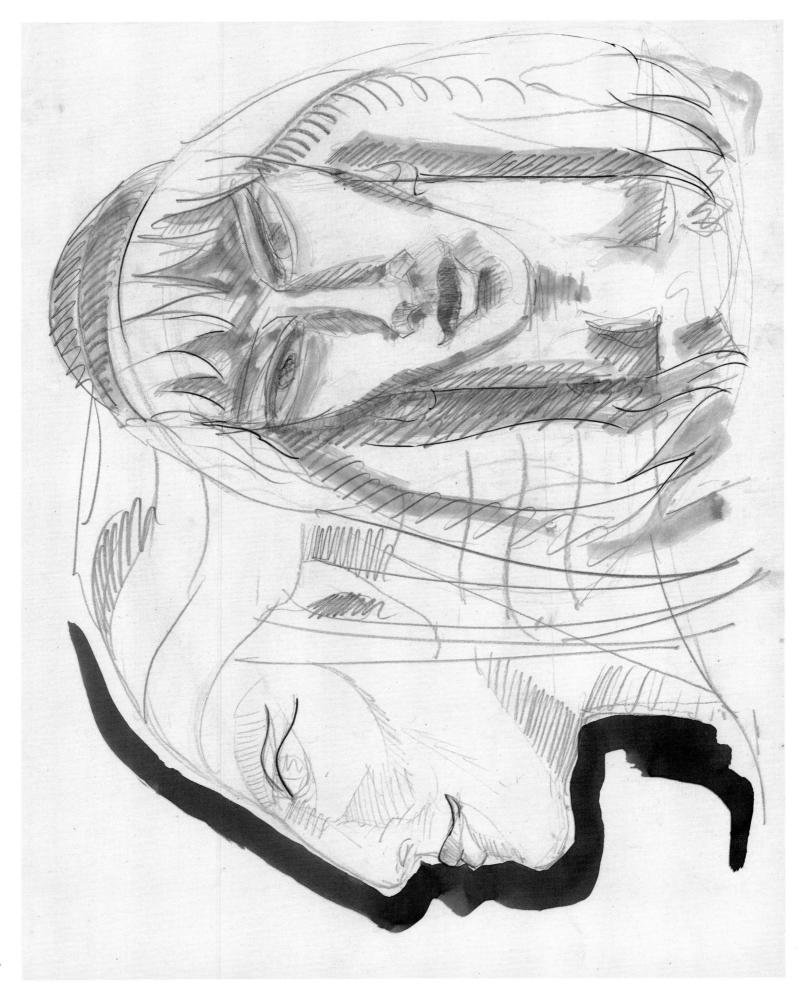

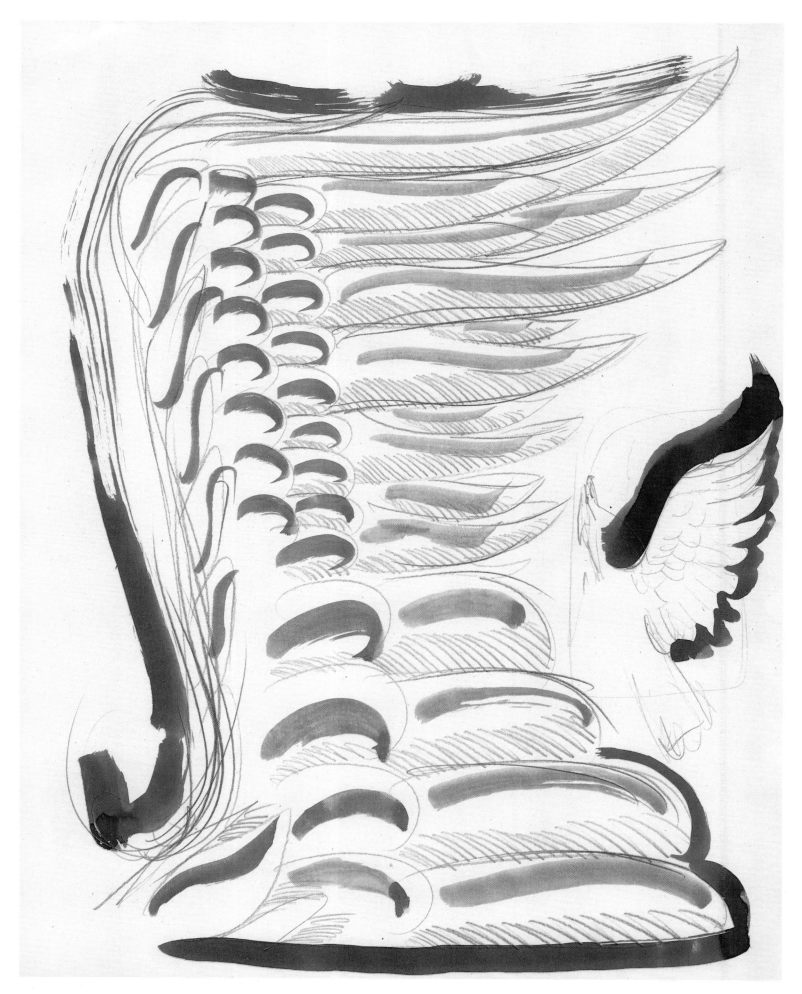

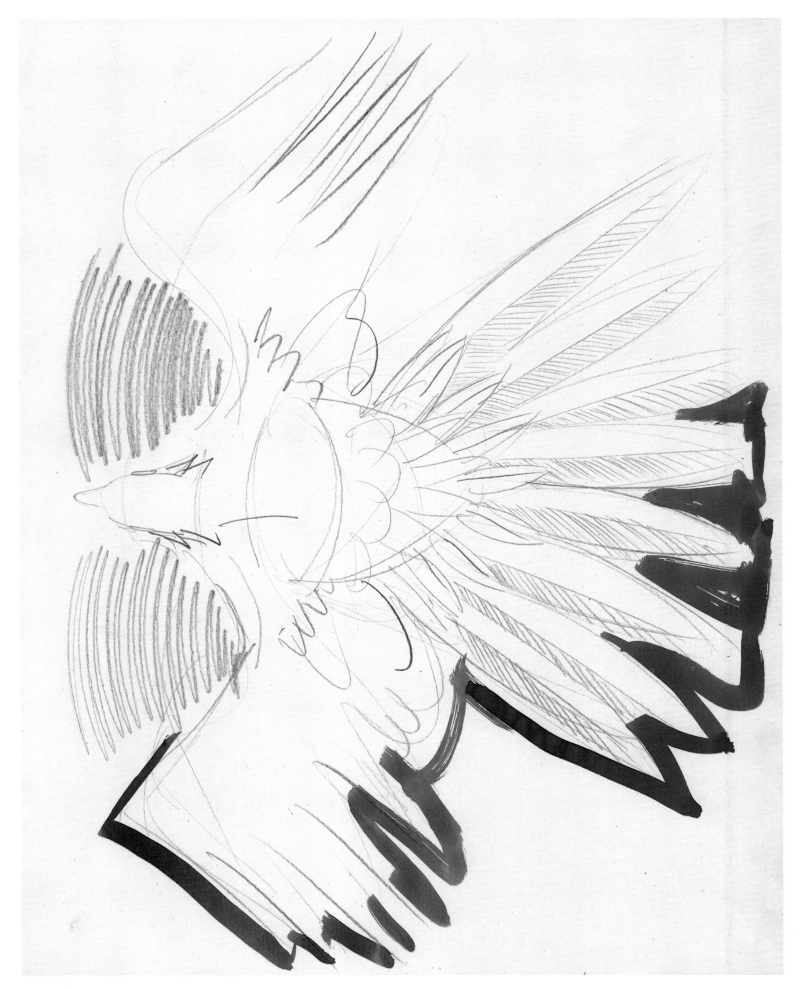

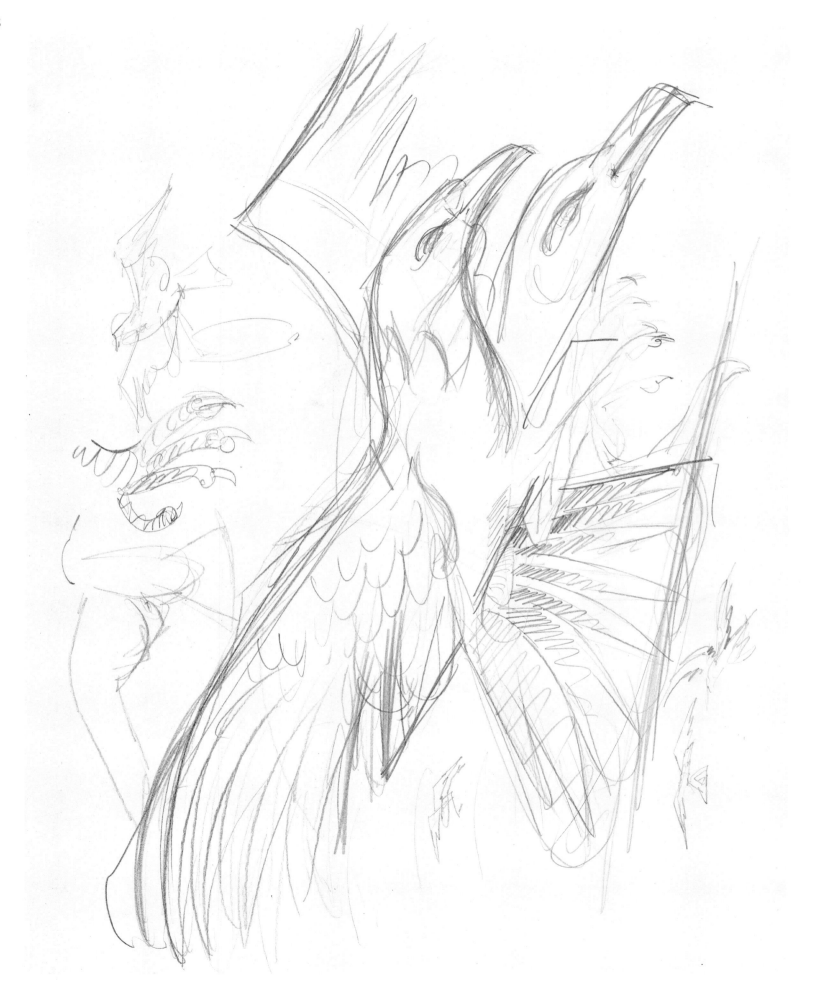

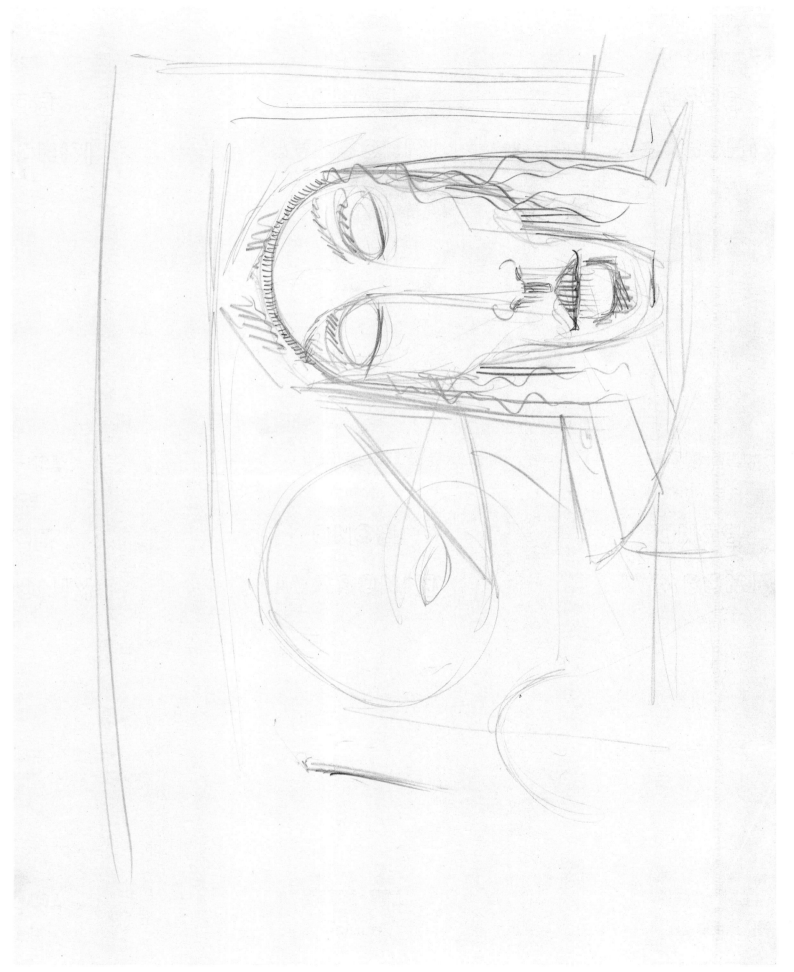

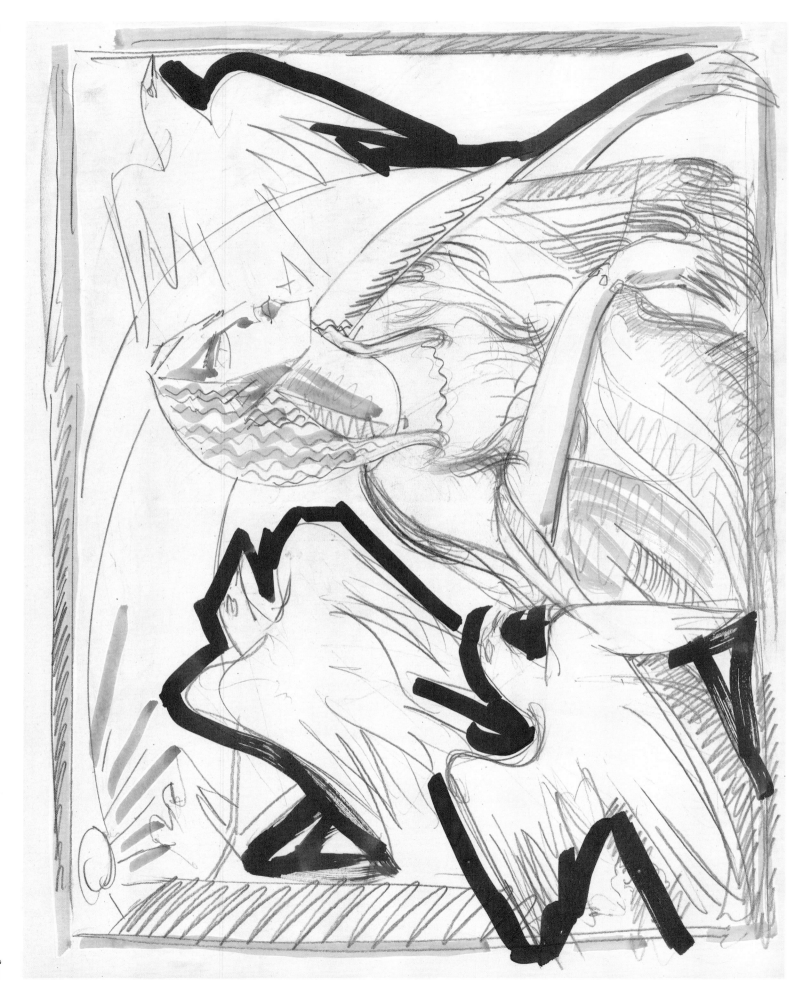

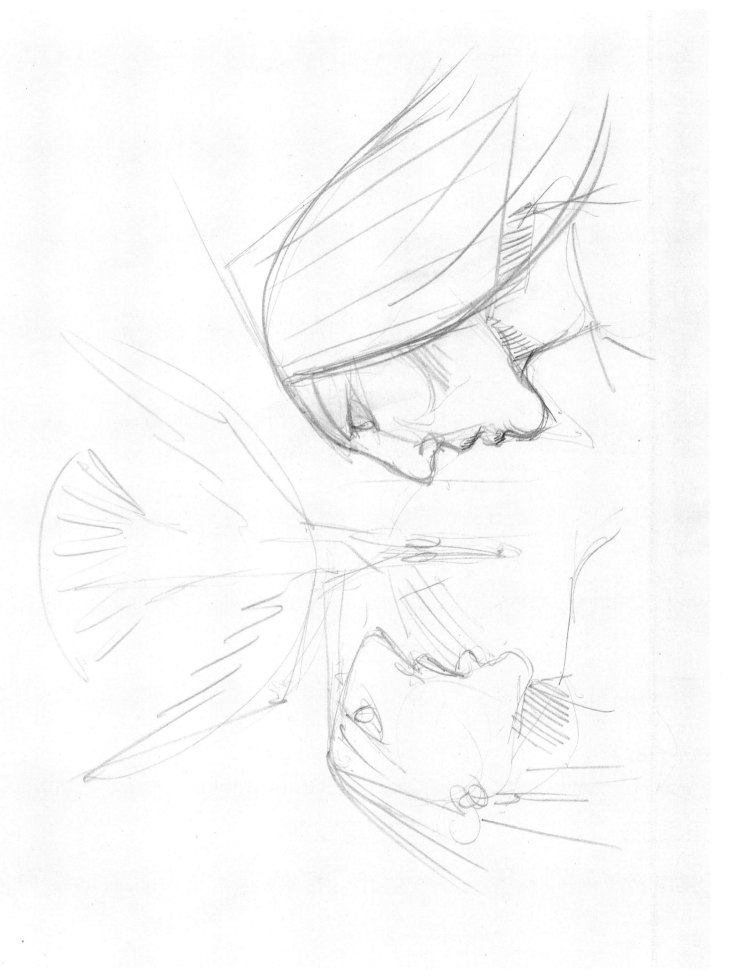

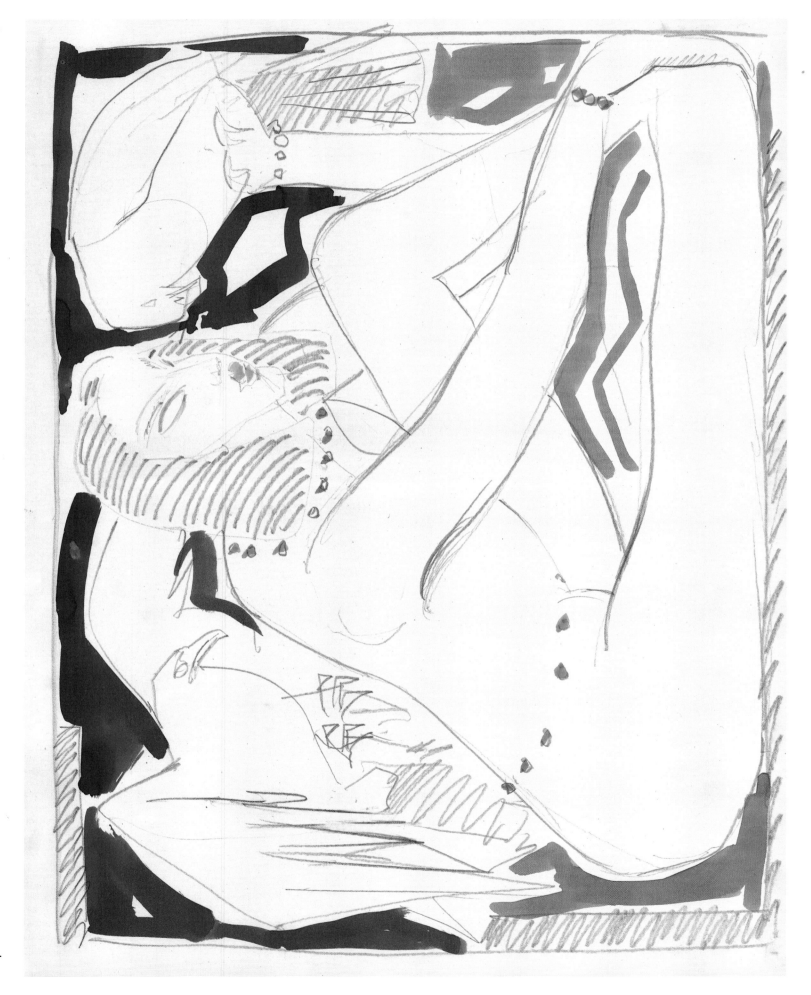

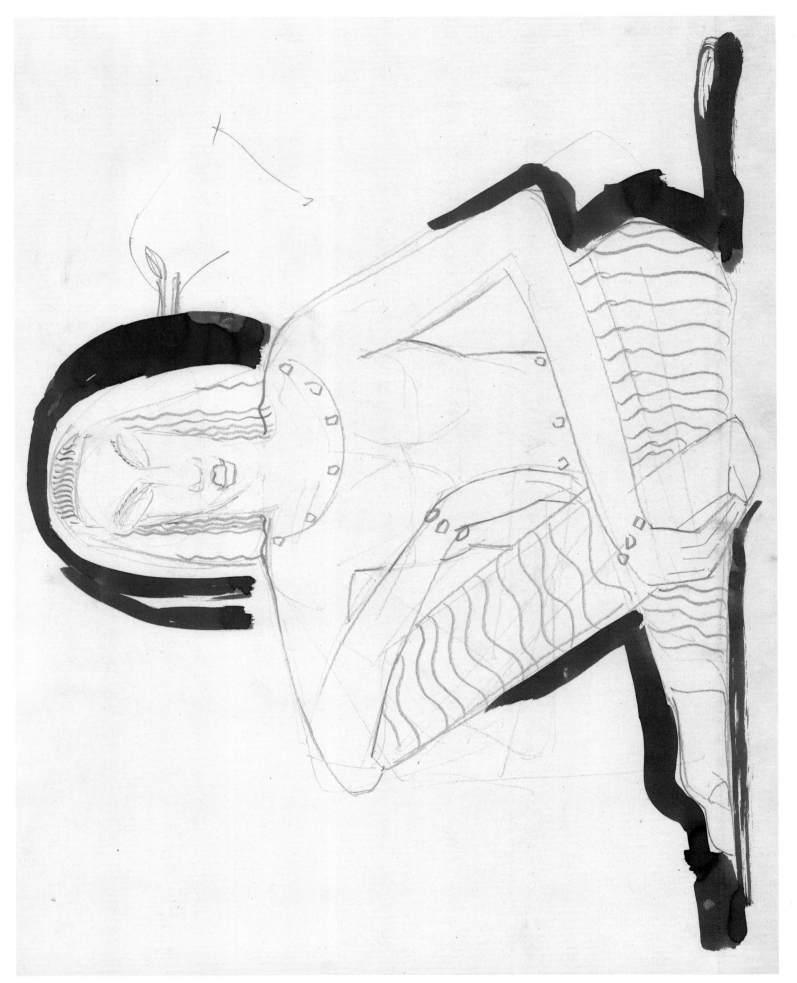

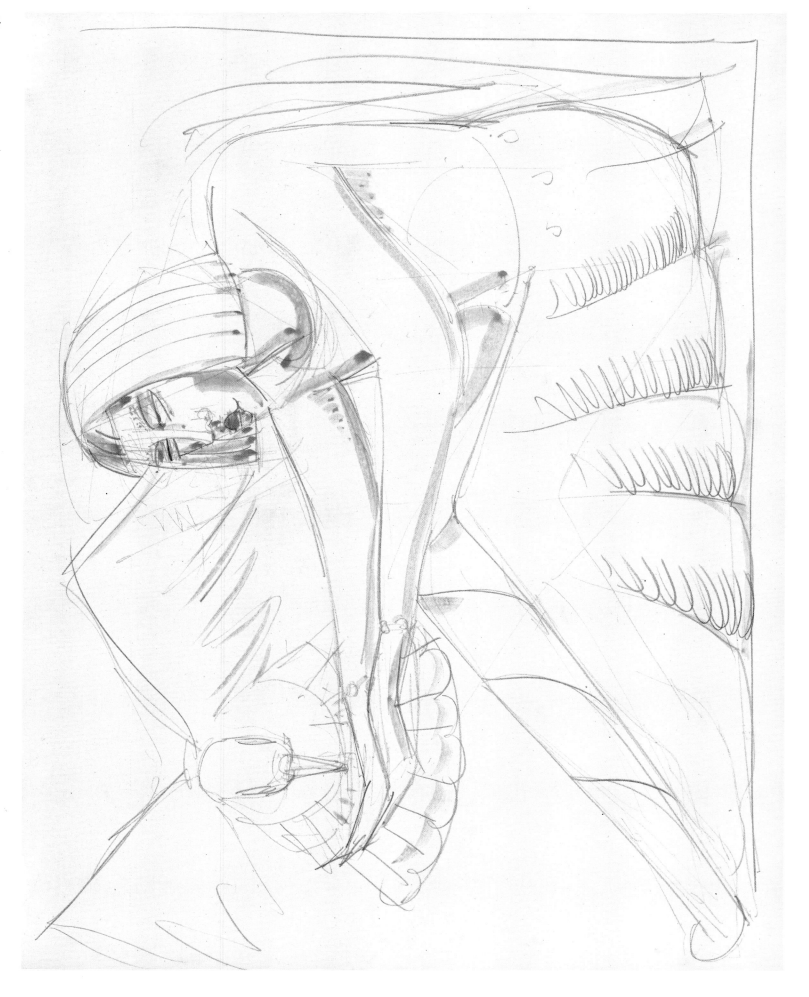

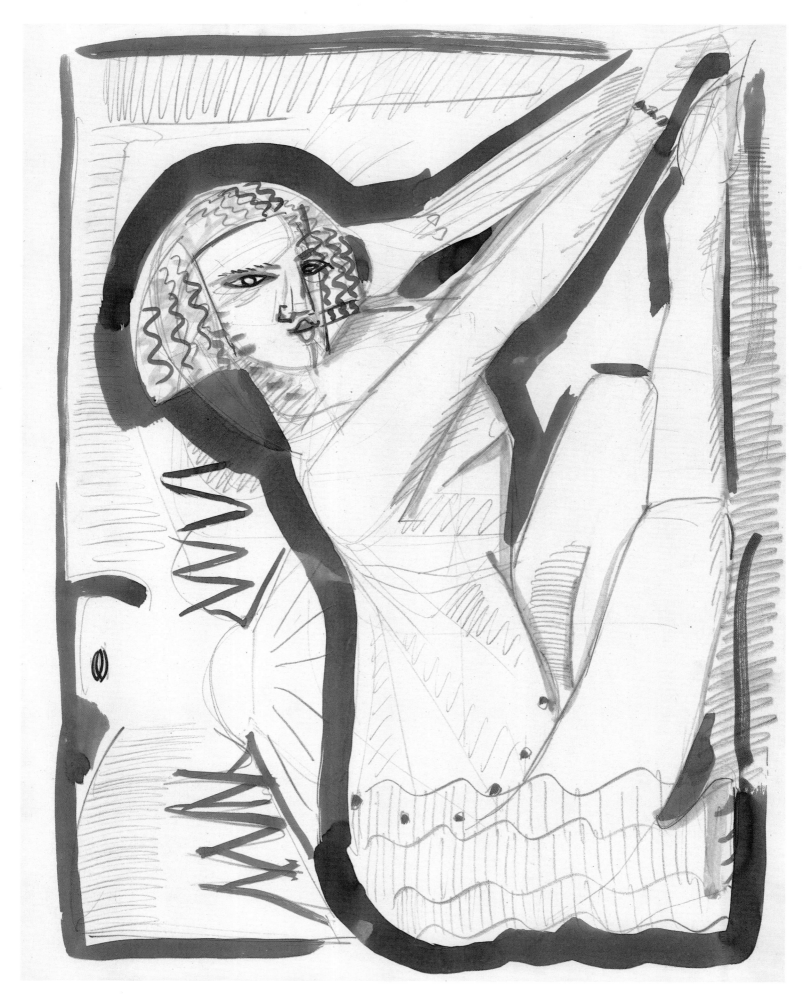

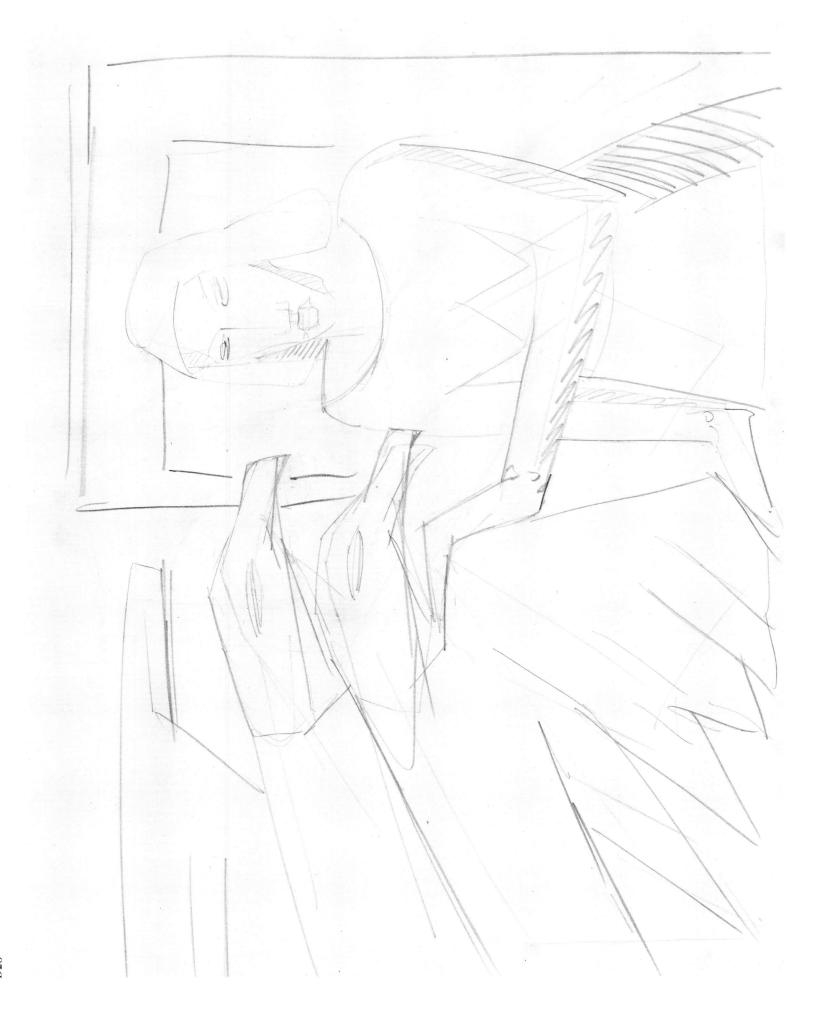

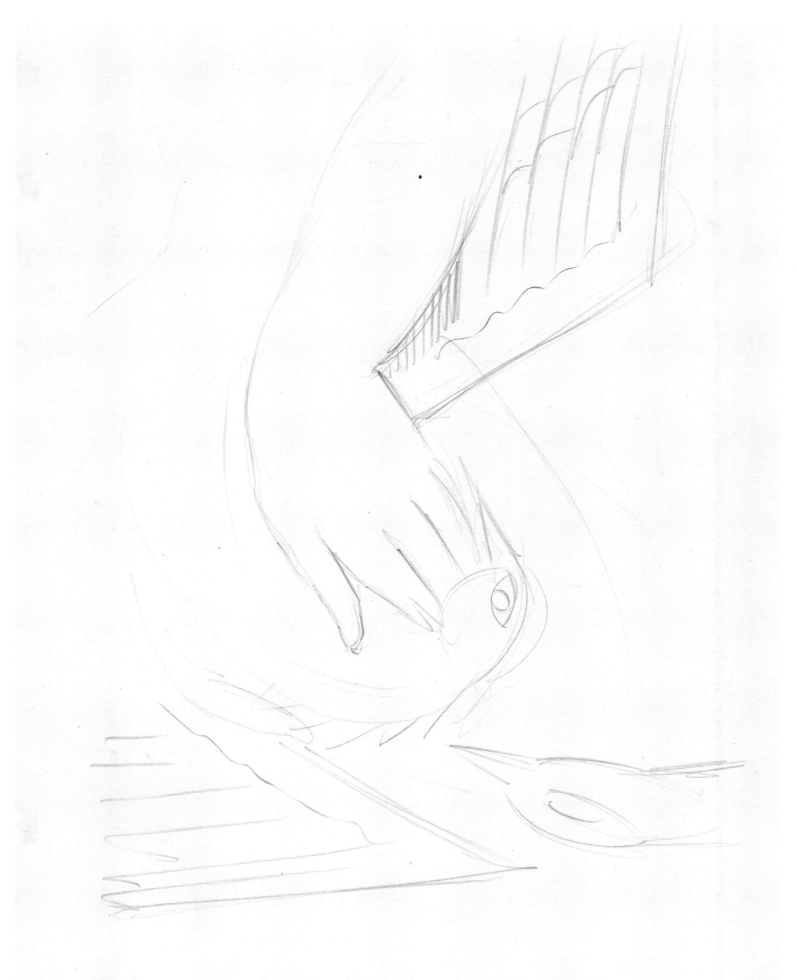

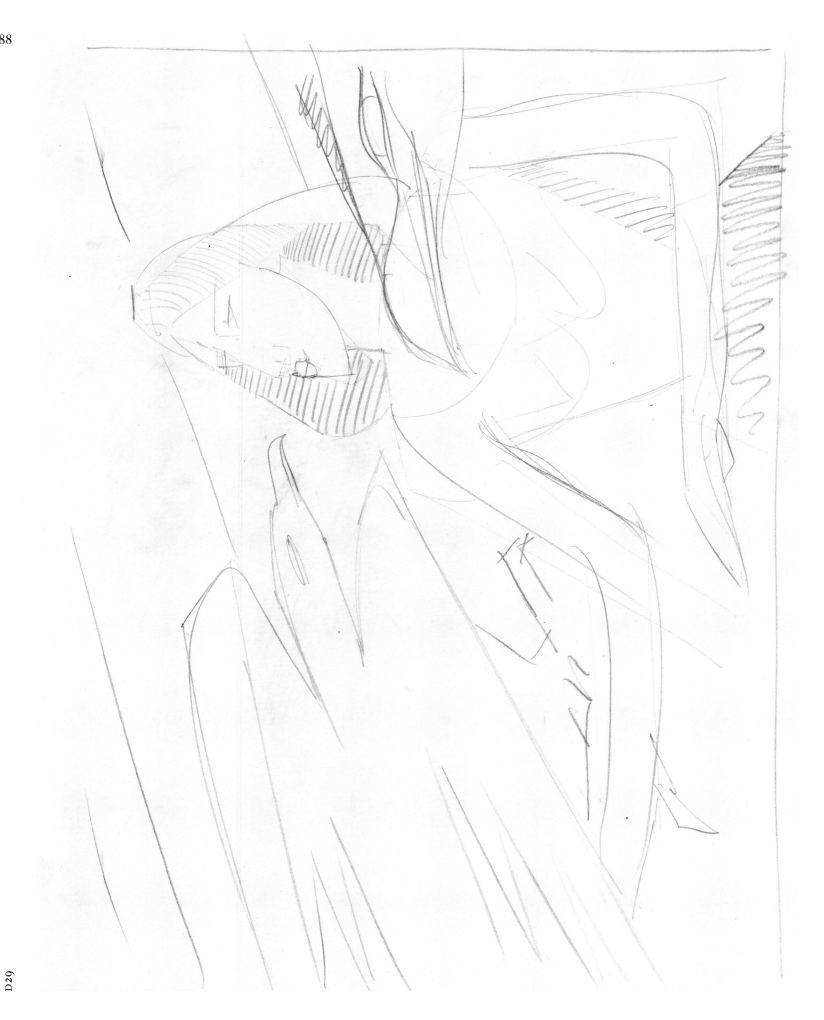

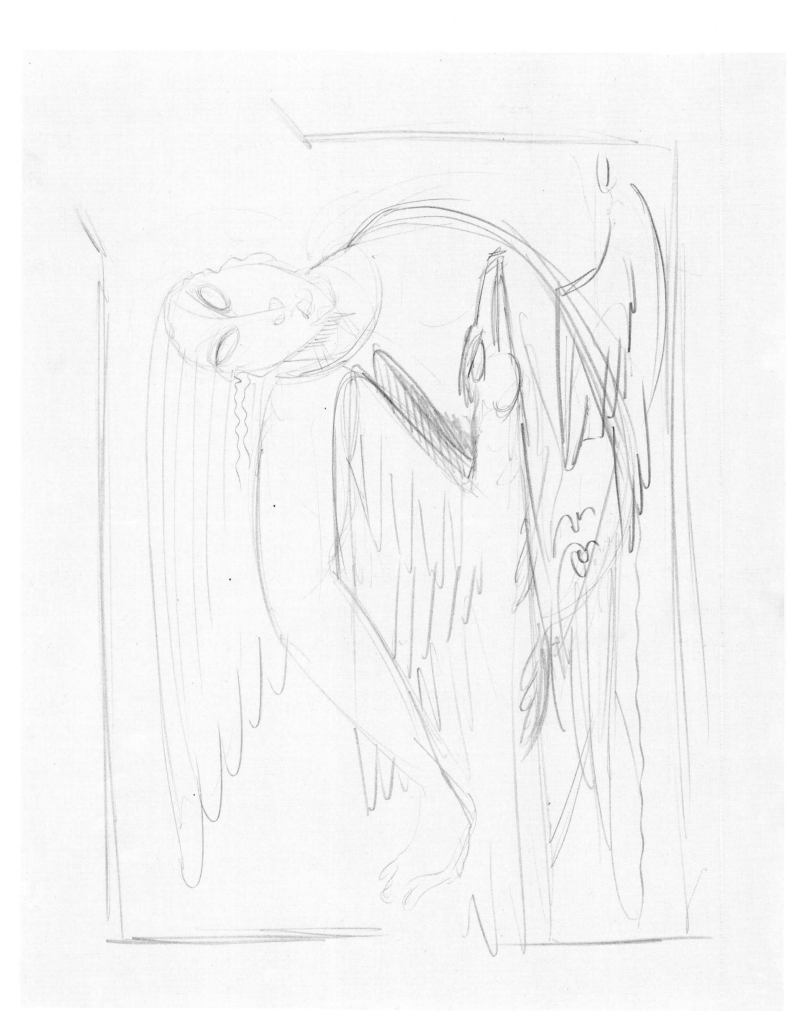

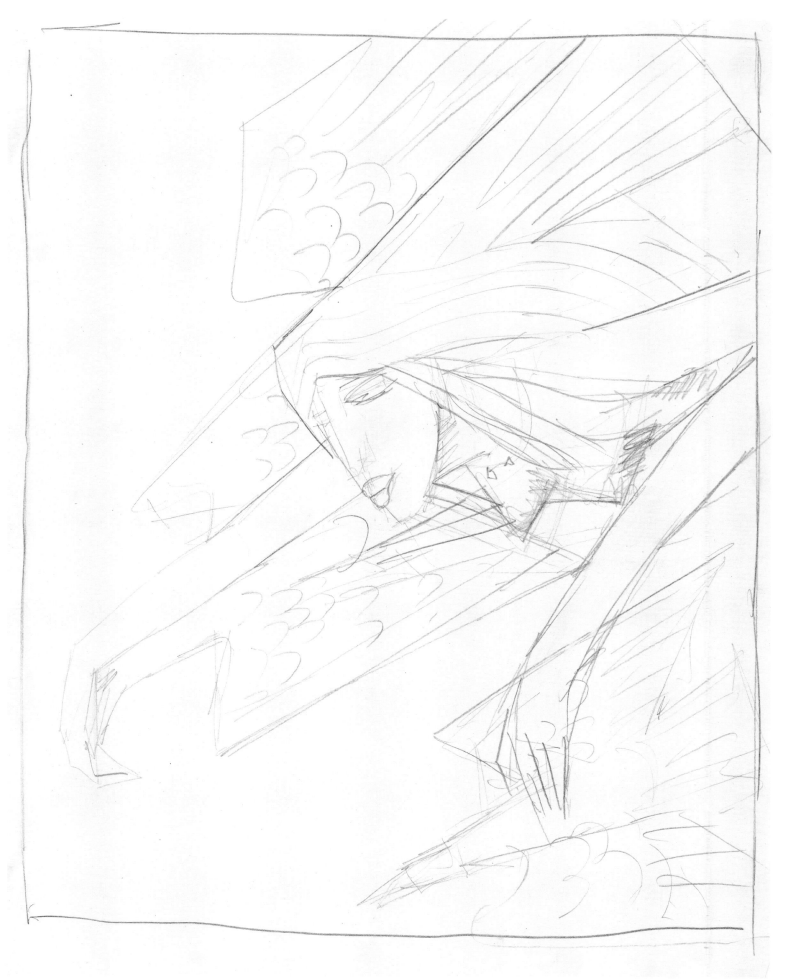

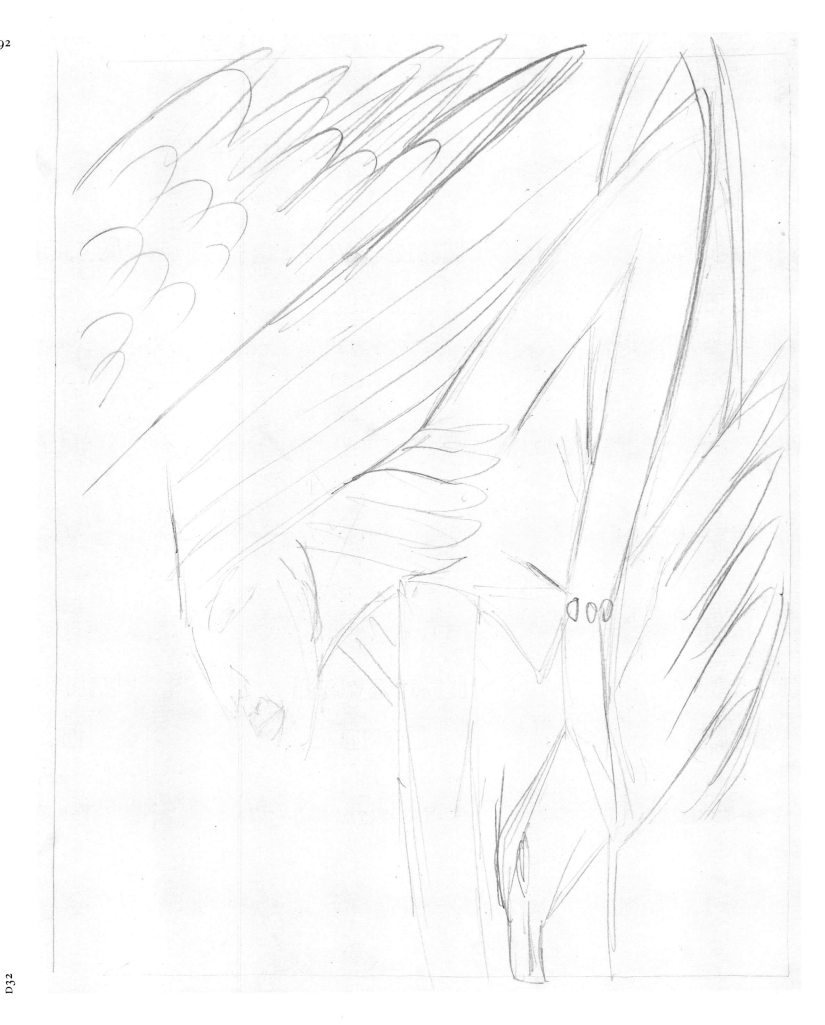

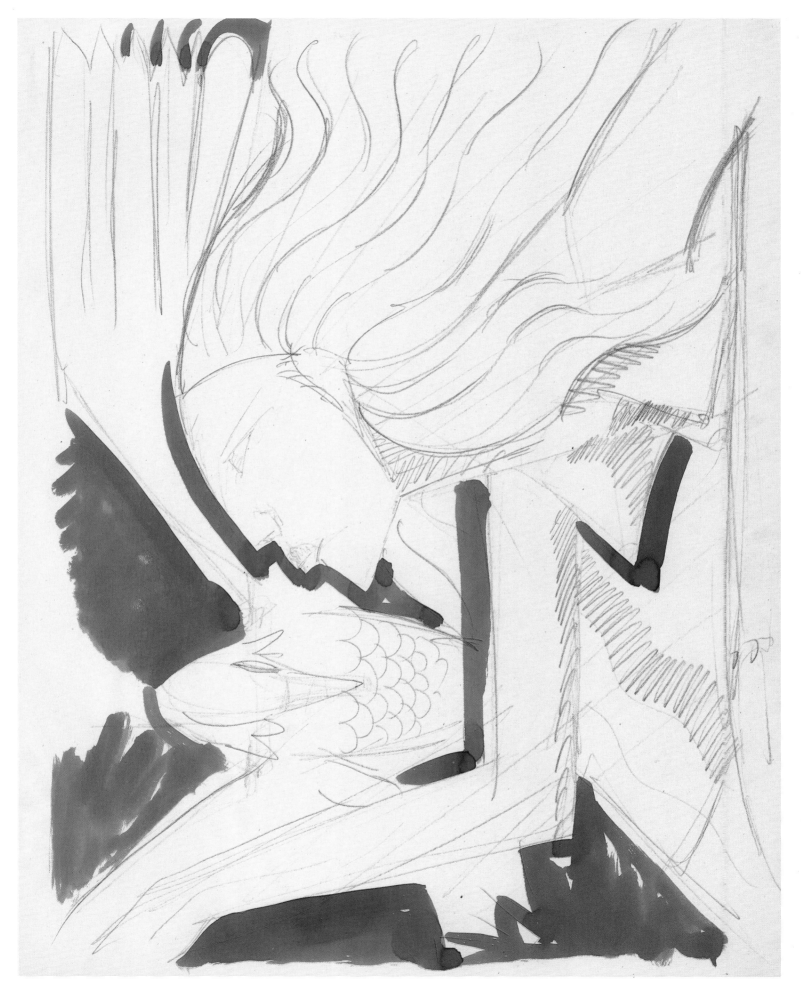

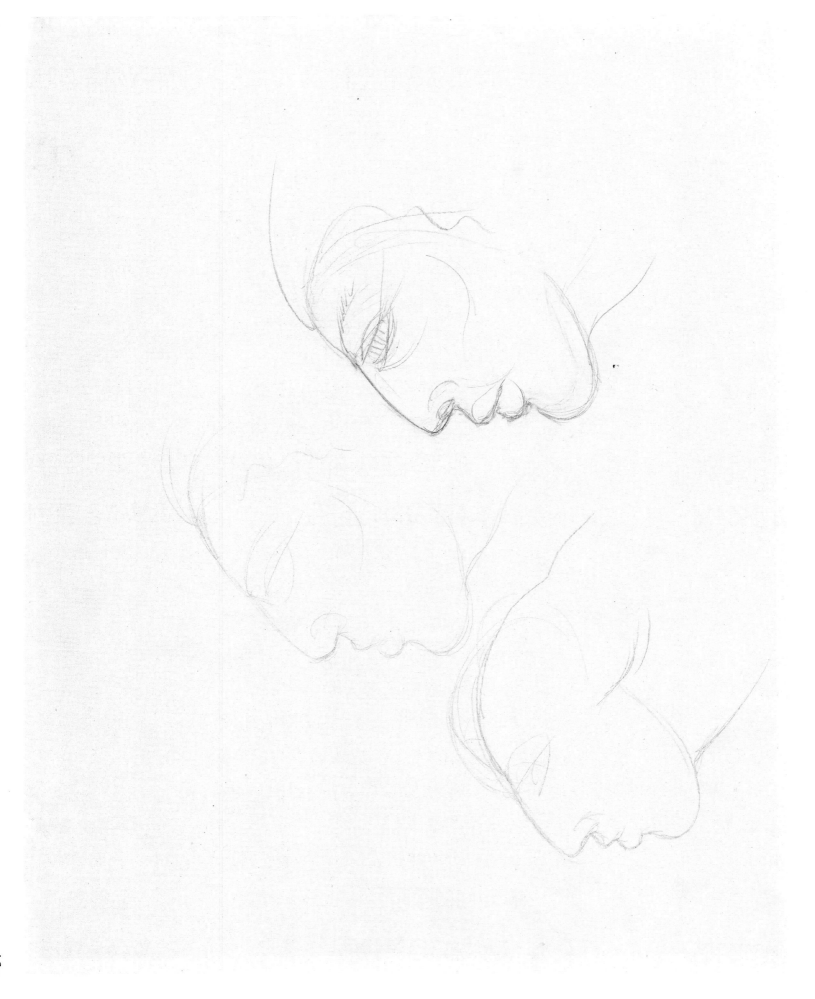

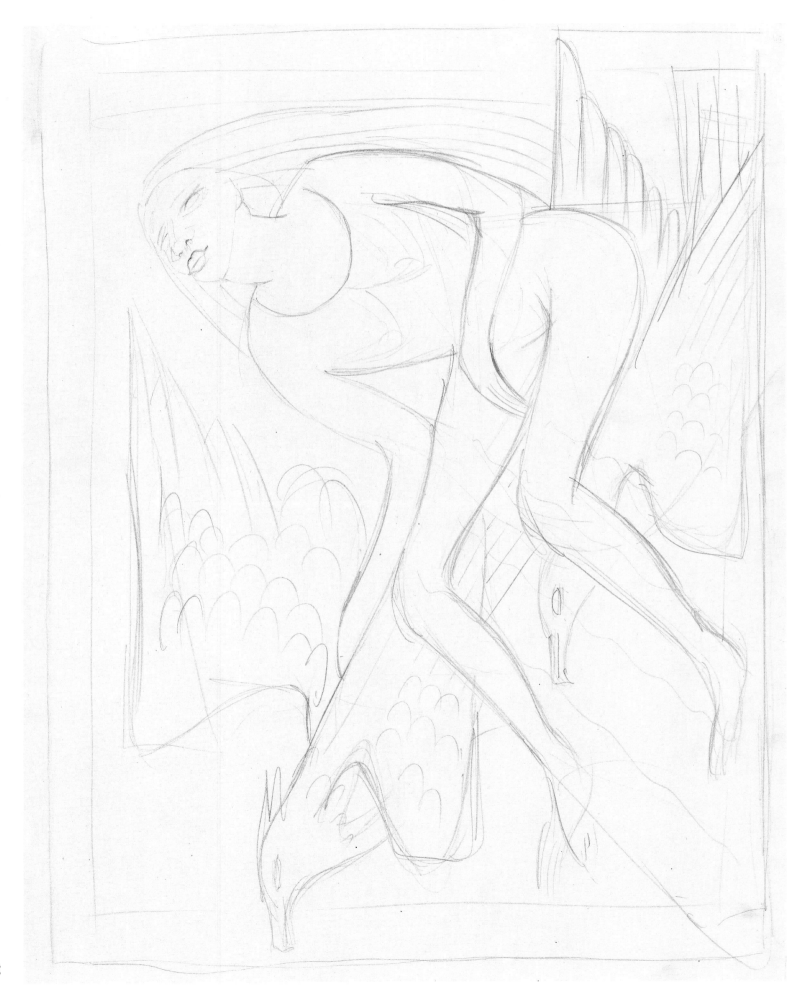

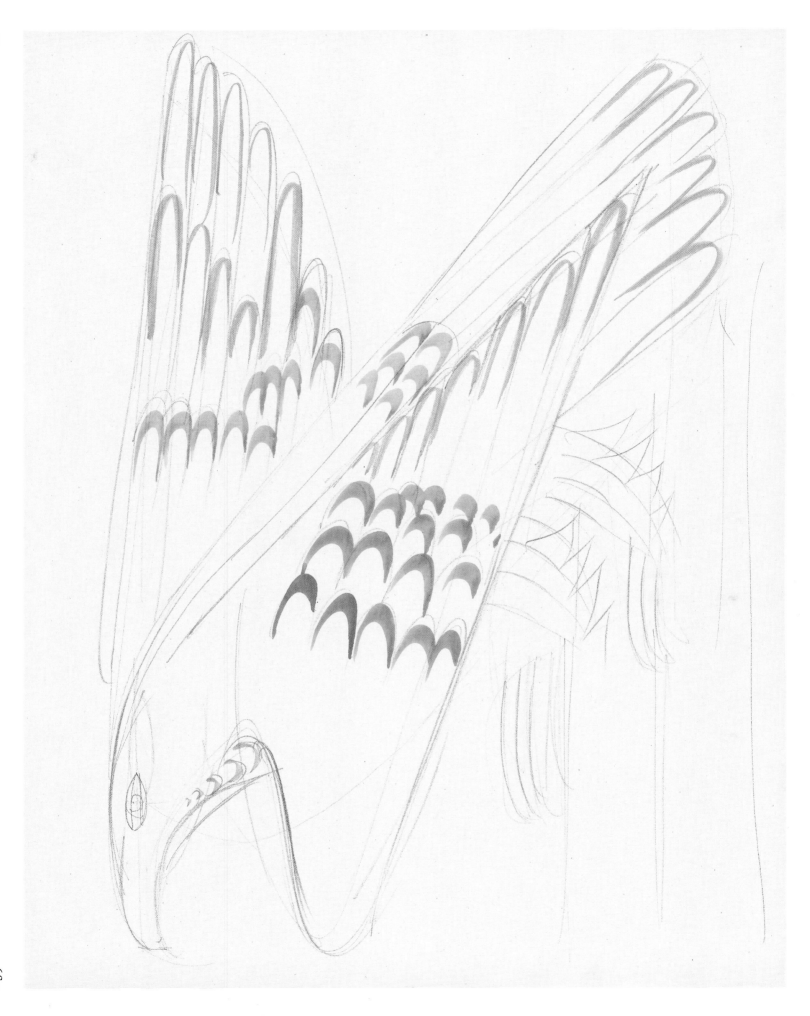

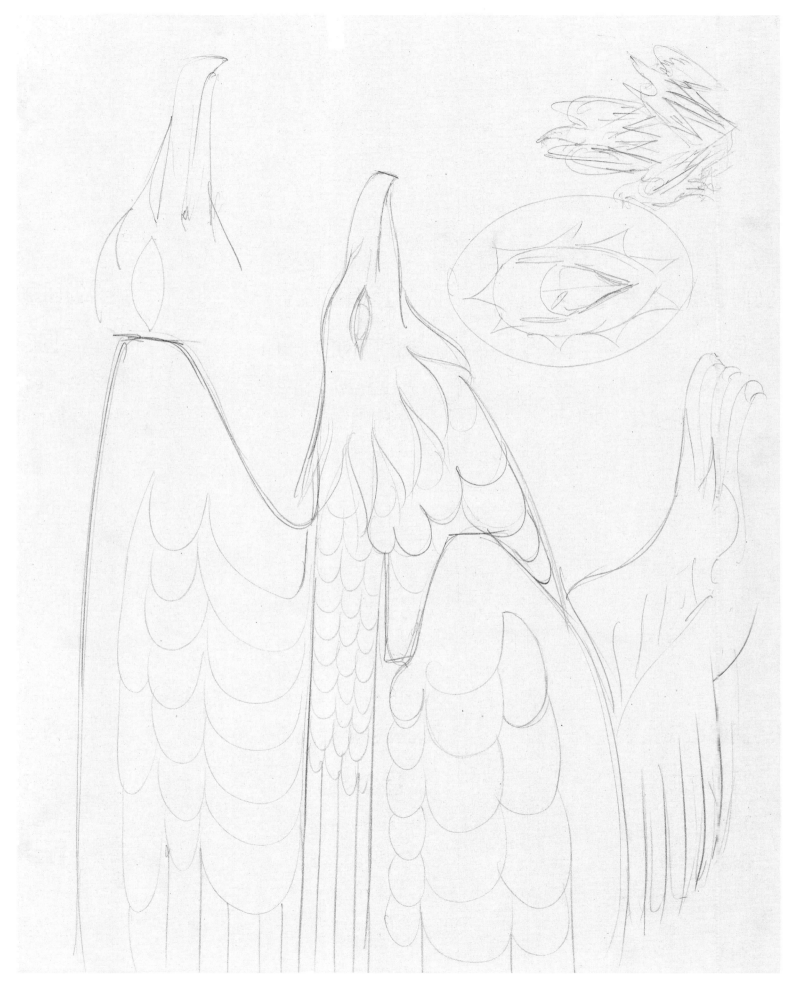

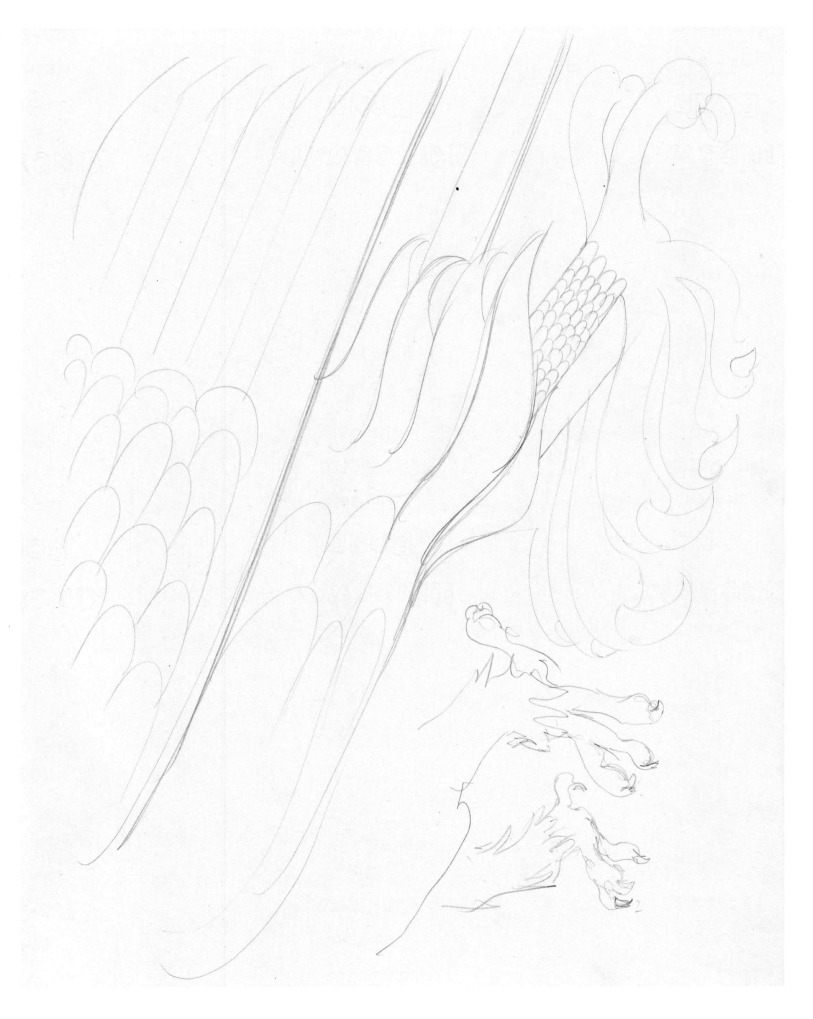

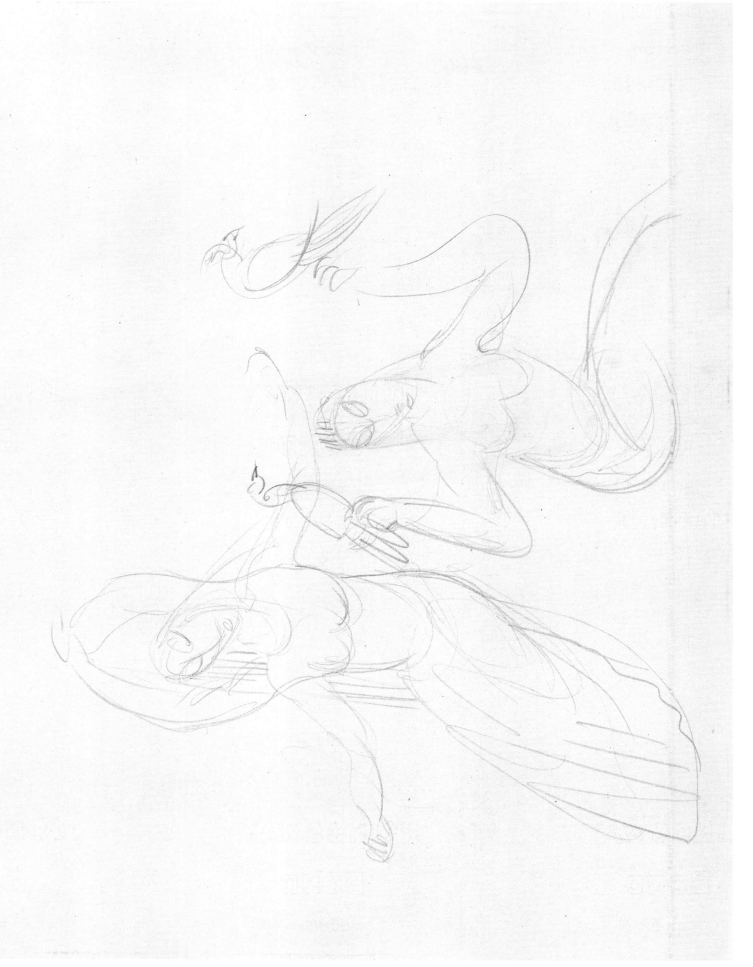

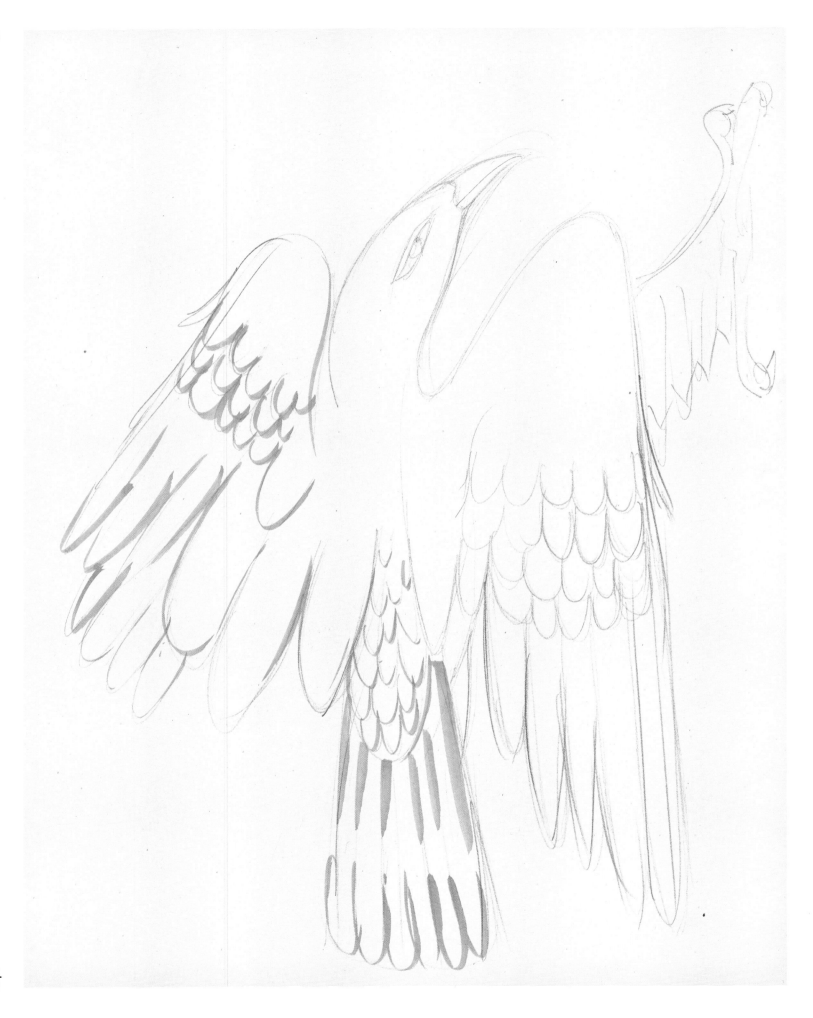

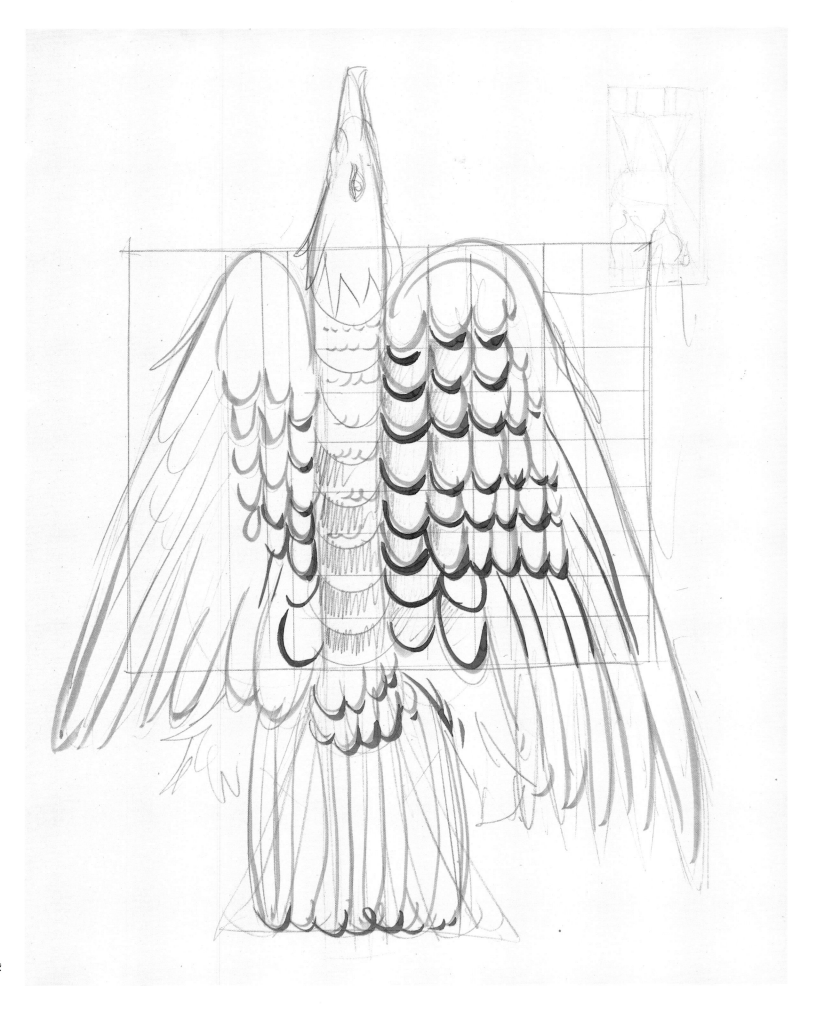

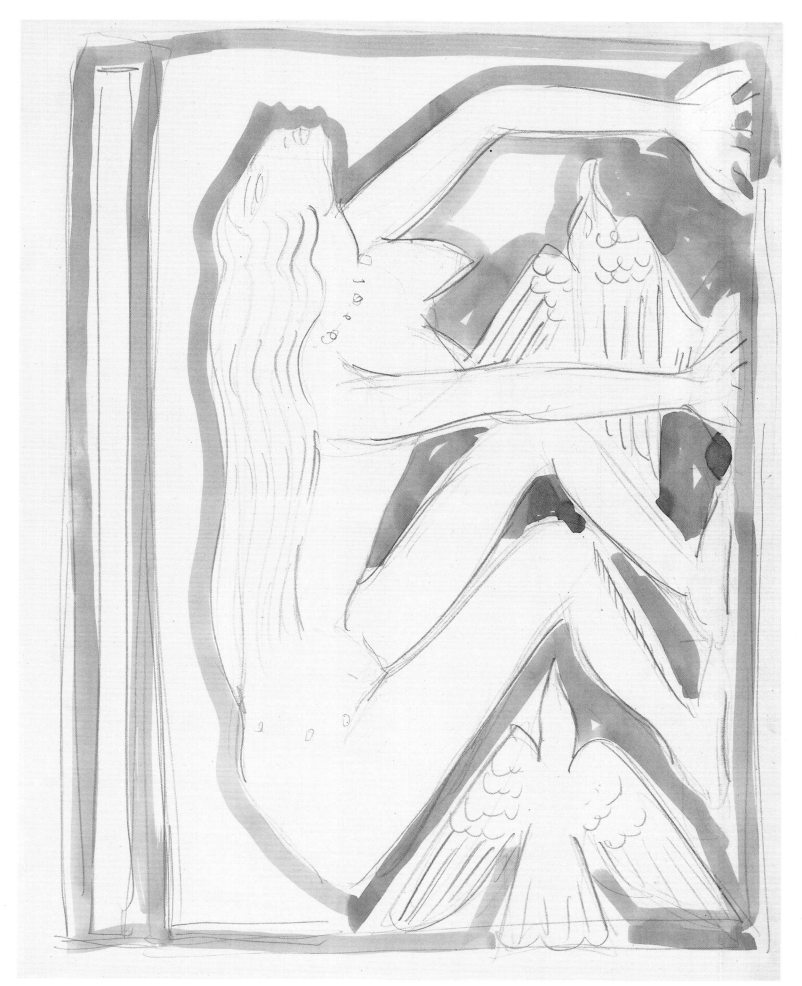

D45

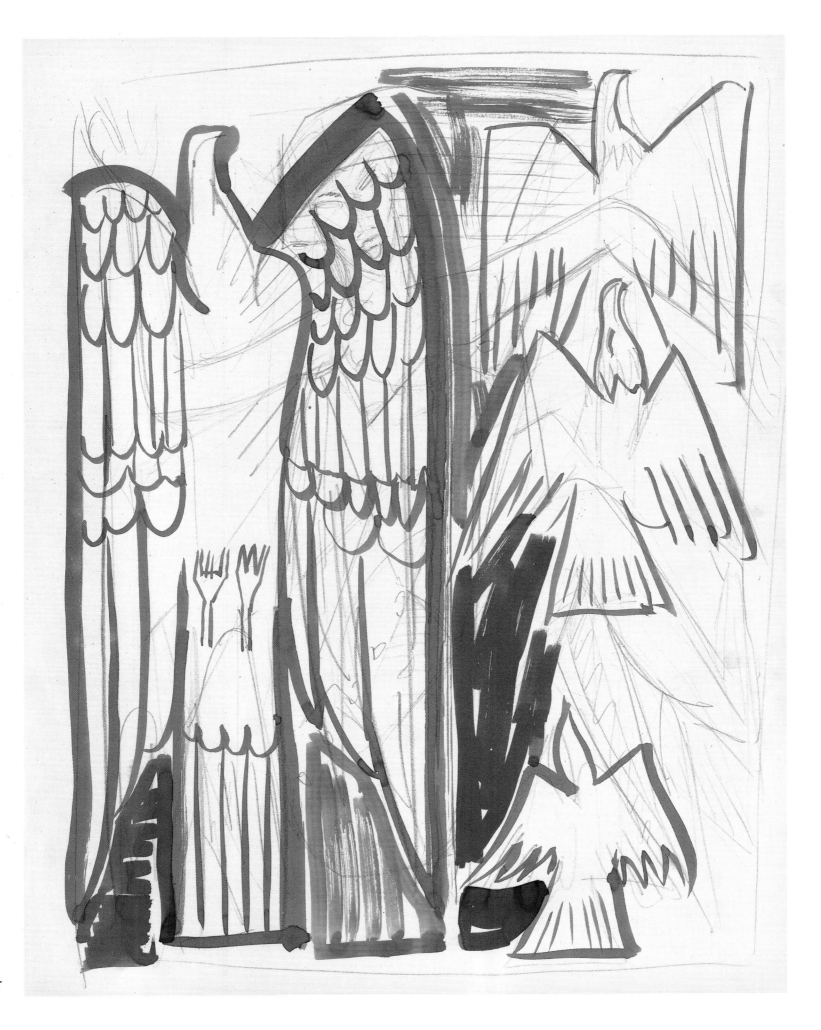

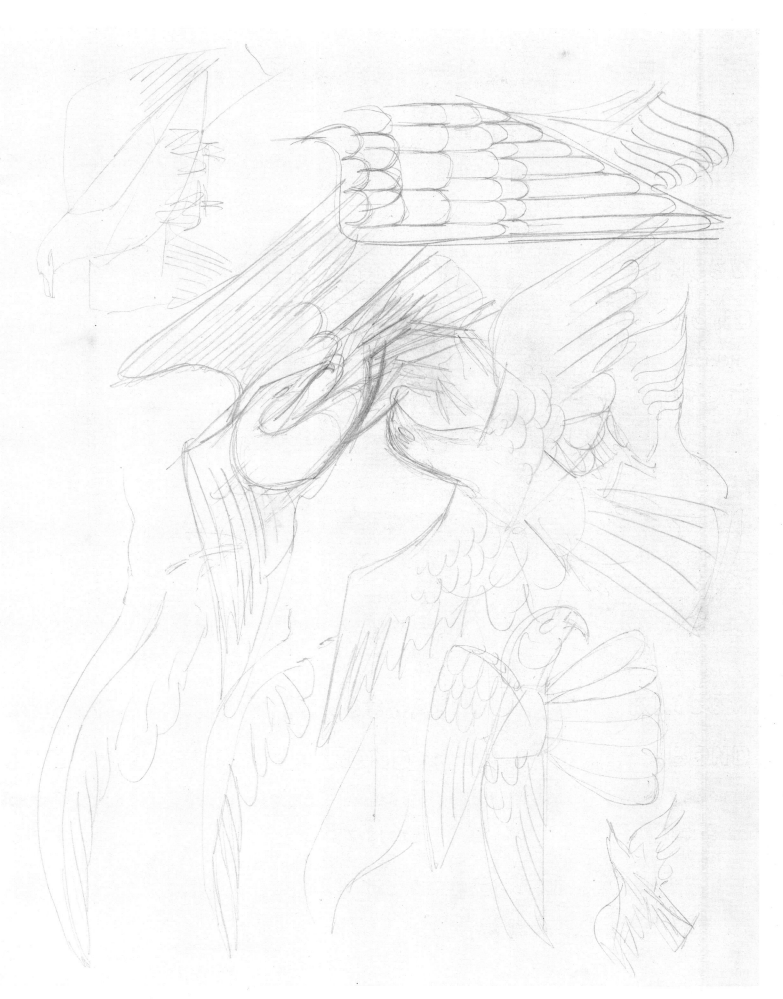

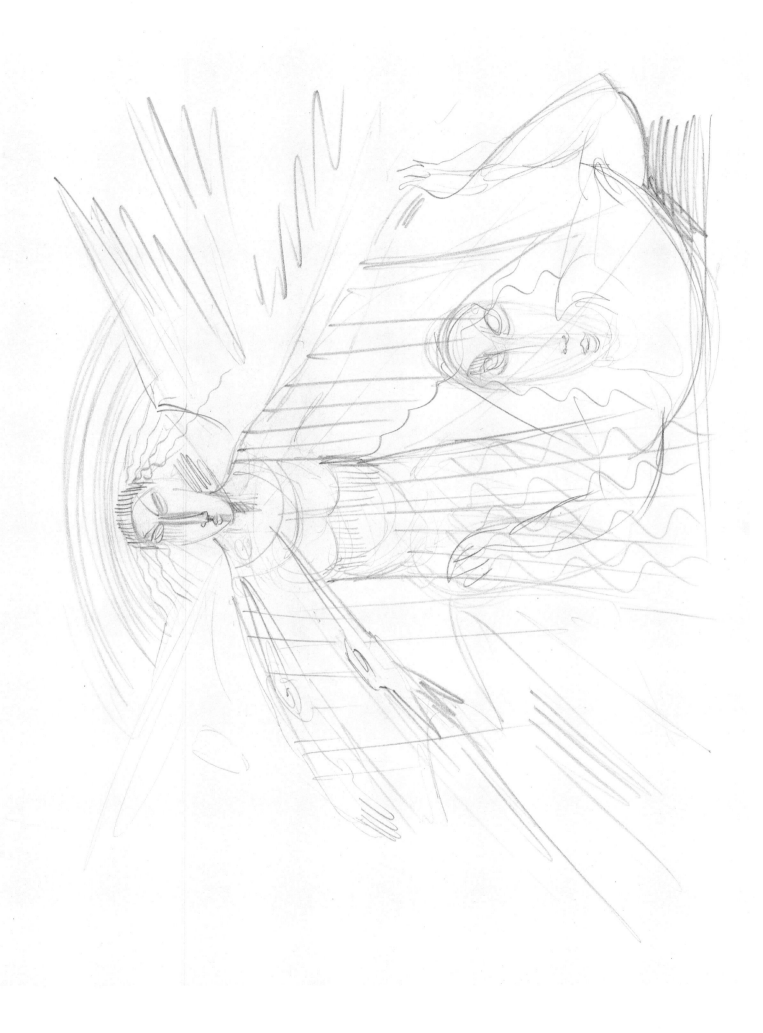

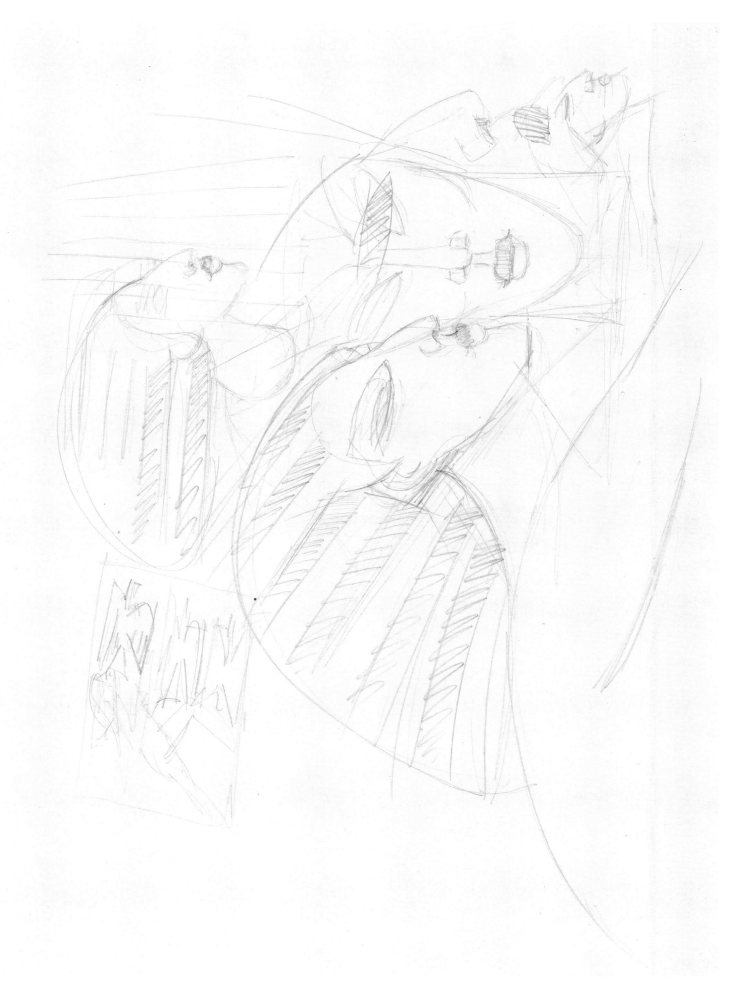

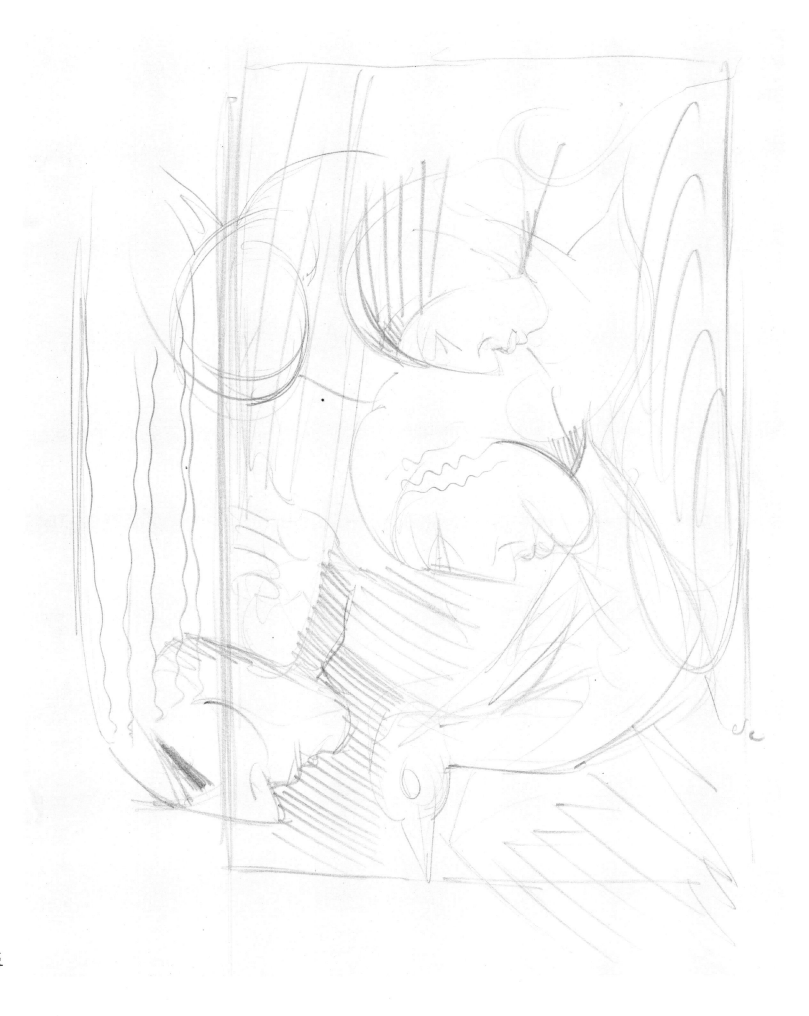

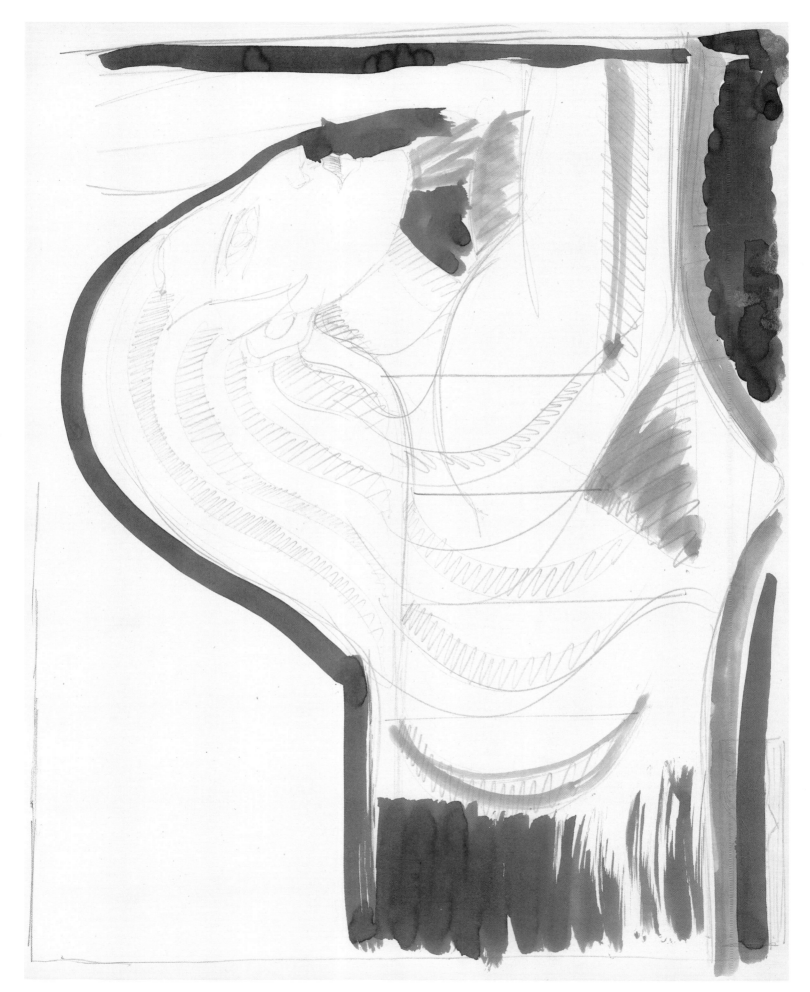

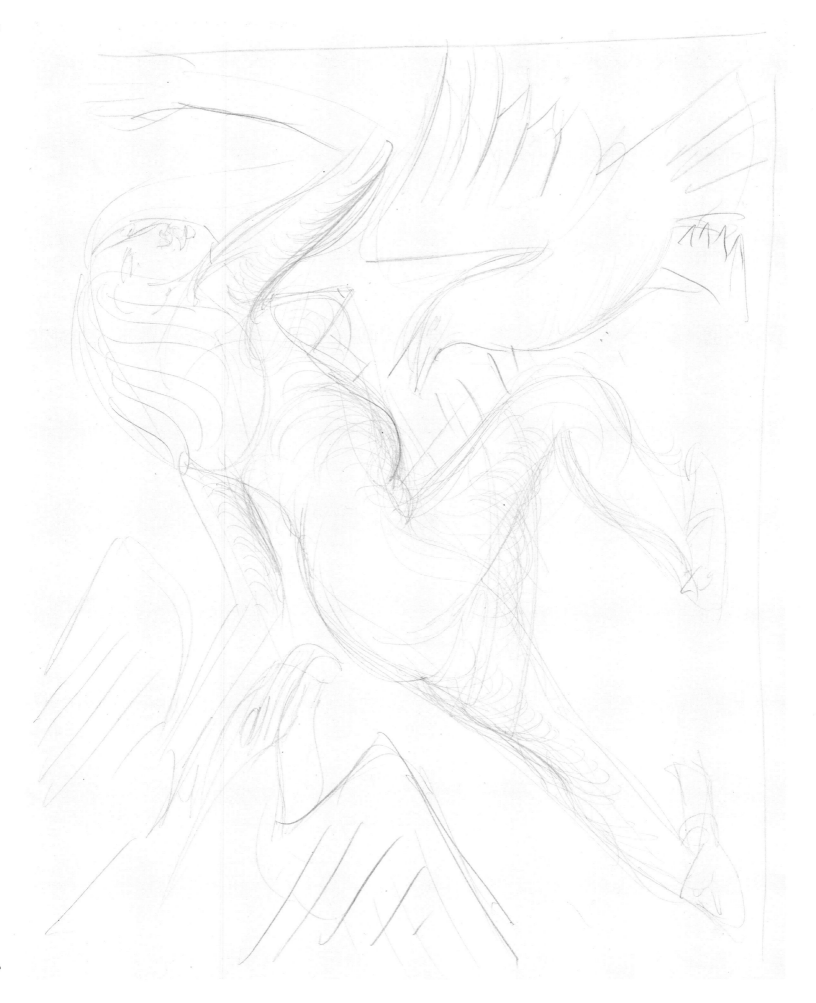

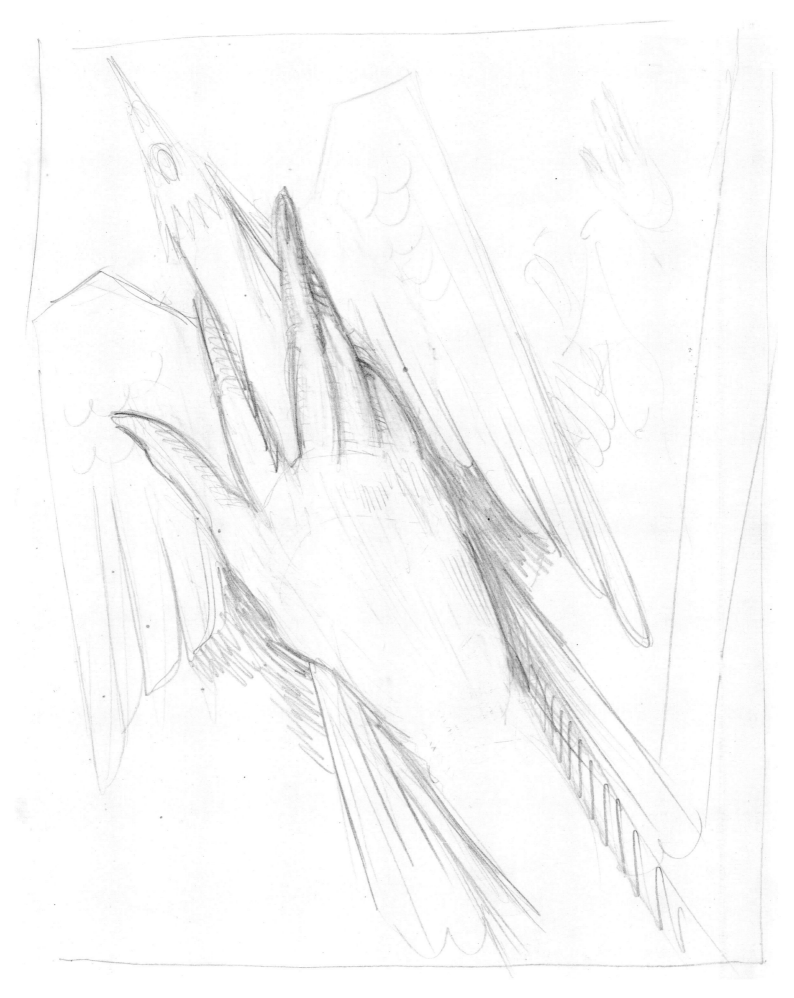

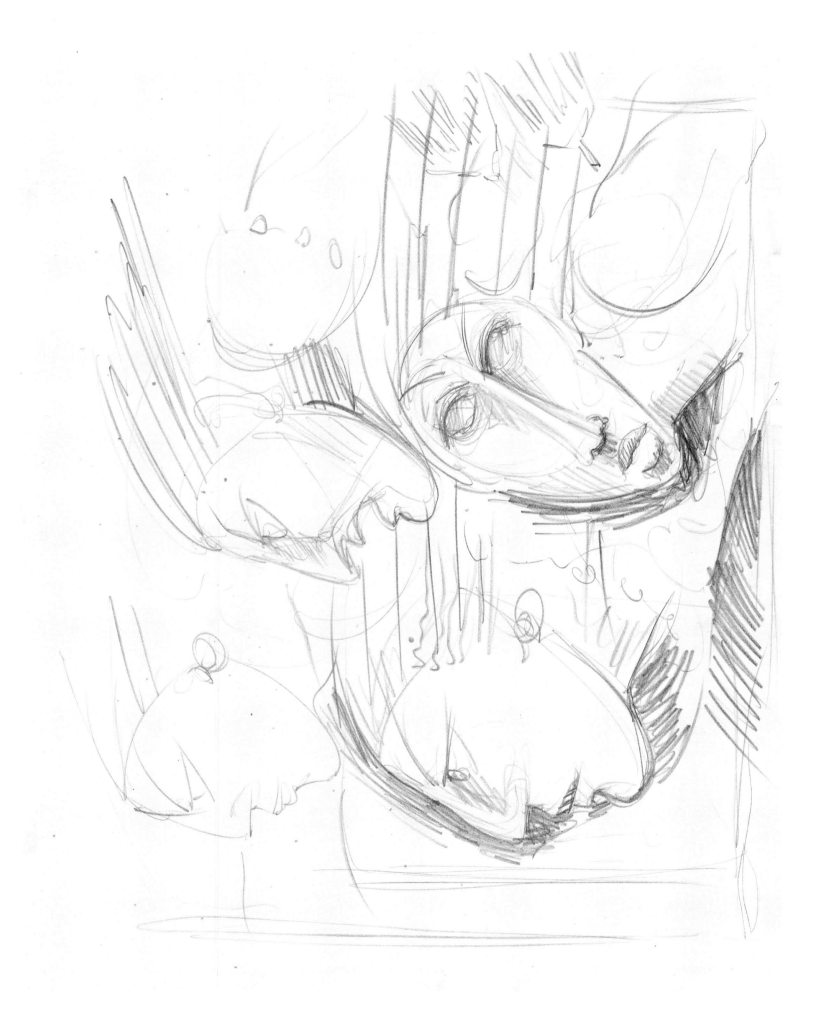

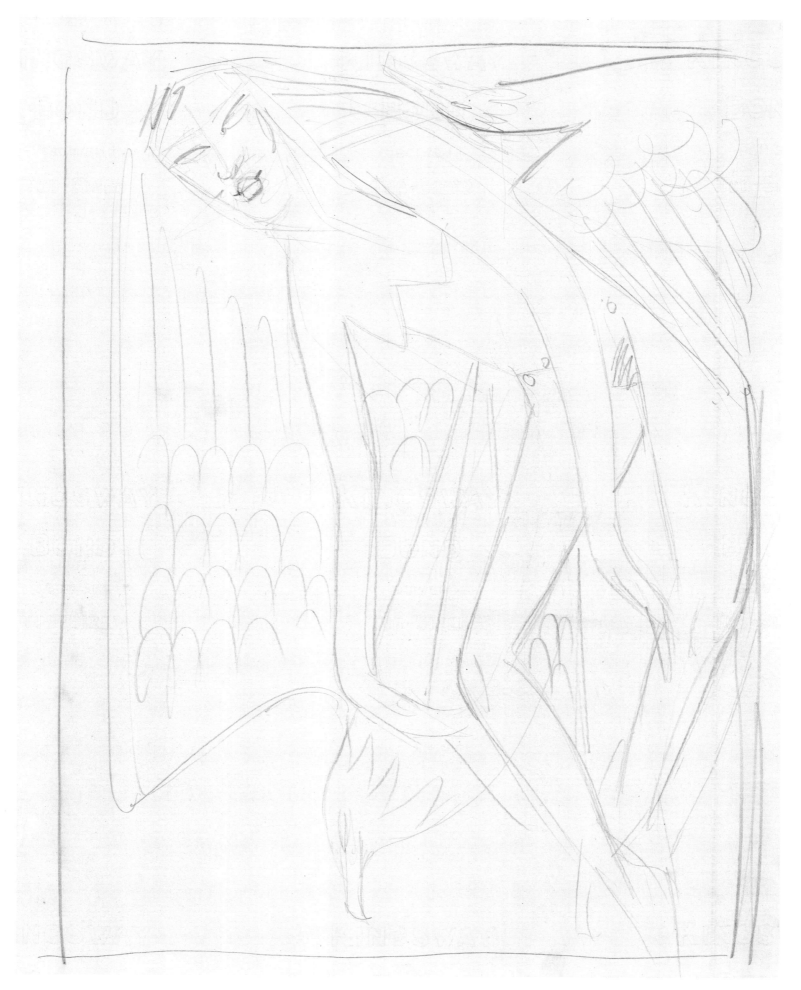

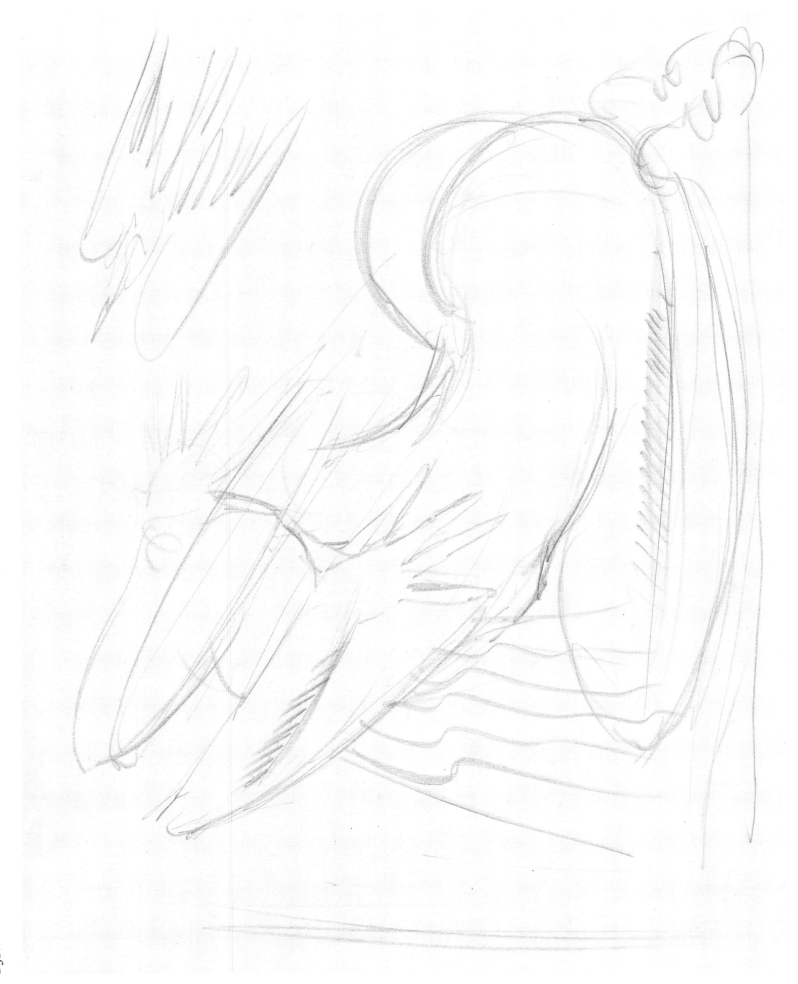

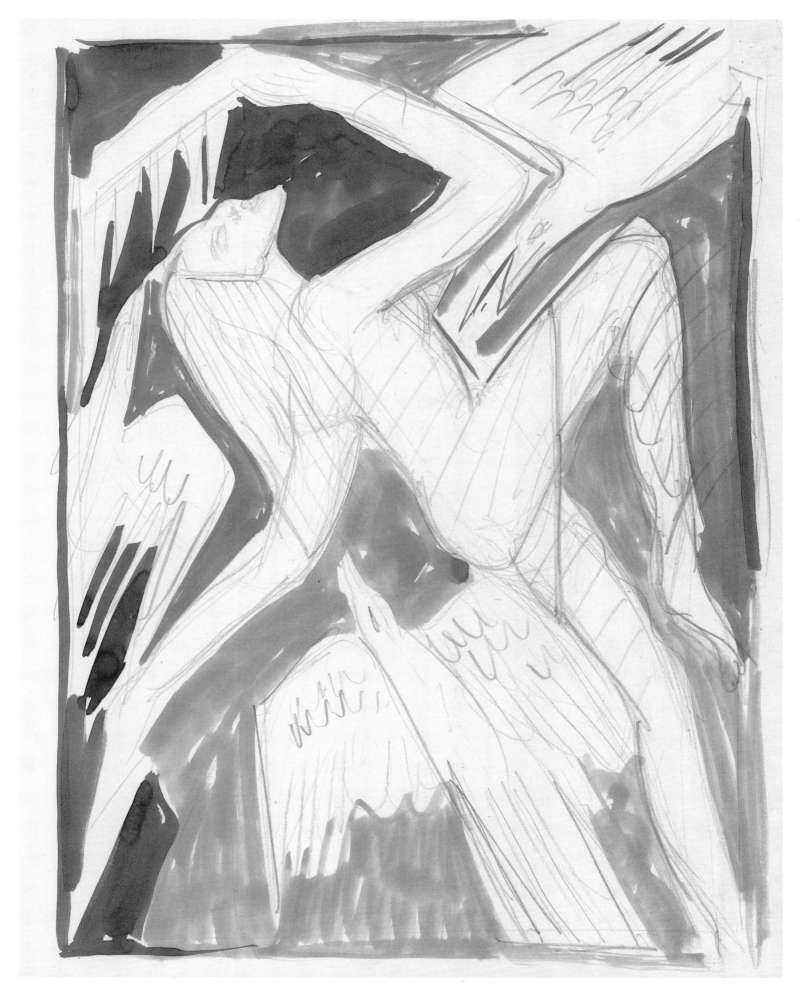

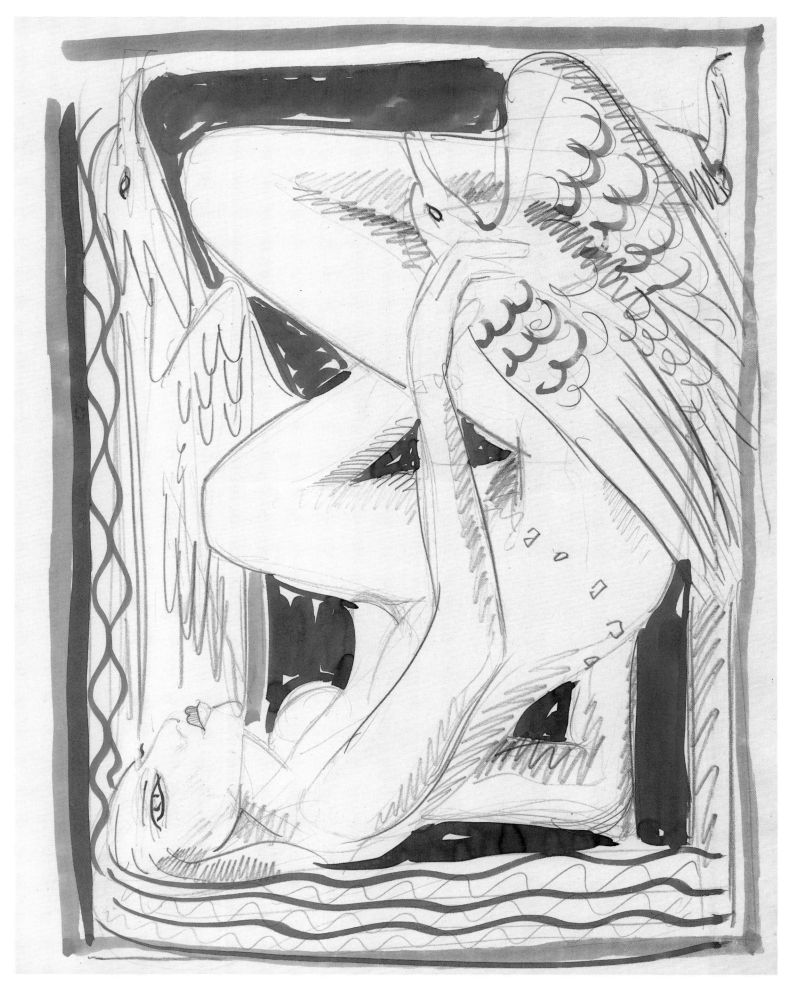

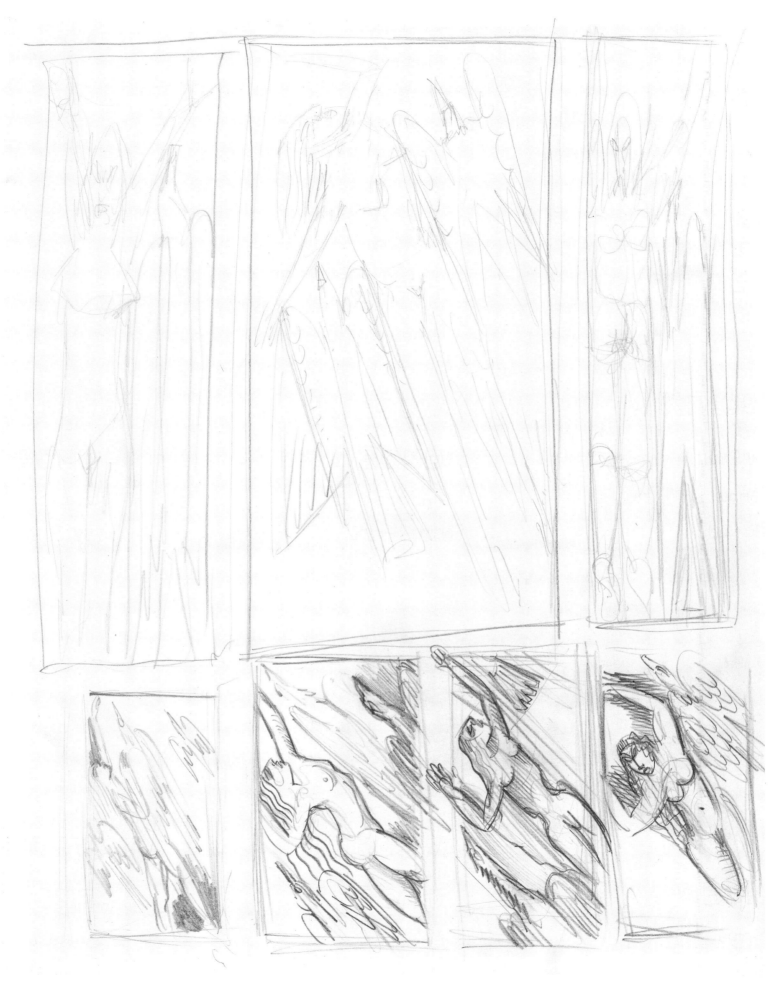

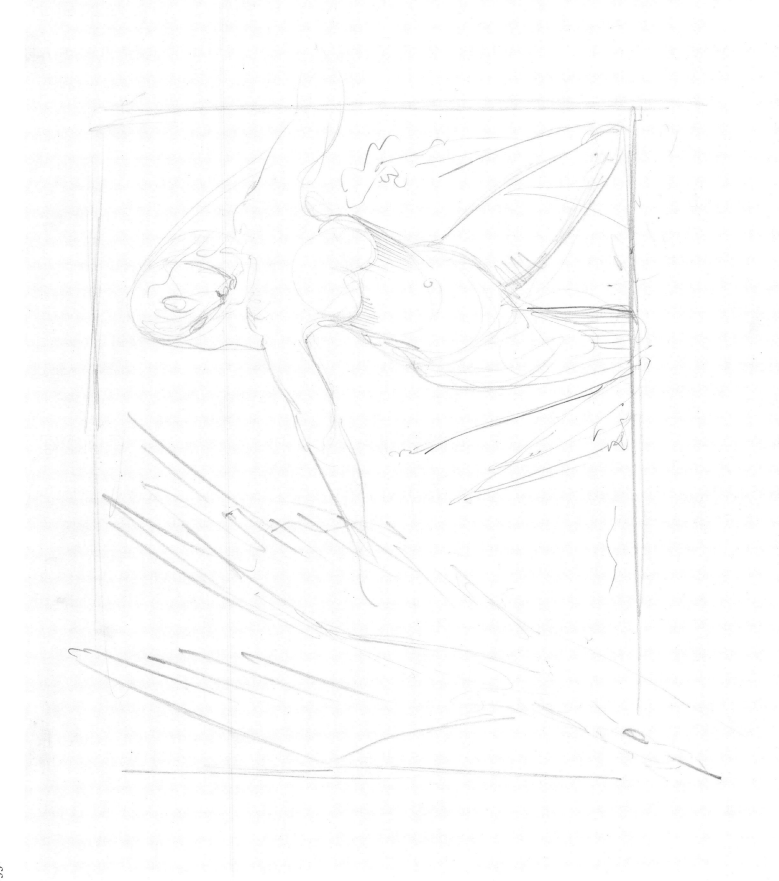

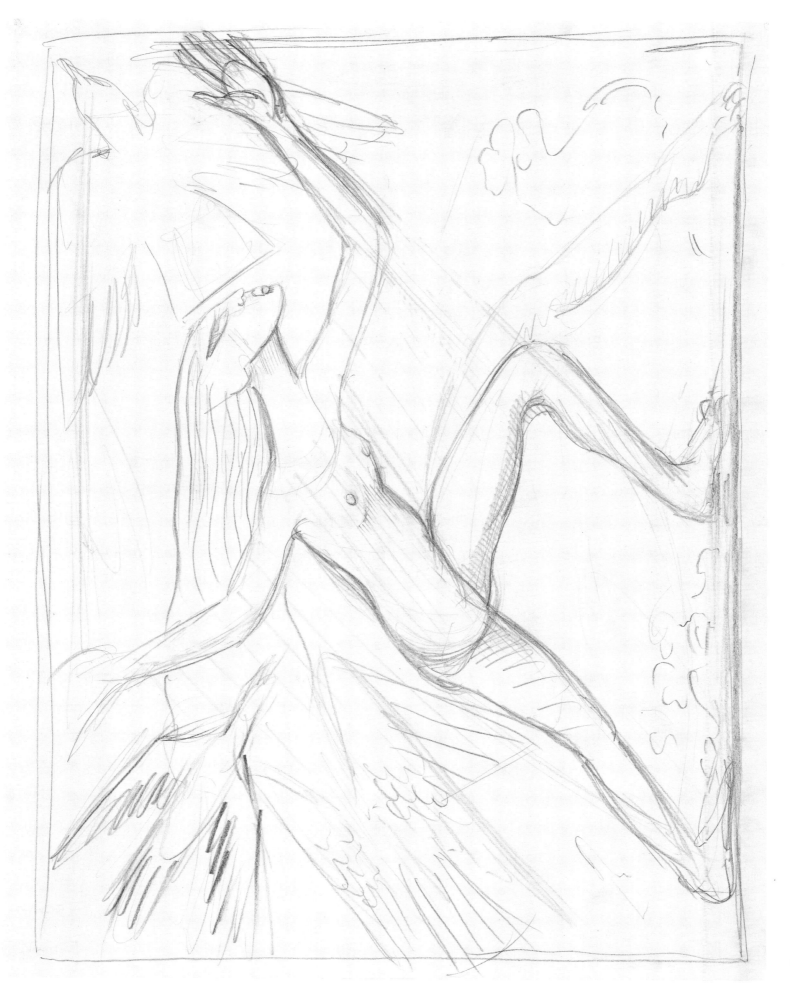

D57. DESIGN FOR THE RIMA RELIEF,
PROBABLY ORIGINALLY PART OF
THE LEEDS SKETCHBOOK, 1923,
PRESENT WHEREABOUTS UNKNOWN.
FROM R. BUCKLE, JACOB EPSTEIN
SCULPTOR, 1963, PLATE 208

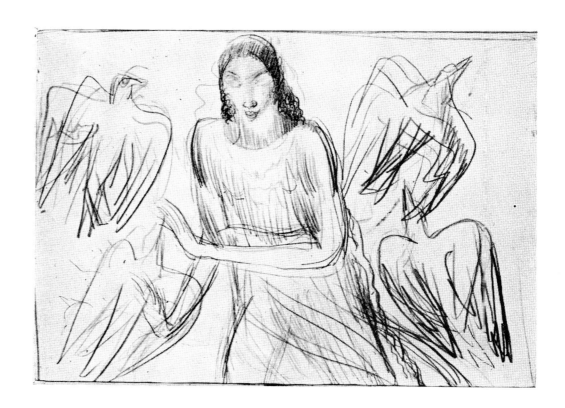

ABBREVIATIONS AND NOTES

BAL The British Architectural Library, The Royal Institute of British Architects, London: Manuscript and Archives Collection

Bone James Muirhead Bone

Cork R. Cork, *Art Beyond The Gallery in Early 20th Century England*, 1985

D Prefix to *Rima Sketchbook* drawings (1–56v): The Henry Moore Centre for the Study of Sculpture, Leeds City Art Galleries

Earle Sir Lionel Earle, Secretary, The Office of Works

Epstein 1940 J. Epstein, *Let There Be Sculpture*, 1940

Epstein 1987 *Jacob Epstein: Sculpture and Drawings*, Leeds City Art Gallery, 1987

GM W. H. Hudson, *Green Mansions*, 1904 (1927 edition)

Graham Robert Bontine Cunninghame Graham

Haskell *The Sculptor Speaks: Jacob Epstein to Arnold L. Haskell: A series of conversations in Art*, 1931

HMCSS The Henry Moore Centre for the Study of Sculpture, Leeds City Art Galleries

Jowett F. W. Jowett, First Commissioner, The Office of Works (1924)

Lemon Mrs Frank Lemon, Secretary, W. H. Hudson Memorial Committee (1922–23)

Manning E. Manning, *Marble & Bronze: The Art and Life of Hamo Thornycroft*, 1982

Pearson Lionel G. Pearson

Peel Viscount Peel, First Commissioner, The Office of Works (1925)

Powell L. B. Powell, *Jacob Epstein*, 1932

PRO Public Record Office, Kew (Work 20/ 175)

RA The Royal Academy of Arts, London

RIBA The Royal Institute of British Architects: Drawings Collection, London

RSPB The Royal Society for the Protection of Birds, Sandy, Bedfordshire (*MB*: *W. H. Hudson Memorial Minute Book*)

Rothenstein W. Rothenstein, *Men and Memories: Recollections of William Rothenstein 1900– 1922*, I, 1931, II, 1932

Rutter 'Epstein and Hudson. Irreconcilables in Art. Charm v. Force', undesignated press cutting dated 24 May 1925 (*TGA*)

Sarawak Margaret Brooke, The Ranee of Sarawak

Silber E. Silber, *The Sculpture of Epstein*, 1986 (*S*: catalogue reference)

TGA The Tate Gallery Archives, London

Tomalin R. Tomalin, *W. H. Hudson: A Biography*, 1982

Vogel S. M. Vogel, *African Aesthetic: The Carlo Monzino Collection*, 1986

I
'RIMAPHOBIA'

1. *BAL* HoC/4/15, letter dated 17 December 1940. In MS notes on Epstein (HoC/1/13 (v–vi)) dated 3 December 1940, Holden stated: 'I am a profound admirer [of *Rima* and] after many pilgrimages to it I am more and more convinced that the 20th Century has no finer piece of sculpture to its credit'.
2. W. Muir, 'Epstein in Hyde Park. An Interview with the Famous Sculptor, whose Memorial has Aroused a Storm of Controversy', *The Sphere*, 30 May 1925, p. 258.
3. Statues of royalty and statesmen were the rule; only Burns, Byron, Carlyle, Milton, Rossetti and Shakespear had been so honoured by 1925 (C. S. Cooper, *The Outdoor Monuments of London*, 1928, pp. 15, 18, 66, 81, 85).
4. J. C. Squires, in *The London Mercury*, June 1925, XII, no. 68, p. 113.
5. Brief accounts of Baldwin's speech are given in *The Daily Telegraph*, 20 May, *The London Mercury*, June, XII, no. 68, p. 114, *The Yorkshire Post*, 20 May 1925, and *Rothenstein*, I, p. 15.
6. *Epstein 1940*, p. 129 and F. A. Roper, in *The Worthing Herald*, 20 July 1977, recalling that she thought *Rima* the 'most awful travesty I ever could imagine'; her father, George Hubbard was an outspoken critic of the work: he wrote to Lemon, 30 May 1925: 'I can imagine the scorn that Hudson would have shown had he seen the horrible thing erected to his memory' (RSPB);

he also published protest letters in *The Daily Mail*, 21 May and *The Times*, 26 May 1925, and is mentioned in other contemporary letters to the press concerning *Rima*.
7. 25 and 21 May, 22 July, 16 and 28 November, 26 November 1925 respectively.
8. 'The word "Epsteinism" is a synonym for "art atrocity"' (*The Liverpool Post and Mercury*, 20 January 1932).
9. J. Lavery, *The Life of a Painter*, 1940, pp. 126–27, *The Daily News*, 6 October, *The Yorkshire Evening News*, 1 June 1925 and *Jacob Epstein: Rebel Angel* (Central Independent Television plc production, 1987) respectively.
10. 'Shall we stop and have a look at that Memorial affair they made such a fuss about?''I've seen it, Dad.' 'So have I,' said Soames. 'Stunt sculpture!' (J. Galsworthy, *Swan Song*, the final part of *A Modern Comedy*, 1928, in *The Forsyte Saga* (1970 edition, p. 63)).
11. 1981 edition, p. 13.
12. *The Evening Standard*, 18 November 1925.
13. Anonymous MS, among the papers of the academic sculptor, Sir William Hamo Thornycroft, RA (*HMCSS*).
14. *The Times*, 9 September 1925. Elsewhere Epstein referred to a 'campaign of vilification' (*Epstein 1940*, p. 129).
15. *Haskell*, p. 3.

1. *S* 49.

2. 'Epstein Panel to Hudson. A Travesty of Nature', *The Daily Mail*, 21 May 1925.

3. *Rutter* (who had been curator of Leeds City Art Gallery in the previous decade) added: 'If . . . we can forget Hudson, and regard Epstein's new work simply as his own expression of the soaring desires and upward gaze of Genius, then I think we must admit that it is an expressive and impressive work of great power and originality'. Rutter's *Evolution in Modern Art: A Study of Modern Painting 1870–1925*, 1926, pp. 124–27, mentions only *Rock Drill*.

4. Dent also thought the relief a 'fine piece of work', while admitting that it would not 'please everybody'.

5. *Tomalin*, select bibliography, pp. 300–04.

6. Quoted in E. Pound, 'Hudson: Poet Strayed into Science', *The Little Review*, May–June 1920, reprinted in W. Cookson, ed., *Ezra Pound: Selected Prose 1909–1965*, 1978, pp. 399–402.

7. *Rothenstein*, II, p. 161.

8. 'An appreciation of W. H. Hudson', Foreword to *Dead Man's Plack, An Old Thorn and Miscellanea*, 1923.

9. *Tomalin*, p. 25.

10. *Feathered Women*, 1893, *The Trade in Birds' Feathers*, 1898 (G. F. Wilson, *A Bibliography of The Writings of W. H. Hudson*, 1922; *Tomalin*, pp. 243–46).

11. *RSPB*: MB, pp. 3–5. 3,700 appeal leaflets and 3,000 single sheets were distributed by 10 January 1923 (*RSPB*: MB, pp. 11–12).

12. Galsworthy wrote an enthusiastic foreword to the Alfred Knopf 1916 edition of *Green Mansions* (*Tomalin*, p. 222). An undated typescript (PRO: Work 20/175) states that Fallodon suggested the *Rima* theme, but there is no firm evidence to support this.

13. *S* 148–49.

14. *Rothenstein* has much to say about Hudson.

15. Ford Madox Ford recounts that Garnett gave a lunch at the *Mont Blanc* in London attended by Hudson, Bone, Conrad and Galsworthy (*Return to Yesterday*, 1932; 1972 edition, p. 397). The other Committee members were Vicountess Grey of Fallodon, Holbrook Jackson, Mrs Frank Lemon (Secretary), H. J. Massingham and Mrs Reginald McKenna (*RSPB*: MB, p. 1); For Gardiner and Garnett, see *Tomalin*, pp. 183–84, 189–92, 195–200, 230–31.

16. *RSPB*: MB, p. 3. Roberts was the author of *W. H. Hudson: A Portrait*, 1924.

17. *RSPB*: MB, pp. 3–5; the site was undesignated. The scheme is mentioned in *RSPB*: Sarawak to Lemon, 3 December 1922. *The Architect*, 5 June 1925, p. 404, suggested that Epstein 'wanted to let the memorial . . . take the form of a portrait model'.

18. The Appeal leaflet, November 1922 (*RSPB*) mentions a portrait medallion to be executed in stone or marble. T. Spicer-Simson, *Men of Letters of the British Isles. Portrait medallions from the life*, 1924, p. 87. Graham recollected the Committee discussing 'several sculptors', none of whom are mentioned by name (*The Daily Telegraph*, 25 May 1925).

19. 25 May 1925, referring to Thomas Brock's statue of *Sir Henry Irving*, 1910, Charing Cross Road (C. S. Cooper, *The Outdoor Monuments of London*, 1928, pp. 54–55). For Thorndike's bust, *S* 161.

20. *RSPB*: Sarawak to Lemon, 22 May 1925.

21. *RSPB*: Mrs Reginald McKenna to Graham, 10 July 1923; *MB*, p. 34.

22. *RSPB*: E. Maitland to Lemon, 3 December 1922, remarking that the firm had 'most excellent . . . designs [and] some really beautiful things in stone work'. The sculptor, Gilbert Bayes (1872–1953) was employed by the firm from c1923 (L. Irvine, 'The Architectural Sculpture of Gilbert Bayes', *Journal of the Decorative Arts Society*, 4, 1980, pp. 6–7). Stanley Casson (*XX Century Sculptors*, 1930, p. 111) thought Henri Gaudier-Brzeska (1891–1915) 'alone could have met the situation. Something on the lines of his 'Faun' would have succeeded' for the *Hudson Memorial*, or perhaps a work by the Dane, Carl Milles. Casson had illustrated *Fawn* in *Some Modern Sculptors*, 1928, p. 109, fig. 36.

23. *Epstein 1940*, p. 107; *S* 145. 'I have just come from Epstein's. I am sitting for my bust' (*RSPB*: Graham to Lemon, 18 April 1923). Graham once owned the *Rima Sketchbook* now at Leeds (see Appendix A).

24. *Silber*, pp. 18, 34–37; *S* 75.

25. Appendix B1.

26. *Epstein 1940*, p. 302. The typescript of Bone's 29 November 1925 government report, reprinted in *Epstein 1940*, pp. 294–302, is *PRO*: Work 20/175.

27. *RSPB*: MB, p. 3 and Appendix B2, *MB*, p. 28. Hudson was 'a lonely man, with something of the animal about him' (*Rothenstein*, II, p. 63).

28. *RSPB*: Graham to Lemon, 6 and 7 December 1922.

29. *RSPB*: MB, p. 9.

30. *Epstein 1940*, p. 128. Galsworthy apparently attended only two meetings to give 'friendly advice' ('"Rima" Fund', *The Morning Post*, 27 November 1925).

31. See Chapter 1, note 10. On this occasion Soames also remarked on sculpture by Augustus St Gaudens in Washington and Charles Sergeant Jagger's *Artillery War Memorial*, Hyde Park Corner (pp. 63, 79–80, 82–83).

32. *RSPB*: Bone to Lemon, 29 December 1922. A. F. Tschiffely, *Don Roberto: Being the Account of the Life and Work of R. B. Cunninghame Graham 1852–1936*, 1937, pp. 402–03, states that Galsworthy and Fallodon resigned from the Hudson Memorial Committee when Graham insisted on Epstein.

33. Bone informed Lemon, 29 December 1922, that he had asked 'a friend who is a very good architect to help prepare the scheme so that it can be clearly understood and discussed. My friend has beautiful taste & is a very helpful man'; Pearson thought the site 'splendid . . . and very suitable for our memorial' (*RSPB*; see also Bone to Lemon, 18 January, and Lemon to Earle, 25 January 1923).

34. The firm was also responsible for the London Underground Electric Railways

Headquarters, St James's, London, which incorporates Epstein's *Day* and *Night*, 1928–29 (*S* 9, 40, 189).

35. A. Compton, ed., *Charles Sargeant Jagger: War and Peace Sculpture*, 1985, pp. 83–86 and pl. 67. Pearson advised on the publication of Arnold Whittick's *War Memorials*, 1946 (p. viii).

36. *RSPB*: *MB*, pp. 3–5, 9.

37. *RSPB*: Graham to Lemon, 7 December 1922.

38. *RSPB*: *MB*, p. 15; Lemon (?) to Earle, 11 January; also Bone to Lemon, 18 January 1923. The site was granted in a letter dated 26 January 1923 (*MB*, p. 23).

39. *RSPB*: Lemon to Earle, 25 January 1923.

40. Appendix B1.

41. *RSPB*: Bone to Lemon, 5 February 1923. Bone described this design on 14 February (*RSPB*: *MB*, p. 24).

42. *RSPB*: *MB*, pp. 31–32.

43. *RSPB*: Pearson to Lemon, 28 April and 30 May 1923: 'I had rather a difficulty in doing the drawing owing to not having a drawing of Epstein's model [for the relief] to go on. However, I think it looks quite well' (Bone to Lemon, 31 May 1923). This drawing arrived in London on 5 June (*RSPB*: Holden to Lemon, 5 June 1923).

44. *RSPB*: Pearson to Lemon, 21 June 1923, describing it as one inch to the foot scale; this is confirmed in a letter from Adams, Holden and Pearson to *The Morning Post*, 27 November 1925. 'Mrs [Reginald] McKenna sees great difficulty if the Office of Works are asked to visualise anything else other than the model of 12 June' (*HMCSS*: Lemon to Bone, 3 August 1923).

45. *Epstein 1940*, p. 298. See also '"Rima" And Its Designer', *The Morning Post*, 26 November 1925.

46. *RIBA*: AHP[42]6 is almost identical to [42]8 (see Appendix A).

47. Appendix B1.

48. The drawing, signed and dated 1924, appeared in *The Times* and *The Manchester Guardian*, 21 March, and *Country Life*, 22 March 1924, p. 425, and was widely reported in the press at the time. 'In this drawing the Epstein Panel is shown as it was in the large model submitted to His Majesty's Office of Works' (PRO: Hugh R. Dent to Office of Works, 24 November; '"Rima" and Its Designer', *The Morning Post*, 26 November 1925).

49. Originally attached to the firm's *Specification of Works* (*RSPB*).

III
EPSTEIN'S FIRST DESIGN

1. *RSPB*: *MB*, p. 16 (10 January 1923 meeting). *S*146 and *Epstein 1987*, cat. nos 111–15. Bone told Lemon on 29 December 1922 (*RSPB*) that the 'weather is quite favourable' for Epstein to present his design at the next Committee meeting.

2. *RSPB*: *MB*, p. 16.

3. *Return to Yesterday*, 1932 (1972 edition, pp. 34–35).

4. *Rothenstein*, II, p. 40.

5. *Brooke Boothby*, in a private collection in 1922, was bequeathed to the National Gallery in 1925 (B. Nicolson, *Joseph Wright of Derby: Painter of Light*, 1968, I, pp. 127, 183). Versions of the *River God* (in the Museo Capitolino and the Campidoglio, Rome) had been resited during the Renaissance in fountains designed by Michelangelo and Giacomo della Porta (P. P. Bober and R. Rubinstein, *Renaissance Artists & Antique Sculpture*, 1986, pp. 64–68, pls 64–67).

6. Illustrated in Lady Epstein and R. Buckle, *Epstein Drawings*, 1962, pl. 39, as a scheme of unknown origin. In 1923 Cunninghame Graham mentioned that 'Epstein has a charming fountain with birds in the Tate Gallery (I think) & it is a thing he can do well' (*RSPB*: letter to Lemon, 29 January 1923). What can this be?

7. This episode, including reprinted press articles, is recounted in *Epstein 1940*, Chapter 22. See, in addition, Epstein's related letter published in *The Times*, 21 February 1923.

8. *RSPB*: *MB*, p. 16 (10 January 1923).

9. *RSPB*: Bone to Lemon, 2 February 1923.

Bone had confidently told Lemon that he need only show Earle a photograph of the maquette to gain approval (*RSPB*: 18 January; also Lemon to Earle, 23 January 1923) but in an undated letter to Graham, Mrs Reginald McKenna stated: 'I tried hard to soften [Earle's] view but he was adamant', and she concluded that 'it seems idle for the Committee to expend time and money in a useless design' (*RSPB*; also Appendix B1).

10. S. Nairne and N. Serota, *British Sculpture in the Twentieth Century*, 1981, pp. 15, 17, 252; S. Beattie, *The New Sculpture*, 1983.

11. 'Architecture and Decoration', an address delivered before the RA, January 1923, published in *The Touchstone of Architecture*, 1925, pp. 210–11. Blomfield's attack on Cubism and other modernist attitudes was delivered in an address, 'Off the Track: Some Thoughts on Art', to the Birmingham and Midland Institute, June 1924, and published in *The Touchstone of Architecture*, pp. 223–45: 'Greek sculpture is absolutely beautiful, while Cubist art is intrinsically and objectively hideous' (p. 244).

12. 'The Tangled Skein: Art in England, 1800–1920', a British Academy address, May 1920, published in *The Touchstone of Architecture*, 1925, pp. 124, 132, 134–35. R. Fellows, *Sir Reginald Blomfield: An Edwardian Architect*, 1985, Chapter 6. Blomfield, with Sir Thomas Brock, approved the *Guards* Memorial design in January 1922, for a site in St James's Park (P. Skipwith, 'Gilbert Ledward R. A. and the Guards' Division Memorial', *Apollo*, January 1988, p. 24).

IV
THE 'WONDERFUL WOMAN SPIRIT'

1. Appendix B1. Bone wrote Lemon, 5 February 1923: 'I hope you will agree that the figure of the "nature spirit" in "Green Mansions" is an appropriate subject to carve on

the fountain' (*RSPB*). Two rough sketches of striding figures, on the verso of the drawing of Hudson reclining in the forest [14], may represent early thoughts on such a revised design.

2. *GM*, pp. 9, 32, 34, 72, 217 respectively.

3. *RSPB*: Bone to Graham, 2 February, and Bone to Lemon, 29 January 1923 respectively.

4. Appendix B1; 'we will ask Mr. Epstein to proceed along the original course decided by the committee' (Lemon to Bone, 8 February 1923).

5. *RSPB*: *MB*, pp. 24–25 (14 February); Bone to Lemon, 15 February 1923.

6. *GM*, p. 65.

7. Appendix B2 and *MB*, p. 28. Epstein accepted in a letter to Lemon, 18 February 1923: 'I am in entire accord with the contents of your letter and am to proceed with the design immediately'.

8. *RSPB*: *MB*, pp. 31–33.

9. *RSPB*: Graham to Lemon, 18 April 1923.

10. *RSPB*: Lemon to Earle, 8 June 1923.

11. *Epstein 1940*, p. 128; 'personally I feel satisfied that I have interpreted the spirit of the writer … with a work which may be described as symbolical' (Epstein defending *Rima* in *The Sunday Express*, 24 May 1925).

12. *GM*, p. 314; a 'Spirit of the Tree' (*RSPB*: Graham to Lemon, 6 February 1923).

13. Appendix B1.

14. *RSPB*: Earle to Lemon, 7 June 1923.

15. Appendix B3.

16. *RSPB*: Bone to Lemon, 19 June 1923.

17. *RSPB*: Earle to Lemon, 26 June 1923 and *MB*, p. 34. Graham told Lemon, 4 July 1923, that Earle personally considered the ensemble 'beautiful' (*RSPB*).

18. Mrs Reginald McKenna, favouring a Lutyens bird-bath design, recommended that Epstein receive 'whatever sum is necessary and fair to cover the expenses incurred in making his model and whatever compensation cash can provide for his time and ideas [since] no modification of the present design will be accepted' (*RSPB*: letter to Graham, 10 July 1923 and *MB*, p. 34).

19. Epstein 'is most anxious to do the memorial' (*RSPB*: Graham to Lemon, 28 June 1923).

20. *RSPB*: *MB*, pp. 36, 38 (letter dated 10 July 1923).

V
RIMA REVISED

1. *Haskell*, p. 29. 'I read Hudson long before the memorial was considered, and before I began my design I re-read 'Green Mansions', and considered the committee's wishes regarding Rima' (*The Sunday Express*, 24 May 1925); see Graham's confirmation of this (*The Daily Telegraph*, 25 May 1925). When in 1936 Epstein began the illustrations for a new edition of *Les Fleurs du Mal* (published as *Flowers of Evil*, 1940), he brooded on the 'powerful and subtle images evoked by long reading' of Baudelaire (*Epstein 1987*, pp. 200–05). Later, in 1955–58, working on the monumental bronze *St Michael and the Devil* for Coventry Cathedral (*S* 503), Epstein may have recollected Hudson's description of a native carving in a church in a town on the Orinoco, in which the archangel 'twice as tall as a man' is thrusting his spear into a 'monster shaped like a cayman, but with bat's wings, and a head and neck like a serpent' (*GM*, p. 104).

2. *Pelino Viera's Confession* and *Marta Riquelme* (*Tomalin*, pp. 120, 195, pl. 7).

3. At the time of his death in 1959 the collection numbered nearly 1,000 items, among which were a dozen of the greatest masterpieces of tribal art (E. Bassani and M. McLeod, 'The Passionate Collector', in *Epstein 1987*, pp. 12–19; *Vogel*).

4. According to the sculptor's daughter, Peggy-Jean Lewis (born 1918), who also recalls frequent visits with Epstein to Brancusi's studio (in conversation with the author, 4 July 1987).

5. *Epstein 1940*, pp. 215–16.

6. *The Times*, 9 September 1925, quoting from an undesignated article published in *Teacher's World*.

7. *GM*, pp. 65–66.

8. *GM*, p. 22.

9. *GM*, pp. 301, 199 respectively.

10. Dolores serialised her life in 1930 in *The American Weekly*, with the headlines: '"The Fatal Woman" of the London Studios: The Famous Artists' Model of Modern Times, for Whom Three Men Have Killed Themselves (a "Vampire Who Destroys a Soul,")', in which she alludes to her association with Epstein, who is pictured with Sunita and her son, Enver. The groups of *Day* and *Night* ('Two of Epstein's Monstrosities … "Is This Art or Insanity"') are also illustrated.

11. *S* 39, destroyed 1914.

12. This was an expression of her 'resentment [of the] gratuitous insult to a great work of art' (*The Evening Standard*, 20 November 1925). The following day Epstein denied knowledge of the incident and disapproved of it (*The Daily Herald*).

13. *Epstein 1940*, p. 109. Epstein modelled her on five occasions during 1922–23 (*S* 131–35); the first portrait was described as 'La Bohemienne' at the Leicester Galleries exhibition in 1931; the third and fourth are illustrated in H Wellington, *Jacob Epstein*, 1925, pls 25–28. A plaster of the head of *Marie Collins*, 1924 (*S* 152) was incorrectly associated with *Rima*, in 'Epstein Panel Disfigured', *The Daily Herald* 14 November 1925, illustrated.

14. *S* 17, 122, 128, 159.

15. Vol. MCMXXV, 1925, pp. 174–75.

16. *Vogel*, cat. nos 93, 136.

17. *Epstein 1940*, pp. 216–17, illustrated opposite p. 296; *Vogel*, cat. no. 99.

18. *Epstein 1940*, p. 61.

19. *No. 3 Notebook*, 1922–24, pp.121, 91 respectively (The Henry Moore Foundation), in *Henry Moore at the British Museum*, 1981, pp. 88–89, 100–02 and *Henry Moore: Early Carvings 1920–1940*, Leeds City Art Galleries, 1982, cat. nos 46, 48, XI, XIII; *Epstein 1987*, cat. no. 125, fig. 83. Epstein owned a similar Zaire stool.

20. *GM*, pp. 178, 112, 197 respectively.

21. This Assyrian-inspired work also has strong Egyptian associations (*Epstein 1987*, pp. 124–31; M. Pennington, *an Angel for a Martyr: Jacob Epstein's tomb for Oscar Wilde*, 1987 pp. 34–39).

22. *GM*, pp. 36, 43 respectively; see also pp. 195–96.
23. Recollection of the sculptor's daughter, Peggy-Jean Lewis, who accompanied Margaret Epstein on this particular foray (in conversation with the author, 4 July 1987).
24. Such as the magnificent wood helmet mask in the form of a bird from the Grasslands, Cameroon (*Epstein 1987*, fig. 5, item 2).
25. The carving was for some years at St Augustine's Missionary College, Canterbury and then in the possession of a well-known London collector, J. Hooper, before Epstein acquired it (information from Ezio Bassani and Malcolm McLeod, to appear in their forthcoming catalogue of Epstein's collection of primitive and ancient sculpture and related artefacts).
26. *The Morning Post*, 19 June, *The London Mercury*, June 1925, XII, no. 68, p. 114, *The Morning Post*, 23 November, *The Evening News*, 26 November 1925 respectively.
27. *The Nation and Athenaeum*, 6 June 1925. Woolley published his findings in *Ur 'of the Chaldees'*, 1929.
28. Evelyn St. Leger, in 28 November 1925, referring to Epstein's 'find'.
29. *S*6, 9, 21; *Cork*, pls 14–15, 34–35, 53–55. Epstein possessed a small collection of Greek and Roman sculpture.

30. See also the related D14v.
31. See Chapter 3, note 7.
32. R. Lullies, *Greek Sculpture*, 1957, pp. 54–55, pls 132–35. Patrick (later Sir) Abercrombie of the Liverpool University School of Architecture, referred to the *Ludovisi Throne* in his attack on *Rima* in *The Times*, 30 May 1925; see also *The Morning Post*, 3 June 1925.
33. R. Buckle, *Jacob Epstein*, 1963, p. 134.
34. I am grateful to Ruth Walton for directing attention to this source.
35. *GM*, pp. 269–71. This is the passage, misquoted by Epstein, identified in *Haskell*, p. 28.
36. *GM*, pp. 32–36, 66, 80–81.
37. A. Whittick, *War Memorials*, 1946, Chapter 4.
38. *The Times*, 9 September 1925, quoting from an undated issue of *Teacher's World*.
39. This innovation escaped all but the most perceptive observers at the time, though it may have had significance for the development of open-air sculpture exhibitions in England: the first of these, held in Battersea Park in 1948, included work by Epstein (W. J. Strachan, *Open-Air Sculpture in Britain*, 1984, p. 15).

VI
RIMA CARVED

1. *RSPB: MB*, p. 40.
2. *Epstein 1940*, p. 301.
3. *Epstein 1940*, p. 130. The sizes are unrecorded, though Pearson's site plans indicate panels 54 by 86 inches for the first *Rima* scheme (*RIBA*: RHP[42]7, dated 25 June 1923) and 44 by 72 inches for both RHP[42]8, dated 5 November 1923, and [42]9, dated 5 May 1924.
4. *RSPB*: Bone to Lemon, 5 February 1923.
5. Letter reprinted in *The Times*, 18 June 1925. See also a similar observation by *Powell*, p. 81.
6. Epstein's paraphrase (*Epstein 1940*, p. 130) of Shaw's letter to *The Times*, 12 June 1925, which prompted *Punch* to reply that the relief 'sprawls [and] laps over its limits, like some of Mr. SHAW's plays ... for a really great artist, if he is given four yards, will not go to work as if they were forty' (A.H.P., 'Mr. Shaw, Mr. Epstein and the Pretty Birds', 1 July 1925, pp. 706–07).
7. For Moore's view, expressed in 1925, see *Henry Moore: Early Carvings 1920–1940*, Leeds City Art Galleries, 1982, p. 44.
8. 'Sir Lionel [Earle] mentioned as the sort of thing approved of in the Royal Parks the Peter Pan statue — "because of an imaginary figure." (It does not seem to us to possess much imagination!)' (*HMCSS*: Bone to Graham, 2 February 1923). *Peter Pan* is also mentioned in *RSPB*: Graham to Lemon, 7 December 1922 ('that ridiculous Peter Pan offence'), Dent to Lemon, 11 June and Appendix B3.
9. 'The elbows are striking, but I found it difficult to make out the head until I realized that much of this was shaved off' (George C. Swinton, in *The Times*, 1 June 1925). The Countess of Oxford criticised the way the top of the head 'sloped off', giving 'a foolish expression

which diminishes the energy of the whole, and lends too much importance to her pear-shaped stomach' (*RA: The Daily News*, undated press clipping). 'One critic says that the EPSTEIN relief is too advanced for the crowd, but, after looking at it carefully, we've come to the conclusion that his female's head is distinctly low-brow' ('Charivaria', *Punch*, 3 June 1925, p. 589).
10. *The Meaning of Modern Sculpture*, 1932, p. 104.
11. A. E. Elsen, *The partial figure in modern sculpture from Rodin to 1969*, 1969, pp. 41–42. For Thornycroft's comment on the modernists' over-estimation of the 'charm which a fragment or a limbless statue has beyond which a complete figure would have', see *Manning*, p. 181.
12. Gaudier-Brzeska was killed on the Western Front in 1915; another friend, T. E. Hulme (*S*69), was to die in France in 1917.
13. *RSPB*: Graham to Lemon, 27 June 1923.
14. *The Times*, 25 May 1925.
15. By 16 March 1923 arrangements for selecting the stone were in hand (Lemon to Epstein and Lemon to Dent, 27 March 1923); the contract for carving between Epstein and Graham, with Charles Aitken, Director of the Tate Gallery, deputed as arbitrator, was signed 3 April (*RSPB*); Epstein and Pearson then journeyed to the Island of Portland, where they selected 'a very excellent block ... suitable in every way' from the Bates and Portland Stone Firm quarry (*RSPB*: Pearson to Lemon, 14 May 1923 and *MB*, p. 42). A tracing of Pearson's design for the stone screen (*RIBA*: AHP[42]8) was sent to Bates on 5 November 1923 and another in May 1924, and to the builder, Wallis on 27 January 1925 (*RIBA*: AHP[42]9).

16. *RSPB*: Pearson to Lemon, 30 March 1923, *MB*, p. 16 (10 January 1923) and *Epstein 1940*, p. 301 respectively.

17. Muirhead Bone, quoted in *Epstein 1940*, p. 301.

18. *The Marble Faun: or the Romance of Monte Beni*, 1860, chapter entitled 'A Sculptor's Studio' (Everymans Library edition, pp. 94–95).

19. Bone added: 'The uninstructed public cannot, of course, be expected to understand these matters at present' (*Epstein 1940*, pp. 301–02).

20. *Powell*, p. 80.

21. *Powell's* photograph opposite p. 81 shows the finished relief still in Epstein's studio.

22. W. Muir, 'Epstein in Hyde Park', *The Sphere*, 30 May 1925, p. 258.

23.. *Epstein 1940*, p. 301.

24. 'What's It All Bloom' Well For?', *G. K.'s Weekly*, 20 June 1925, p. 302. *Rothenstein*, II, p. 129, observed in connection with *Rima* that Ruskin 'realised perfectly that roughness is necessary for work which is to be seen at a distance; a roughness which, from a distance, looks smooth. But Epstein's stone carvings look neither rough nor smooth; I doubt whether he would have modelled his figures thus, had he been working for bronze'.

25. 'The Tangled Skein: Art in England, 1800–1920', delivered before the British Academy, 5 May 1920, published in *The Touchstone of Architecture*, 1925, p. 134. Thornycroft believed Rodin's 'foible of leaving part of the work intentionally unfinished was a late development and was unworthy of him' (*Manning*, p. 180).

26. Ernest H. R. Collins, in *The Times*, 21 May 1925.

27. *Epstein 1940*, p. 128. He was undoubtedly in a Whitmanesque mood: 'Here by myself away from the clank of the world' ('In Paths Untrodden', from *Calamus* in *Leaves of Grass*).

28. Pearson's site drawing dated 5 May 1924 (*RIBA*: AHP[42]9) is annotated 'Stone block for carving (now in sculptor's studio)'.

29. The decision to build a new studio for a sum not exceeding £50 was made at the 12 May 1924 committee meeting (*RSPB: MB*, p. 42). The construction, lining and insurance are referred to in *HMCSS*: Lemon to Bone, 16 November 1923 and *RSPB*: Epstein's receipt, 22 July 1924 and *MB*, p. 45.

30. *RSPB: MB*, p. 45 (12 September 1924).

31. Epstein wrote to Vitofski, 11 March 1925: 'I am sorry I have no drawings; I've done nothing except the slightest of sketches for over a year and in that time have been mostly at work on the Hudson Memorial stone … The Hudson thing doesn't pay me and I've given a lot of time to it' (National Art Library, London: MSL 125–1980). For other work during 1924, see *S*144, 148–56.

32. *RSPB: MB*, p. 47 (29 April 1925) recording that the builder, Wallis had also finished on that date.

33. Adams, Holden and Pearson's *Specification of Work* (*RSPB*), drawn-up in October 1924, called for the 'whole of the work … to be executed in accordance with the style, character and finish of first class work with the best workmanship and the materials … to be the best of their respective kind'; the stone was to be the 'best quality … from an approved quarry of the Bath and Portland Stone Firms Ltd … to be carefully and truly worked to detailed drawings' and the contractor was obliged 'to keep a competent Foreman constantly on the Site' as well as to collect the relief from 'the Sculptors Studio at Loughton' and cart it to the site. Pearson recommended that at least three firms tender estimates for the stonework (*RSPB: MB*, p. 45, 12 September 1924).

34. *RIBA*: AHP[42]10. Several variant inscriptions were considered (*Country Life*, 22 March 1924, pp. 425–26; *RHP*[42]8, dated 5 November 1923; AHP[42]11, the latter having been sent to Gill on 3 April 1925). The executed text was resolved by 29 April 1925 (*RSPB: MB*, p. 47). Gill designed the inscription on the *Wilde Tomb* in 1912 (M. Pennington, *an Angel for a Martyr: Jacob Epstein's tomb of Oscar Wilde*, 1987, pp. 50–52).

35. *RSPB:MB*, pp. 24–25 (14 February 1923) and Appendix B2. Graham incorrectly stated Epstein received £400 (*The Daily Telegraph*, 25 May 1925). Bone reckoned the Committee 'ought to be able to get the whole thing … beautifully done for round about £1000' (Appendix B1) and advised an initial payment to Epstein of £100, 'not the usual one third of the whole fee' (*RSPB: MB*, p. 33, 16 March 1923). The 3 April 1923 *Contract* specified a six guinea daily fee 'or for any part of a day during which the personal attendance of the Sculptor is required by the client for giving professional advice or a report upon any matter other than the carrying out the specific work', thought he had to meet the cost of drawing designs and 'repairing or making good any breakage or damage to the work during its presence on his premises' (*RSPB*), which also lists the sculptor's and architect's combined fees as £1,572 15s 2d ('Receipts and Payments Accounts', 22 January 1926). *RSPB: MB*, lists various payments 1923–25.

36. John Galsworthy gave 5s; Neville Chamberlain and Thomas Hardy 1 guinea; Zane Grey £2; Edmund Gosse, Sir Henry Newbolt, Morley Roberts and George Bernard Shaw 2 guineas; John Masefield and Arthur Wing Pinero 3 guineas; *The Manchester Guardian* 4 guineas; Joseph Conrad, Francis Dodd, Arthur Conan Doyle, Sir Lionel Earle £5; Mr and Mrs Frank Lemon, Mr and Mrs William Rothenstein 5 guineas; Samuel Courtauld £10; *RSPB* 10 guineas; Mr and Mrs Muirhead Bone, Edward Garnett, The Ranee of Sarawak £25; Sociedad Ornitologica del Plata £36 14s 6d; Lord and Lady Grey of Fallodon £40; Cunninghame Graham, Reginald McKenna and the Duke of Westminster £50; *Country Life*, Dent, Duckworth, Dutton, Heineman, Knopf and Longmans, Green (publishers) gave from 2 guineas to £50 (*RSPB*: List of Subscribers to Hudson Memorial Fund, and *Country Life*, 3 May 1924, p. 684).

VII
THE PRO-EPSTEINERS

1. He later recalled that 'This small and inoffensive panel produced a sensation wholly unexpected on my part ... For a whole summer troops of Londoners and provincials wore the grass down in hard, beaten earth in front on the monument, seeking the obscenities that did not exist' (*Epstein 1940*, p. 129).

2. 24 May 1925: 'they do not wish their names to be advertised'.

3. *The Times*, 23 May 1925. Kennington was attacked for his stand, in a letter from E. R. Eddison (The Athenaeum Club) to *The Times*, 25 May 1925.

4. 21 March 1924. *Country Life*, which had done so much to promote the appeal for funds (22 March 1924, pp. 425–26) reaffirmed its 'admiration for the conception and vigour of the design' (27 June 1925).

5. 23 November 1925.

6. *The Times*, 18 June 1925. He wrote to HM First Commissioner of Works, 29 November 1925: 'it cannot be in the public interest to humiliate a well-known and experienced sculptor who has done his best with a public commission' (*Epstein 1940*, p. 300).

7. *The Times*, 12 June 1925.

8. 1 June 1925.

9. 'The Hudson Memorial', *Dial*, 79, 1925, pp. 370–73, quoted in *Silber*, p. 45.

10. Letter to Marie Mauron, 10 June 1925 (D. Sutton, ed., *Letters of Roger Fry*, 1972, II, pp. 572–73).

11. *The Yorkshire Post*, 1 June 1925.

12. This conjures up Hudson's description of Rima: 'I felt her fingers touching my skin, softly, trembling over my cheek as if a soft-winged moth had fluttered against it' (*GM*, p. 186) and sketchbook drawing D 51.

13. *The Morning Post*, 21 November 1925. Whittick later wrote *Symbols for Designers. A handbook on the application of symbols and symbolism to Design, for the use of architects, sculptors, ecclesiastical and memorial designers*, 1935, *History of Cemetery Sculpture*, 1938, *War Memorials*, 1946, and *European Architecture in the Twentieth Century*, 1950.

14. *Rutter*.

15. Appendix B 4.

16. 25 May 1925.

17. Lavery was supported by fellow R As Henry Poole and Charles Shannon. Lavery 'has come out as a champion of Epstein ... Nobody can say that Lavery does not stand for sheer beauty of form' (*The Leeds Mercury*, 25 May 1925).

18. *RSPB*: Graham to Lemon, 9 June 1923, reporting on the dinner, which took place the previous evening.

VIII
THE ARMY OF OPPOSITION

1. *PRO*: Lieut.-Colonel D. White, in Parliamentary Debates, 25 May 1925.

2. 26 May 1925.

3. Ironically, Rothermere was to sit for Epstein in 1928 (*S187*), having met him in January of that year on the *Aquitania*, bound from New York, where the newspaper magnate introduced him to wealthy friends as the '"greatest" sculptor in the world'! (*Epstein 1940*, p. 97).

4. 20–21 and 25 May 1925 respectively.

5. 23 May 1925.

6. *The Times*, 31 May 1925.

7. Quoted in '"Rima" and English Art Ideals. "Nightmare in Stone"', *The Morning Post*, 28 November 1925.

8. Article dated 4 June 1925.

9. *RA*: *The Daily News*, undated press clipping.

10. *The Evening Standard*, 18 November 1925.

11. 19 November 1925.

12. Reported in 'Epstein's Rima. Attack by Hon. John Collier. "Bestial." Head and Face of an Idiot', *The Daily News*, 6 October 1925.

13. *RSPB*: K. Gordon to Lemon, 24 May 1925.

14. *The Nation & Athenaeum*, 6 June 1925.

15. *The Morning Post*, 16 June 1925: she thought the relief 'a disgrace to any woman'. '1925 saw [Picasso] incalculably increase the direct expressive force of his painting by applying this mode [that is, a 'more overtly expressive morphology'] of suggestive forming and aggressive distortion to the figure' (C. Green, *Cubism and its Enemies: Modern Movements and Reaction in French Art, 1916–1928*, 1987, p. 100).

16. *Everybody's*, 7 February 1953, p. 23.

17. *The Morning Post*, 16 June 1925: 'Mrs. Epstein stood unnoticed in the crowd in the afternoon'. See also Chapter 1, note 9.

18. 'Art is Long But Oratory is Longer Mr Homerville Hague, the Artist makes 12 hour non-stop speech against Epstein's "Rima" in Hyde Park' included: 'The Start. 8–A.M.' "Rima must be removed!" The Finish. 8–P.M. and still going strong — by remaining!' 'So why should Epstein worry?'

19. 24 June 1925, p. 673. Hague is also mentioned in 'His Hudson Panel Bad Art', *The Westminster Gazette*, 25 May 1925, as having had an altercation with Epstein on the site. This article includes a caricature of the sculptor.

20. 'Charivaria', p. 589.

24. See pp. 595, 609.

21. p. 605.

23. p. 611, referring to *Rima*. See also 'Epstein Again', *Punch*, 10 June, p. 618, 'Mr. Shaw, Mr. Epstein and the Pretty Birds', pp. 706–07, and 'A Forerunner of Epstein', 1 July 1925, pp. 707–08, where Epstein is compared to Edward Lear.

22. 'The Epstein Gold Memorial', p. 612.

25. *Epstein 1987*, fig. 27.

26. Pp. 14–15, published by Cecil Palmer, London. A copy owned by James Hamilton includes an unspecified and undated press clipping entitled '"Rude Book's" Author Disclosed', identifying Tell as Buhrer, a young Chelsea artist and son of a sculptor, currently showing caricatures at the Chenil Galleries.

27. See Appendix B 6.

28. *RA*: Cuthbert James, 'The Philistines', letter, undated press clipping.

29. *Haskell*, pp. 27–28.

30. R. Haver, *David O. Selznick's Hollywood*, 1986, p. 81.

1. *Epstein 1940*, p. 129.
2. Appendix B4.
3. 'Mr. Epstein and Hyde Park', *The Spectator*, 30 May 1925.
4. 'The Hudson Memorial. Views on Mr. Epstein's Panel. Conception, Treatment, and Execution', *The Times*, 26 May 1925.
5. *The Meaning of Art*, 1931, pp. 2–3.
6. 'A Defence of "Night." Mr. Epstein Talks About its "Unfamiliar Beauty." ', 27 May 1929; he added: 'All this stuff about my wanting to 'shock' people, and being a revolutionary in art is nonsense . . . I am a traditionalist; I believe that one learns from the past. The beauty I am trying to conserve is older than the beauty of fifty years ago. Perhaps it is older than the beauty of the Greeks.' See also 'A Discourse on Beauty', *Haskell*, p. 26, in the chapter devoted to *Rima*, quoting Modigliani's phrase: 'faiseur de beauté' or 'beauty manufacturer'. Bone declared that the *Hudson Memorial* relief was going to be 'really beautiful' (*RSPB*: Bone to Lemon, 29 December 1922); he also told Lemon: 'I think I can guarantee that the fountain [design by Epstein] will be a thing of beauty' (*RSPB*: 5 February 1923).
7. *GM*, pp. 79–80.
8. *TGA*: 'Another Hudsonian', in unidentified press clipping, 31 May 1925.
9. *RSPB*: typescript dated 7 March 1923.
10. *The Evening Standard*, 18 November 1925.
11. *The Morning Post*, 19 November 1925. The writer, Sir Alfred Fripp, was the royal surgeon and co-author, with A. R. Thompson, of *Human Anatomy for Art Students*, 1911, a standard reference.
12. From *Household Words*, 15 June 1850, referred to in Bone's 1925 government report (*Epstein 1940*, p. 300).
13. 'Highbrow Art and Hyde Park Panel. Support among Painters for Mr. Collier', *The Evening Standard*, 'Epstein's Rima. Attack by Hon. John Collier. ' "Bestial". Head and Face of an Idiot', *The Daily News* and *TGA*: ' "Bestial" Art of Epstein . . . "Ugly and Inhuman', unidentified press clipping, 6 October 1925. This became the standard vocabulary of abuse in subsequent discussions on *Rima*; for example, Lord Edward Gleichen (*London's Open-Air Statuary*, 1928, pp. 67–68) wrote of a 'Coarse face minus a forehead . . . monstrous arms and great claw-like hands . . . Verily a masterpiece by the much-advertised apostle of ugliness'.
14. *The Evening News*, 6 October 1925, also asking the sculptor: 'Is the figure of Rima your ideal of a beautiful woman?', who replied: 'I never set out to make ideals'. Epstein also accused Collier of having a 'feminine complex on the brain' and being 'abusive about nature. He talks about things which, in a sense, I do not understand' (*The Star*, 7 October 1925).
15. 7 October 1925. L. Reed and H. Spiers, *Who's Who in Filmland*, 1931, p. 30. Gladys Deacon, who sat for portraits in 1917 and 1923 (*S*86, 142), the latter disconcertingly revealing the unsuccessful results of plastic surgery, believed an endemic unhappiness in Epstein caused him to veer 'so much towards ugliness in

his work' (H. Vickers, *Gladys, Duchess of Marlborough*, 1979; 1987 edition, p. 276).
16. *The Times*, 12 June 1925. Misses Compton and Cooper, stars of *Peter Pan*, 1918, and *The Second Mrs Tanqueray*, 1922, respectively. See also, in reference to *Rima*: 'All these tedious and outworn tags about emancipation from realism and the photographic manner' (O.S., 'Epstein Again', *Punch*, 10 June 1925, p. 618); M. Bogart, 'Photosculpture', *Art History*, 4, no. 1, March 1981, pp. 54–65.
17. *Powell*, p. 81, remarked that 'there can be no question of Rima's lines and proportions violating the canons of academic draughtsmanship, because these considerations have not the remotest bearing upon the deity of the woods whom Hudson imagined'. Herbert Maryon also attempted to explain why Epstein was 'prepared to sacrifice likeness to the normal human body (if indeed he would have considered it a sacrifice) to attain this end' (*Modern Sculpture: Its Methods and Ideals*, 1933, p. 98).
18. *The Times*, 25 May 1925, which also published a letter remarking that the relief 'carries . . . an entirely wrong . . . suggestion of painful effort and sad yearning, whereas in sculpture for woodland you look for a suggestion of freedom, brightness, and joy' (G. F. Bridges, 'The Epstein Panel', 23 June 1925). The British public familiar with the ideas of modernist sculpture understood its concept of the rejection of naturalism: for example, following the publication of an article by K. Parkes, 'The Constructional Sculpture of Jacques Lipchitz' in *The Architect*, 18 September 1925, pp. 202–04, a correspondent observed that the 'human form is beautiful when it reveals the life within . . . The life within is not necessarily expressed by lifelike forms, [so that] correct appreciation of nature in no way satisfies the artistic longings or aspirations of the real sculptor' (*The Architect*, 25 September 1925, p. 222).
19. *The Times*, 25 May, *RSPB*: Sarawak to Lemon, 22 May 1925 respectively.
20. *PRO*: Sir W. Davidson, in Parliamentary Debates, 25 May (reported in *The Times*, 26 May) and *The Daily News*, 25 May 1925 respectively. In 1917 Parliament rejected the statue by George Grey Barnard (Epstein's New York teacher) of *Abraham Lincoln* for Westminster, which was attacked as portraying 'a coarse, imbecilic dolt [with] anthropoidal hands and feet'; it was subsequently sited in Manchester (J. Clapp, *Art Censorship: A Chronology of Proscribed and Prescribed Art*, 1972, p. 202).
21. Appendix B4.
22. *Rutter*.
23. *The Daily Mail*, 21 May and *RSPB*: Sarawak to Lemon, 22 May 1925 respectively.
24. 'Why should one wing of the easternmost [right-hand] bird spring from what in the human form we call the hip?' (*The Times*, 1 June 1925).
25. *The Evening Standard*, 18 November 1925.
26. A. G. Hastings-White, in *The Builder*, 19 June, p. 932, *The Daily Mail*, 25 May, James K. Fowler, in *The Times*, 10 June and Sir Edwin Ray Lankester, in 12 June, *RSPB*: Sarawak to

Lemon, 22 May, *The Daily Mail*, 26 May and Edgar B. Argyles, in *The Times*, 27 May 1925 respectively.

27. John Transford, in *The Morning Post*, 23 November 1925.

28. Sidney Bechet recalled that 'Jazz could mean any damn thing . . . high times . . . ballroom. It used to be spelled *jass*, which was screwing' (L. Haney, *Naked at the Feast: A Biography of Josephine Baker*, 1986, p. 75). The black American entertainer arrived in Paris on 22 September 1925, a member of *La Revue Nègre*, which opened soon after at the Théâtre des Champs-Elysées (p. 49). She was described as 'part kangaroo and part prizefighter. A woman made of rubber, a female Tarzan' (p. 54); her performance as that of 'a sinuous idol that enslaves and incites mankind. The plastic sense of a race of sculptors came to life . . . and the frenzy of the African Eros swept over

the audience. It was no longer a grotesque dancing girl who stood before the audience, but the black Venus that haunted Baudelaire', though one critic thought it 'lamentable transatlantic exhibitionism, which brings us back to the monkey' (p. 64).

29. *Epstein 1987*, fig. 25. *The Sunday Graphic and Sunday News*, 20 December 1931, reporting Alfred Gilbert's return to London after many years residence abroad and asking 'What will he think of Rima?', recalls Lorado Taft's observation (*Modern Tendencies in Sculpture*, 1921, p. 27): 'You can imagine the emotions of a wistful artist returning to the scene of these early loves to find them replaced by strange gods like this foolish caricature of a woman . . . It is a work by the notoroious painter, Matisse', referring to fig. 51, *Standing Nude*, 1906 (I. Monod-Fontaine, *The Sculpture of Henri Matisse*, 1984, pl. 17).

X
POLITICS AND ANTI-SEMITISM

1. Though an early martyr to this confused doctrine, *Rima* was by no means alone. In 1930, Henry Moore was associated with 'certain circles of unconventional or what is called "Bolshevist" art' (*The Morning Post*, 13 December 1930) — 'this kind of "art" represents nothing more nor less than Bolshevism in art. It aims, as Bolshevism in politics aims, to bring us back to the level and standards of the cave men' (a review of Moore's Leicester Galleries exhibition, in *The Bournemouth Echo*, 12 May 1931) — and in 1932 the American cartoonist, Orr showd Daniel Chester French's celebrated statue of *Lincoln* in Washington DC replaced by one of Lenin, with members of the Radical Congress carrying a pail of red paint, and the caption 'Will It Come to This?' (W. L. Shirer, *20th Century Journey: A Memoir of a Life and the Times*, 1984, II, p. 47).

2. 21 May 1925. *Rima* was regarded as 'Admirable for the Tiergarten in Berlin ('The Hyde Park Atrocity', *The Daily Mail*, 22 May 1925).

3. 'The Epstein Panel', *The Morning Post*, 25 November and 'Epstein's M.P. Critics', *The Daily News*, 25 May 1925 respectively.

4. *PRO*: Parliamentary Debates, 21 July, which provoked 'Labour laughter' (*The Daily Mail*, 22 July 1925); see also Appendix B 5.

5. '"Rima" and English Art Ideals', *The Morning Post*, 28 November 1925. See also the lengthy moralistic babblings of R. Mitchell Banks, Conservative and Catholic, in 'The Epstein Challenge. What Lies Behind It', *The Sunday Times*, 31 May 1925.

6. 'An Overlooked Fact About Rima. A "Goddess" of Deliberate Discord. She Becomes a Party Question . . . Anarchism in Stone — and that Parliamentary Vacuum!', *The Evening News*, 26 November 1925.

7. *The Westminster Gazette*, 27 November, *PRO*: Parliamentary Debates, 30 November 1925 also mentioned the 'Fascisti' in connection with *Rima*.

8. 9 September 1925.

9. 'I am not a German, a Bolshevist, or a eugenist. I am a sculptor' ('Highbrow Art and Hyde Park Panel', *The Evening Standard*,

6 October 1925); see also 'Mr. Epstein's Reply to Criticism', *The Times*, 9 September 1925. In the late 1930s Epstein was among a group of British artists, which also included Frank Dobson, Eric Gill and Henry Moore, speaking out against the spread of Fascism in Europe (T. Friedman, 'Epsteinism', in *Epstein 1987*, pp. 42–43).

10. W. F. Lloyd, in *The Morning Post*, 24 November 1925; also 'it is un-English and inartistic' ('Hudson Memorial Defaced', *The Times*, 14 November 1925). Eric G. Underwood dismissed Epstein swiftly: 'there is practically nothing English [in his work]. He is with us but not of us' (*A Short History of English Sculpture*, 1933, p. 154; Appendix V, 'London's Statues and Monuments', a selection of the hundred principal examples, does not list *Rima*).

11. The details of this unfortunate episode are related in *Silber*, pp. 35–37.

12. Letter to Hamo Thornycroft, 19 February 1920 (*HMCSS*: Thornycroft Papers c.486), quoted in *Epstein 1987*, p. 210.

13. *Epstein 1940*, p. 267.

14. 14 February 1920, reprinted in *Epstein 1940*, pp. 124–25.

15. 'The Bolshevisation of Art', p. 36, quoting an article by D. Maxwell in *The Graphic*, who also remarked: 'It is reserved for Mr. Epstein to bring to the world a new gospel, a Black Gospel, a gospel in which everything is to be inverted and distorted'. 'Epstein's Art and the Learned Elders of Zion', *The Hidden Hand*, February 1924, V, no. 2, pp. 22–23, reported Epstein's un-English call (in *The Observer*, 27 January) for the removal of *Nelson's Column* in Trafalgar Square, and also attacked the BMA figures and the 'horribly obscene' *Wilde Tomb*. I am grateful to Elizabeth Barker for drawing attention to this source, which is discussed more fully in her essay 'The Primitive Within: The Question of Race in Epstein's Career 1917–1929', in *Epstein 1987*, pp. 44–48.

16. *The Hidden Hand*, V, no. 4, pp. 57–58 (Cubism, Futurism and Dadaism are also attacked: 'There is no doubt the British public do not like Bolshevist art'). The Jew, Lev

Davidovich Bronstein (alias Leon Trotsky) published *Literature and Revolution* in 1924.
17. *The British Guardian* (successor to *The Hidden Hand*), May 1924, V, no. 5, p. 69. Jones's memorial is illustrated in the issue of July–August 1924, V, no. 7, p. 112.
18. 'The Protocols Plan at Work in the Sphere of Art', *The British Guardian*, 12 June 1925, VI, no. 15, pp. 2–3, which described *Rima* as the 'hideous and disgusting monstrosity for which the Jew Epstein is responsible'. An unidentified

press clipping concerning *Rima*, dated 30 May 1925 (*PRO*), mentions *Risen Christ*: 'a large, unproportioned, emaciated man of imbecile expression, of loathsome formation, with the mouth of a fanatic, the staring eyes of a madman, the receding forehead of a mental defective, and the head of an Ethiopian', and *The London Mercury's* article on *Rima* (June 1925, XII, no. 68, p. 116) refers to the 'powerful but repugnant "Christ"'.

XI
'THE HYDE PARK ATROCITY. TAKE IT AWAY!'

1. Sarawak also remarked that Hudson, an old friend, 'hated *sculptured memorials*' (*RSPB*: letter to Lemon, 22 May 1925).
2. *PRO*: Parliamentary Debates, 25 May 1925, Eden asking 'whether in point of fact there has ever been any work of art of merit that has not led to a storm of abuse?'.
3. *The Builder*, 12 June 1925, p. 896.
4. 'Mr. Epstein and the Birds', *The Evening News*, 24 November, *PRO*: Lieut.-Colonel Dalrymple White, in *Parliamentary Debates*, 30 November, J. E. Mortimer, in *The Morning Post*, 21 November 1925 respectively.
5. 'The Epstein Panel', *The Morning Post*, 25 November, A. H. Henderson-Livesey, 'The Hudson Memorial', in *The Times*, 28 May, 'The Epstein Carving', *The Morning Post*, 3 June 1925, respectively.
6. A. H. Henderson-Livesey, in *The Times*, 28 May and James K. Fowler, 'The Hudson Memorial. A "Philistine's" Proposal', 10 June, *RSPB*: G. Hubbard to Lemon, 5 June 1925 respectively (the latter enclosing a sketch for a bird bath). W. Woodward, 'Modern Sculpture A Suggestion for the Epstein Panel', *The Morning Post*, 13 October 1925, reported in connection with *Rima* that the Viennese authorities had recently hid a group of indecent sculptures behing thick bushes.
7. 18 November 1925. Lady Frances Balfour, Hilaire Belloc, E. F. Benson, Hon. Stephen Coleridge, Hon. John Collier, Sir Arthur Conan Doyle, Sir Frank Dicksee, Sir Philip Burne-Jones, Sir E. Ray Lankester, Sir David Murray, RA, Alfred J. Munnings, RA, Sir Bernard Partridge, Sir Johnston Forbes-Robertson, The Ranee of Sarawak, H. Avary Tipping.
8. 'Another Attack on "Rima"', *The Evening Standard*, 18 November 1925.
9. 'A Counter-Blast for "Rima"', *The Evening Standard*, 19 November 1925.
10. *The Daily News*, 19 November 1925; also *The Westminster Gazette* of the same date. Cunninghame Graham told *The Evening Standard*, 19 November 1925 that Epstein's supporters were not 'troglodytes, but rather real live people [representing] far weightier opinion of all walks of life and artistic and intellectual endeavour' than Dicksee's hordes.
11. *The Manchester Guardian*, 21 November 1925. See also 'Must is the Word', *The Morning Post*, 19 November 1925. A. Compton, ed., *Charles Sargeant Jagger: War and Peace Sculpture*, 1985, pp. 80–99.
12. Three lists were published in *The Times* on 23 November ('The Epstein Panel. Reply to

Advocates of Removal') and 24 November 1925 respectively; reprinted in part in *Haskell*, pp. 32–35 and *Epstein 1940*, p. 132. Bone wrote again deploring the censorial role of the press and RA: 'I confess this Saturnine temperament makes me shudder' (*The Times*, 24 November 1925).
13. *The Times*, 25 November 1925. This is followed by an anti-*Rima* letter from Philip Burne-Jones, son of the Pre-Raphaelite painter.
14. 23 November 1925 (quoted in *Epstein 1940*, p. 132): the list was unpublished and is untraced. 'In all the schools of art there has been a big rally to the side of Mr. Epstein' (*The Manchester Guardian*, 25 November 1925).
15. *HMCSS*: Thornycroft Papers c.199. *Manning*, p. 194; M. Stocker, 'Edmund Gosse on Sculpture', *The University of Leeds Review*, 1985, 28, p. 297.
16. 'The Hyde Park Atrocity How the Panel was Accepted', 22 May 1925. Frampton 'alone voted against acceptance', Blomfield, who was not present on the occasion, had earlier objected to the model; nevertheless, a majority of 6 to 1 favoured the design (*PRO*: typescript exonerating the Office of Works from blame in approving *Rima*, probably dating November 1925). See also 'Jury of Experts', *The Daily Telegraph*, 25 May and *PRO*: Graham to Earle, 26 November 1925. Frampton later wrote: 'Rima did not look so grotesque on paper as when sculpted, yet . . . the designer obviously did not know the A.B.C. of sculpture and . . . the figure was an insult to the intelligence of the country' ('The "Rima" Protest', *The Morning Post*, 25 November 1925).
17. 'The Epstein Panel', *The Morning Post*, 25 November and 'Government and "Rima"', 24 November, *PRO*: 23 November 1925. The Memorial Committee apparently received only four letters of complaint about *Rima* from subscribers (*Epstein 1940*, p. 298).
18. 'No Change at the Epstein Panel', *The Manchester Guardian*, 24 November 1925.
19. *The Daily Sketch*, 23 November 1925.
20. *Haskell*, p. 30.
21. Also David Young Cameron, J. A. Gotch, Sir Edwin Lutyens and Sir Aston Webb, with the Earl of Crawford and Balcarres as Chairman (*PRO*: Work 20/175); see also *The Builder*, 19 June 1925, p. 947.
22. *PRO*: Crawford and Balcarres to Earle, 26 November 1925; the latter also stating: 'It is quite clear . . . that these people are ready for reprisals and retaliation'. Bone mentioned that 'wide dissatisfaction has been publically

expressed' about the *Cavell Monument* (*Epstein 1940*, p. 298). Fortunately, Crawford was sympathetic to Epstein, having praised his bust of *Professor Samuel Alexander*, 1924 (*S156*) as 'a fine and noble piece of sculpture' at its unveiling (*The Manchester Guardian*, 25 November 1925).

23. *Epstein 1940*, pp. 294–302.

24. *HMCSS*: Thornycroft Papers c.199, letter dated 29 November 1925.

25. *PRO*: Parliamentary Debates, 30 November 1925. Nevertheless, in 1928 a persistent MP, Sir W. Davidson, asked if the Under-Secretary of State for the Home Department was 'now in a position to realise the dislike of the public generally to this stone, and will he consider the question of removing it to a museum' (*PRO*: Parliamentary Debates, 14 May 1928).

XII
'THE INEVITABLE HAS HAPPENED'

1. '"This is the Limit." Outspoken Comments in Hyde Park', *The Daily News*, 25 May 1925. The author of the letter appears to have been Sir Charles Walpole, a former Chief Justice of the Bahamas. A policeman guarded the relief for three days, at the expense of the Memorial Committee (*PRO*: letter to Horwood, 27 May 1925). See also 'The Hyde Park Atrocity', *The Daily Mail*, 26 May, *PRO*: Parliamentary Debates, 11 June, *The Times*, 12 June, 'The Hudson Memorial', *The Builder*, 19 June 1925, p. 947. *The Morning Post*, 7 October 1925 commented: 'were not the English a tolerant people, [*Rima*] would have long ago been broken into pieces' (quoted in *Epstein 1940*, p. 130) and 'Perhaps a dose of T.N.T. or dynamite would be even a better cure than the green paint!', in 'Man in the street', 27 November 1925.

2. *PRO*: Metropolitan Police report, 13 November 1925. The incident was widely reported in the press. 'The *inevitable* has happened to Mr. Epstein's Rima. She has been ingloriously daubed with green paint' ('The Green Goddess Rima's Tenacious Coat of Paint', *The Morning Post*, 14 November 1925).

3. 'Epstein Panel Disfigured', *The Daily Herald*, 14 November 1925.

4. *PRO*: 13 and 24 November 1925. See also 'Rima Washed with Turpentine', *The Evening Standard*, 14 November 1925. Photographs showing the restoration in progress were published in 'Green Painted Rima in Sackcloth. Curious Crowd's Glimpse of a Hand and Name', *The Evening News*, 13 November, 'Fancy Dress for Rima on the Ball Night', *The Daily Graphic*, 14 November 1925.

5. W. S. Kennedy, 'The Epstein Panel "One of the Glories of London"', 19 November 1925, and an undated typescript (*PRO*: Work 20/175), referring to the stoning of the statue by a youthful band of Medici supporters on 14 May 1504 (F. Hartt, *Michelangelo: The Complete Sculpture*, 1969, p. 106).

6. 13 November 1925. In December, the Office of Works received a postcard hinting at further vandalism (*PRO*: 30 December 1925, written by Edward Henderson, a wealthy eccentric known to the police); however, nothing happened.

7. *PRO*: Office of Works report; the repairs cost £35, though the stain was not entirely removed (21 and 30 October 1929 reports).

8. 'Rima Tarred & Feathered', 9 October 1929.

9. 'Rima Painted', *The Daily Mail*, 22 January 1930, reporting an incident of the previous night. See also *PRO*: 22 January report.

10. *PRO*: Metropolitan Police report, 8 October 1935. The stains were removed within three days (10 October report). The IFL is referred to in *Epstein 1940*, p. 132.

11. 28 November 1925. See J. Clapp, *Art Censorship: A Chronology of Proscribed and Prescribed Art*, 1972, pp. 205–66.

XIII
'BANALITIES AND EYESORES'

1. *HMCSS*: Thornycroft Papers c.293, letter to Lady Thornycroft dated 26 October 1937. The careers of these artists are recounted in S. Beatty, *The New Sculpture*, 1983.

2. *The Studio*, MCMXXV, 1925, p. 313.

3. E. Gleichen, *London's Open-Air Statuary*, 1928, p. 171. B. Read, *Sculpture in Britain Between the Wars*, 1986, p. 10.

4. *The Yorkshire Post* articles beginning 18 May 1923 (E. R. Gill, *Bibliography of Eric Gill*, 1973, p. 161, no. 407; M. Yorke, *Eric Gill: Man of Flesh and Spirit*, 1981, pp. 220–25, illustrated).

5. *Country Life*, 22 March 1924, pp. 425–26. Descriptions of the relief also appeared in *The Daily Chronicle*, *The Daily Herald*, *The Daily Telegraph*, *The Glasgow Evening Times*, *The Manchester Guardian* and *The Times*, 21–24 March 1924.

6. *Punch*, 3 June 1925, p. 609. The main group of BMA figures are positioned on the Agar Street elevation of the building. For the BMA, see *Cork*, chapter 1, *Epstein 1987*, pp. 103–11, *Silber*, pp. 16–19, *S9*.

7. Pp. 66–68.

8. *TGA*: Frank Gibson, 'The Hudson Memorial', unidentified press clipping dated 31 May 1925. G. F. Watts's *Physical Energy*, 1883–1906, Kensington Gardens, and Gilbert's *Shaftesbury Memorial (Eros)*, 1886–93, Piccadilly Circus, were singled-out for exception. An article entitled 'Mobs and Monuments', *G.K.'s Weekly*, 6 June 1925, p. 241, condemned all public memorials.

9. F.K.L., 'Modern Art', 26 November 1925. See also 'The Rima Controversy', *The Builder*, 27 November 1925, p. 764 and B. Read and P. Skipwith, *Sculpture in Britain Between the Wars*, 1986.

10. *The Observer*, 27 January 1924, *The Hidden Hand or Jewish Peril*, February 1924, V, no. 2, pp. 22–23 and 'The Epstein Touch', unidentified and undated press clipping (*TGA*).

11. 'Mr. Epstein's Reply to Criticism', *The Times*, 9 September 1925.

12. 18 June 1925. Reginald Blomfield expressed similar misgivings some years earlier: 'It is, unfortunately, a well-known fact that our English cities are lamentably deficient in public sculpture

... We in England put up statues, by fits and starts ... but we nearly always put them in the wrong places ... The right position for a statue is in some place of rest and quiet, where its immobility is not outraged by the rush of modern life; and clearly parks and public gardens can offer them this decent refuge' ('Of Public Spaces, Parks and Gardens', in *Art and Life, and the Building and Decoration of Cities*, 1897, pp. 205–06); unfortunately this visior was in no way fulfilled for him by *Rima*.

13. 'The Hudson Memorial', 29 May 1925, p. 821. A similar point was made in 'The Epstein Controversy', *Drawing & Design*, 1 July 1925, p. 43.

14. *The Leeds Mercury*, 1 June 1925.

XIV
'THE PROVOCATIVENESS OF GREAT ART'

1. 'The Provocativeness of Great Art', *The Manchester Guardian*, 25 November 1925.

2. *Chiaroscuro: Fragments of Autobiography*, 1954, p. 99. *Epstein 1940*, pp. 88–89, *Silber*, p. 38.

3. *S*189. In 1940, he began *Youth Advancing* for the Festival of Britain (*S*423), marking the beginning of an Indian Summer of public sculpture commissions.

4. 'Frank Criticism of Sculpture Grotesque Figures at Tube G.H.Q. Rima Recalled', *The Morning Post*, 13 April 1929. *Day* and *Night* 'in the manner of "Rima," have aroused the same fierce controversy' (*The Studio*, October 1929). See also Sir Reginald Blomfield, 'The Cult of Ugliness', *The Manchester Guardian*, reprinted in *Epstein 1940*, pp. 303–04.

5. R. R. Tatlock, 'A Coarse Object', 24 May 1929.

6. *Cork*, pp. 54–60. The figures were mutilated in 1937 (*S*9).

7. *Rima* is illustrated in 'Epstein Panel to Hudson', *The Daily Mail*, 21 May, W. Muir, 'Epstein in Hyde Park', *The Sphere*, 30 May, *Punch*, 3 June, p. 603, 'Film Beauty and Rima', *The Daily Mail*, 7 October, H. Owen, 'An Overlooked Fact about Rima', *The Evening News*, 26 November, 'Seen by Epstein', *The Daily News*, 17 December 1925; E. Gleichen, *London's Open-Air Statuary*, 1928, opposite p. 67, *Haskell*, binding and opposite p. 29, *Powell*, opposite p. 81, H. Maryon, *Modern Sculpture: Its Methods and Ideas*, 1933, fig. 99, S. Casson, *Sculpture of To-Day*, 1939, p. 96, *Epstein 1940*, opposite p. 178, R. Black, *The Art of Jacob Epstein*, 1942, binding and pl. 20, A. Whittick, *War Memorials*, 1946, pl. 143, R. Buckle, *Jacob Epstein Sculptor*, 1963, pls 209–10 and subsequently various other publications.

8. *Cork*, pp. 266–67, pl. 325. A Fox Photograph of Gill carving one of these panels is in *HMCSS*: Gill Archive. See also James Woodford's *Sea Panel*, 1954, on Lloyds New Building, Lime Street, London. Sidney Geist, the American art historian, recalled making a relief (lost) in the early Thirties inspired by photographs of *Rima* (conversation with the author, 15 June 1987). See also the case of Lily Workum of Antwerp, reported in 'Seen by Epstein', *The Daily News*, 17 December 1925.

9. On the occasion Epstein appeared in New York City in 1927 to testify on behalf of Brancusi's polished bronze *Bird in Space*, 1926, he was appropriately described in the press as the 'Stormy Petrel of Sculpture' (*Epstein 1940*, pp. 154–58; A. T. Spear, *Brancusi's Birds*, 1969, no. 15, IV, pl. 20).

10. 'Epstein Panel New Demand For Rima's Removal', *The Morning Post*, 18 November 1925.

11. Candidus, 'The Sense of Things', 23 November 1925. See also Amelia Defries, 'The Rima Controversy', *The Builder*, 4 December 1925, p. 802.

12. 'Mr Epstein And Hyde Park', 30 May 1925. The writer, Hugh Walpole, who was to sit for Epstein in 1934 (*S*255), commenting on attempts to officially censor *Rima*, abhorred this method as 'specially illiberal and unjust' ('Hugh Walpole and "Rima"', *The Daily Express*, 26 November 1925).

13. 27 January 1928, reviewing Moore's first one-man exhibition, held at the Dorothy Warren Gallery, London, from which Epstein purchased the cast-concrete *Suckling Child*, 1927 (*Epstein 1987*, p. 36, fig. 14).

14. *The Northern Whig*, 14 April 1931; *Epstein 1987*, pp. 39–40.

15. *Epstein 1987*, pp. 41–42, fig. 18. Both sculptures are now in Leeds City Art Galleries.

16. I, p. 24; see also p. 81.

17. 'Epstein and Dramatic Sculpture', in *Some Modern Sculptors*, 1928, pp. 111, 113, 116 ('He has no liking for relief and little success at it, as "Rima" shows').

18. *XXth Century Sculpture*, 1930, p 111.

19. *The Meaning of Modern Sculpture*, 1932, pp. 103–04.

20. 'The Provocativeness of Great Art', 25 November 1925, an article on *Rima*.

21. 'Hudson Memorial', *The Times*, 28 May 1925.

22. *Powell*, p. 81. For A. L. Chanin writing in 1958, *Rima* remained a 'daring departure from the average innocuous "park statuary"' (in C. McCurdy, ed., *Modern Art: a pictorial anthology*, p. 238).

23. Chapter Ten and Appendix Four.

24. *The Yorkshire Evening News*, 20 November 1925.

25. *Powell*, p. 82.

APPENDIX A

DOCUMENTS

1 THE BRITISH ARCHITECTURAL LIBRARY,
THE ROYAL INSTITUTE OF BRITISH ARCHITECTS, LONDON

BAL Manuscripts and Archives Collection, HoC: correspondence and typescripts of Charles Holden, of the architectural firm of Adams, Holden and Pearson.

2 THE HENRY MOORE CENTRE FOR THE STUDY OF SCULPTURE,
LEEDS CITY ART GALLERIES

A The Rima Sketchbook: eighty-seven numbered drawings on fifty-six sheets, pencil and coloured wash, each 59.7 by 47 cm. Purchased from the Anthony d'Offay Gallery, London, 1983, by Leeds City Art Galleries, with the aid of an HM Government Grant and contributions from Stanley H. Burton and Bernard Lyons through the Leeds Art Collections Fund (inventory number 25/83). The drawings, originally bound in a 'Kingsway Bond Tub-sized' folio, inscribed by the sculptor on the inside cover: 'Jacob Epstein 49 Baldwyn's Hill Loughton Essex. 1923', with each sheet stamped (for Robert Bontine Cunninghame Graham, presumably a one-time owner). A single study, perhaps removed from the sketchbook at a later date (present location unknown), is illustrated in R. Buckle, *Jacob Epstein Sculptor*, 1963, pl. 208, and here as D 57. Of the 'exact drawing of the panel as it now exists', presented to and approved by HM Office of Works ('Jury of Experts', *The Daily Telegraph*, 25 May 1925) there is no trace. The present fifty-six sheets were removed from the sketchbook in 1984 and mounted separately (illustrated here as D 1–56v). Epstein began considering the Rima theme in February 1923. Mrs Frank Lemon, the Hudson Memorial Committee Secretary, wrote to Muirhead Bone, 16 November 1923 that Mrs Reginald McKenna 'has quite finished with the book of Mr. Epstein's sketch ideas for Rima. Could Mr. Cunninghame Graham call and collect the work' (*HMCSS*). Epstein was apparently still making drawings in 1924, for he mentions in an undated letter (private collection) to Kathleen Garman 'today I have finished a fairly elaborate sketch for the Hudson memorial' (now unidentified), which also refers to work on the 'weeping figure' (*The Weeping Woman*, 1922, exhibited at the Leicester Galleries in 1924, *S* 126) that 'goes to the Tate Gallery to be viewed next week', and a 'sketch for a building . . . I expect to finish . . . by the middle of next week', perhaps the (abortive) Bush House commission of 1924 (*S* 155). Two of the Leeds drawings, D 11 and 45, were exhibited in 1983 (*Drawing in Air: An Exhibition of Sculptor's Drawings 1882–1982*, cat. nos 24–25, illustrated) and nine in 1987 (*Jacob Epstein Sculpture and Drawings*, cat. nos 117–22, 124–26).

B Sheet of sketches showing W. H. Hudson reclining in the forest (related to the bronze relief cast in 1922–23, *S* 146), presented to the Study Centre in 1987 by Beth Lipkin in memory of Sir Jacob and Lady Epstein.

C Miscellaneous correspondence, contemporary photographs and printed material in the Epstein Archives; related miscellaneous papers in the Thornycroft Archives.

3 PUBLIC RECORD OFFICE, KEW

Parliamentary debates (printed extracts), Police reports and Office of Works correspondences, May 1925–October 1935 (Work 20/175).

4 THE ROYAL INSTITUTE OF BRITISH ARCHITECTS
DRAWINGS COLLECTION, LONDON

Eleven pencil and ink drawings by Lionel Pearson, of the architectural firm of Adams, Holden and Pearson, for the *Hudson Memorial Sanctuary*, Hyde Park, London.

AHP[42]1 unidentified sketches and dimension notations
AHP[42]2 site plan before alterations
AHP[42]3 site plan with Sanctuary indicated
AHP[42]4 'Revised Plan of Lay-Out Showing Existing Trees Etc.',
 dated 23 October 1923
AHP[42]5 'Plan of Lay-out Showing Memorial Stone and Pools',
 dated October 1924
AHP[42]6 'Revised Design of Portland Stone Sculptured Block Etc', undated

AHP[42]7 'Plan and Elevation of Portland Stone Block for Sculpture',
 dated 25 June 1923

AHP[42]8 'Revised Design to the Carried Out in Portland Stone',
 dated 5 November 1923

AHP[42]9 'Detail of Memorial in Portland Stone showing Position of Panel for
 Sculpture and of Lettering for Inscription Etc', dated 27 January 1925

AHP[42]10 Dedication inscription, undated

AHP[42]11 Dedication inscription, dated 3 April 1925

5 THE ROYAL SOCIETY FOR THE PROTECTION OF BIRDS,
 SANDY, BEDFORDSHIRE

Various papers (02.01.07) deposited in The Library: a letter from Hugh Dent,
Treasurer, to Mrs Frank Lemon, Secretary, of the Hudson Memorial Committee, dated
23 July 1926, refers to documents, including correspondence, list of subscribers,
miscellaneous printed matter, receipt books, paying-in books, architect's specifications,
sculptor's contract, Minute Book, being transferred to the *RSPB*.

A W. H. Hudson Memorial Minute Book (*MB*): Minutes of the Executive Committee
meetings held between 27 November 1922 and 5 January 1926, 49 pp., including names
and addresses of Committee members.

B Correspondence relating to the *Memorial* dating between November 1922 and July 1926.

C *List of Subscribers to the Hudson Memorial Fund*, 21 pp., typescript.

D *Agreement and Schedule of Conditions of Sculpture Contract between W. H. Hudson Memorial
Committee and Jacob Epstein*, dated 3 April 1923.

E *Specification of Works*, Adams, Holden and Pearson, dated October 1924.

F Receipts.

G Miscellaneous manuscripts and printed matter.

H Manuscript papers relating to William Rothenstein's portrait of W. H. Hudson.

Of the large number of press clippings relating to the *Hudson Memorial*, the present study
has made use of specimens at The Henry Moore Foundation, Public Record Office (3),
The Royal Academy of Arts Library (Epstein file), The Royal Society for the Protection
of Birds (5), and The Tate Gallery Archives (Epstein file), copies of which are deposited
in The Henry Moore Centre for the Study of Sculpture.

APPENDIX B

SELECTED LETTERS AND
PRESS CLIPPINGS 1923–25

I MUIRHEAD BONE TO ROBERT BONTINE CUNNINGHAME GRAHAM,
 2 FEBRUARY 1923 (HMCSS)

Dear Cunninghame Graham —

I had a long interview with Sir Lionel Earle at the Office of Works, and, as I was warned
by Mrs McKenna, he would not hear of the idea of a figure representing Hudson
forming part of the memorial. He said that a representation of an actual person in the
Royal Parks was quite impossible so it is clear the design will have to be charged there. I
take it this would have ruled out also the 'medallion portrait' especially as it would have
had to be a very bold medallion indeed which could have been enjoyed from 20 feet away.
He expressed approval of several features of the 'lay out' of the fountain and plot of
ground and my friend Pearson the architect (who was with me) has a good grasp now of
all the points made by the Office of Works and is drawing out a new plan which will
conform with them. The chief difference is that they insist on an 'unclimbable fence'
going across the front of the plot and being part of the design — they will not hear of a
lower wall. Still this is good in a way as it will keep out all possible dogs and boys from
troubling our birds when they are enjoying their baths! In other ways too the scheme will
be more modest than we first intended but that will be all to the good in saving expense.

Sir Lionel and his experts thought our idea of the water coming away from underneath
a simple stone set against the bank at the back of our plot, a good one and he does not
object at all to the stone having a carving only it must not represent Hudson. Indeed (as I
pointed out to him) as the water supply cannot be kept continually running but it will only
be possible to fill the bird bath pools from time to time, it is absolutely necessary to have

something beautiful carved on the stone — otherwise there will be absolutely nothing to look at at all, which is absurd! So it comes to this — what shall be put on the stone? I confess I am as anxious as ever to get something really strikingly imaginative and beautiful from Epstein, and I want to know what you think of the idea of the relief on the stone representing the wonderful woman spirit in 'Green Mansions'? This seems to me a very fine subject for the sculptor and ought to result in a beautiful thing. I imagine this would be approved as a subject by the Office of Works — in any case I could enquire at once as to that. Sir Lionel mentioned as the sort of thing approved of in the Royal Parks the Peter Pan statue — 'because of an imaginary figure' (It does not seem to us to possess much imagination!) Of course I quite understand the approval of the whole Committee must be got, as this is quite a change from the proposed representation of Hudson himself, but I want you to tell me what you think of the idea to begin with and if you think there is a better one? The stone will probably now be a smaller one as the area proposed to be enclosed has also become smaller. I think myself we ought to be able to get the whole thing done and beautifully done for around about £1000 and I am certain we can easily raise that. Please do not think that Epstein's sketch has cost the Committee anything so far — that is not so, as of course I was careful that he should not embark on the careful model of the sculptured stone till we had the full approval of the Office of Works. I rang you yesterday before coming down here, to arrange a meeting with you, but did not have luck. I won't be in London next week but the week after could meet you any day or time after Tuesday morning. Forgive this long scribble! I hope very much your mother is better again. Very sincerely yours

Muirhead Bone (over)

PS

There is this to be said for an imaginary figure from one of his books being sculptured instead of himself, that the other part of the memorial — the portrait by Rothenstein in the N.P.G. is a portrait. This figure on our fountain would represent nature and that is pretty near Hudson and perhaps we might agree on a representation of her where we could never have agreed exactly how to represent him.

2 MRS FRANK LEMON TO JACOB EPSTEIN, 15 FEBRUARY 1923 (RSPB)

Dear Sir,

At the meeting of the Hudson Memorial Committee held yesterday, I was instructed formally to ask you to undertake the Memorial which is to be erected in Hyde Park on the approved site, with which you are already acquainted.

The Committee learned from Mr. Muirhead Bone that you would be willing to do this for a fee of £500 (five hundred pounds), and that you would be prepared to endeavour to satisfy H.M. Office of Works with regard to the design.

It was also understood that the Memorial would be in stone, and that in all probability you would, in a setting of trees and birds, in some way portray Rima, the character in Mr. Hudson's book called Green Mansions.

We were all agreed that the creation of that bright spirit in human form, so akin to wild Nature, and yet endowed with such extraordinary intelligence, is one of Mr. Hudson's masterpieces; we were also assured that you hold a like opinion, and that such a theme would be in accordance with your inclination; it was therefore felt that Rima in her Green Mansion would be a suitable subject to use in connection with what we hope will be an enduring Memorial to a great Writer and Naturalist.

Believe me to be, Yours truly, M. L. Lemon Hon. Secretary

W. H. Hudson Memorial Committee

3 MUIRHEAD BONE TO SIR LIONEL EARLE, 19 JUNE 1923 (RSPB)

Dear Sir Lionel Earle,

I have just heard from Mrs Lemon that you would like to know more exactly what the proposed W. H. Hudson Memorial would be like and I expect before this reaches you, you will have seen Epsteins model which was only shown in a general way in my sketch, as what I intended was chiefly the general aspect of the whole 'lay-out'. I quite see that the

Committee and its sculptor propose something a little more ambitious than merely providing a drinking bath for birds but I feel sure you sympathise with our desire to make the Hudson Memorial something more imaginative and at the same time provide that part of the Park with a decorative carving which would work into a charming setting out of gardening. Yet it is not so ambitious for instance as the Peter Pan figure in the round, and will be I think even more imaginatively decorative and artistically satisfying.

I feel certain your artistic advisers will approve of the Committee's choice of a sculptor and of the subject, a carved relief of a draped ideal female figure representing the spirit of Nature in Hudsons 'Green Mansions', this as a background to a bird drinking pool in front. Myself and other members of the Committee are really anxious to give the Nation a dignified piece of art and we quite appreciate the importance of the fact that only work of a high artistic calibre should be allowed to beautify Hyde Park. But speaking for myself it would be a very great grief to me if, after all our efforts in proposing something really fine in memory of Hudson we were now chilled in our endeavours down to some quite insignificant thing which cannot be a symbol of this great nature writer. Give us a chance and I think we can safely promise to add a new decorative beauty to Hyde Park. Good sculpture is really too rare to be frowned upon. I know you feel with me in this matter. Epstein is really a very fine artist — his work has been bought for the Chantry Bequest (by his fellow sculptors who are Academicians) He is certainly looked upon with very great respect by the artists of England. Give him a chance to show what a fine and noble thing he can do. I feel confident that your Sites Committee will view the Hudson Committee's efforts to get a fine thing with sympathy, and I would suggest that if you see fit the opinion of such a Government Committee dealing with Modern art as the Trustees of the Tate Gallery might be asked on the matter. I appreciate very much the helpful spirit which you have brought to the discussion of our scheme. I am very confident we could bring into existence an artistic success which would be a popular success also, and I venture to think that has not been too common in decorative sculpture work or memorials of any kind. I wish I were in London and so able to spare you this long letter, but have work on hand here which will keep me till the end of July.

Sincerely yours,

(sd) Muirhead Bone.

4 THE WESTMINSTER GAZETTE, 26 MAY 1925

THE HUDSON MEMORIAL. | MR. JAMES LAVER'S REPLY TO CRITICS. | A DEFENCE OF MR. EPSTEIN. | WHAT DOES THE PUBLIC WANT?

'What does the public want? A semi-developed female figure feeding chickens, or a marble angel? If so they should have gone to a monumental mason, not to Mr. Epstein.'

This remark was made to the Westminster Gazette yesterday by Mr. James Laver, of the Victoria and Albert Museum, whose recent book of studies of contemporary artists — 'Portraits in Oil and Vinegar' — has fluttered the conventional dovecotes. He was discussing the new Hudson memorial in Hyde Park, which has aroused a storm of controversy. 'I am not a believer in Mr. Epstein's infallibility,' he said, 'but I am bound to confess that I think him a great artist and this particular work a great work of art.

'Let us look at the objections that have been raised. I think we can dismiss at once the objection that the sculptor is not a typical Englishman. Art has no frontiers.

'A more serious objection is that the work does not illustrate Hudson. The answer is that it does not try to. Does anyone demand that a statue of Pickwick shall be erected on the tomb of Dickens? What the sculpture does effectively illustrate is the *primitiveness* of Hudson.

Distortion.

'Then it is objected that the figure of Rima is distorted. It is. Distortion is the only way of conveying the sense of movement in sculpture. There is an upward motion The whole block is in flight. As Mr. E. V. Lucas once said of the Victory of Samothrace. "It weighs a ton and is as light as air."

'There has been much detailed criticism of the figure. The large hands, for instance. Tiny hands are the ideal of the drawing-room. They have no place in the primitiveness of nature.

'This work, moreover, is conceived in terms of its medium. The sculptor's problem is: What is the loveliest shape, having emotional fitness, into which I can carve this block of stone?

'The sculptor did not say: "What female form pleases the most and how can I imitate it in clay, affix some symbol to relate it to Rima, and then get a workman to copy it for me in marble with a point machine?"

'My own belief,' Mr. Laver concluded, 'is that Mr. Epstein has succeeded in translating into stone something of the emotion which Hudson felt in the presence of Nature and which he himself translated with splendid prose.'

5 THE TELEGRAPH, 22 JULY 1925

THE EPSTEIN BAS-RELIEF. | 'BOLSHEVIK ART' TO REMAIN.

In the House of Commons yesterday.

Mr. B. Peto (U., Barnstable) asked whether the First Commissioner of Works had arranged for the early removal from its present site in Hyde Park of the Epstein bas-relief, and whether he would see that it is not re-erected in any other public place in this country.

Mr. Locker-Lampson: The answer to the first part of the question is in the negative — (Socialist cheers) — and the second part consquently does not arise (Renewed Socialist cheers).

Mr. B. Peto: Does this so-called work of art belong to the nation? If so, will the right hon. gentleman consider removing this specimen of Bolshevik art?

The Speaker: Argumentative adjectives are out of order. (Laughter and hear, hear.)

Sir W. Davison (U. Kensington, S.): Will Mr. Locker-Lampson say whether he has not now had an opportunity of seeing the indignation of the public — (derisive Lab. Soc. cheers) at having this thing, which has been called a work of art, placed in an otherwise charming bird sanctuary?

Mr. G. Locker-Lampson: We had a good many communications in the first con-demning this particular form of memorial statue. We also had others lyrical in their praise. But during the last three or four weeks we have had no communications at all. (Laughter.)

Sir W. Davison: Is that not due to the fact that it was understood that the First Commissioner of Works was making enquiries as to the feeling of the public? Surely he should now have no misgivings as to what that feeling is. (Cheers and counter-cheers.)

The Speaker: It is obvious that there are two feelings in the matter. (Cheers and counter-cheers).

6 UNIDENTIFIED PRESS CLIPPING, OCTOBER 1925 (TGA)

FRACAS AT THE CAFE ROYAL. | EPSTEIN INSULTED BY YOUNG MEN. | GLASS AND BOTTLE AS WEAPONS.

Mr. Jacob Epstein, the sculptor, was the central figure in a remarkable incident at the Café Royal on Monday night.

He was sitting with a young woman at a table when three young men sitting nearby made loud remarks in criticism of Mr. Epstein's work. His statue of Rima in Hyde Park was especially criticised.

Mr. Epstein became infuriated. A fracas occured, in the course of which a wine bottle was brought down with force on the head of one of the young men, while a glass was hurled and struck Mr. Epstein's girl companion, causing a slight cut on the wrist.

At this stage the manager interfered, and the three young men were forbidden to enter the Café Royal again. Mr. Epstein and his companion left.

APPENDIX C

THE HUDSON MEMORIAL COMMITTEE'S PRESENTATION OF WILLIAM ROTHENSTEIN'S PORTRAIT OF W. H. HUDSON TO THE NATIONAL PORTRAIT GALLERY 1922–23

Hudson records Rothenstein drawing his head in letters to Graham dated 10 June (c1912) and 29 June (c1919) (R. Curle, ed., *W. H. Hudson's Letters to R. B. Cunninghame Graham*, 1941, pp. 95, 103, 126). In a letter to Lemon, 17 February 1923, the artist dates the oil portrait [4] to 1902 and describes it as 'a preparatory study for a completer one I hope to, but never did paint' (see also Milner to Lemon, 2 March 1923)*. On 27 November 1922, Graham proposed commissioning a bust of the author, to be presented to the NPG (*MB*, p. 3). Though the idea was abandoned almost immediately, the Committee expressed the wish to purchase the oil portrait and present it to the NPG (no. 1965). Edmund Gosse, one of its Trustees, pointed out that it was 'contrary to their usual practice, to accept any posthumous portraits'; nevertheless, the proposal was agreed; moreover, the artist pledged monies arising from the transaction to the Memorial Fund (*MB*, pp. 4–5, 27 November 1922). Rothenstein subsequently presented the portrait to the Committee as a gift (*MB*, p. 7, printed leaflet; Graham wrote Lemon, 6 December 1922: 'Rothenstein's picture will cost nothing'). Muirhead Bone was deputed to negotiate with the NPG (*MB*, p. 8, 6 December 1922). Rothenstein wrote Graham (12 and 14 December 1922) agreeing to these arrangements — the portrait had already been sent for the Trustees' scrutiny — and expressing his support for the park project (see also *MB*, p. 13, 10 January 1923), despite the fact that the painter and Epstein were then 'not on good terms' (Graham to Lemon, 19 December 1922). James D. Milner, the NPG Director, wrote Bone, 15 December, expressing the Trustees' pleasure at the gift, and again on 18 December, mentioning that the painting will 'need some attention before it can be exhibited. There are a few bad breaks in the paint' (see also Bone to Lemon, 29 December 1922; undated letter from Rothenstein to Lemon; *MB*, pp. 13–14, 10 January; letter to Rothenstein, 11 January; Graham to Lemon, 15 January; Bone to Lemon, 29 January; *MB*, p. 27, 15 March 1923). The Memorial Committee reported, 14 February 1923, that it had been Viscount Grey of Fallodon's opinion that Hudson's books were 'classics and would remain so, which had influenced the trustees to accept the portrait at once, and without demure'; also that repair costs had been defrayed by the Trustees, and that the portrait now hung in Room XXV, 'devoted to pictures of men of letters'. The Trustees' Chairman, Lord Dillon, expressed hope that Rothenstein's preparatory drawings, then on exhibition at the Grosvenor Gallery, might also be acquired (*MB*, pp. 19–21), though no purchase was made. For the drawings, see J. Rothenstein, *The Portrait Drawings of William Rothenstein 1889–1925*, 1926, nos. 173–77, 193–96, 500, 533, 639–40 (drawings), no. 119 (lithographs), pl. XXXIX.

There was a brief discussion regarding the artist's copyright of the oil portrait (Milner to Lemon, 5 March; *MB*, p. 27, 15 March 1923), which he decided to retain (Rothenstein to Lemon, 16 March; *MB*, p. 35, 10 July 1923). Finally, Graham reported that the picture was 'hung rather high' in the Gallery (letter to Lemon, 16 April 1923).

* Documents quoted in Appendix C are in *RSPB*.

Without Rima reason. — The Epstein panel.

THE STAR, NOVEMBER 1925